CITY OF THE SOUL
ROME AND THE ROMANTICS

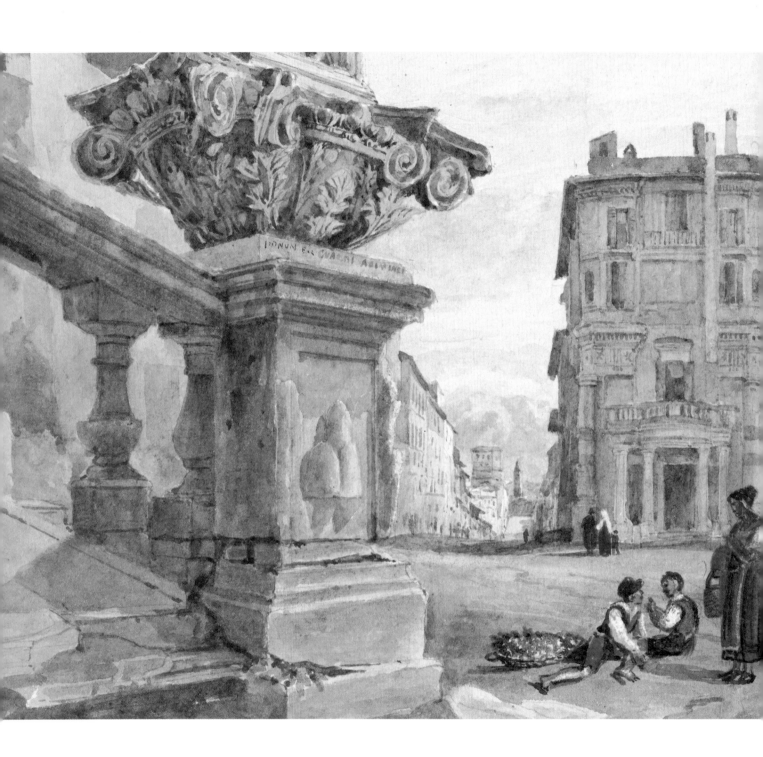

CITY OF THE SOUL
ROME AND
THE ROMANTICS

JOHN A. PINTO

The Morgan Library & Museum, NEW YORK

The University Press of New England, HANOVER AND LONDON

The Foundation for Landscape Studies, NEW YORK

Exhibition at the Morgan Library & Museum, New York
17 June–11 September 2016

City of the Soul: Rome and the Romantics is made possible with generous support from the Arthur F. and Alice E. Adams Charitable Foundation and Fendi.

Assistance is provided by Barbara G. Fleischman and the Sherman Fairchild Fund for Exhibitions. The catalogue is made possible by the Franklin Jasper Walls Lecture Fund, the Foundation for Landscape Studies, and the Barr Ferree Foundation Fund for Publications, Department of Art and Archaeology, Princeton University.

In partnership with

FENDI
ROMA

FOUNDATION
for LANDSCAPE STUDIES

LIBRARY OF CONGRESS CATALOGUING-IN-PUBLICATION DATA:
Names: Pinto, John A., author. | Pierpont Morgan Library.
Title: City of the soul : Rome and the romantics / John A. Pinto.
Description: Hanover : The University Press of New England, 2016. | "Exhibition at the Morgan Library & Museum, New York, 17 June–11 September 2016." | Includes bibliographical references and index.
Identifiers: LCCN 2015046027 | ISBN 9780875981710 (cloth : alk. paper) | ISBN 9780875981727 (ebook)
Subjects: LCSH: Rome (Italy)—Civilization—19th century. | Rome (Italy)—In art. | Rome (Italy)—In literature. | Romanticism—History—19th century.
Classification: LCC DG807.6 .P56 2016 | DDC 945.6/3208--dc23
LC record available at http://lccn.loc.gov/2015046027

ISBN: 978-0-87598-171-0

Frontispiece: Thomas Hartley Cromek, *The Via Sistina and the Palazzo Zuccaro* (No. 10).
Full-page illustrations: p. 8 (Fig. 7, p. 24); p. 34 (No. 7); p. 70 (No. 21); p. 88 (No. 29); p. 104 (No. 35); p. 126 (No. 53); p. 154 (No. 59).

MANUFACTURED IN CHINA

CONTENTS

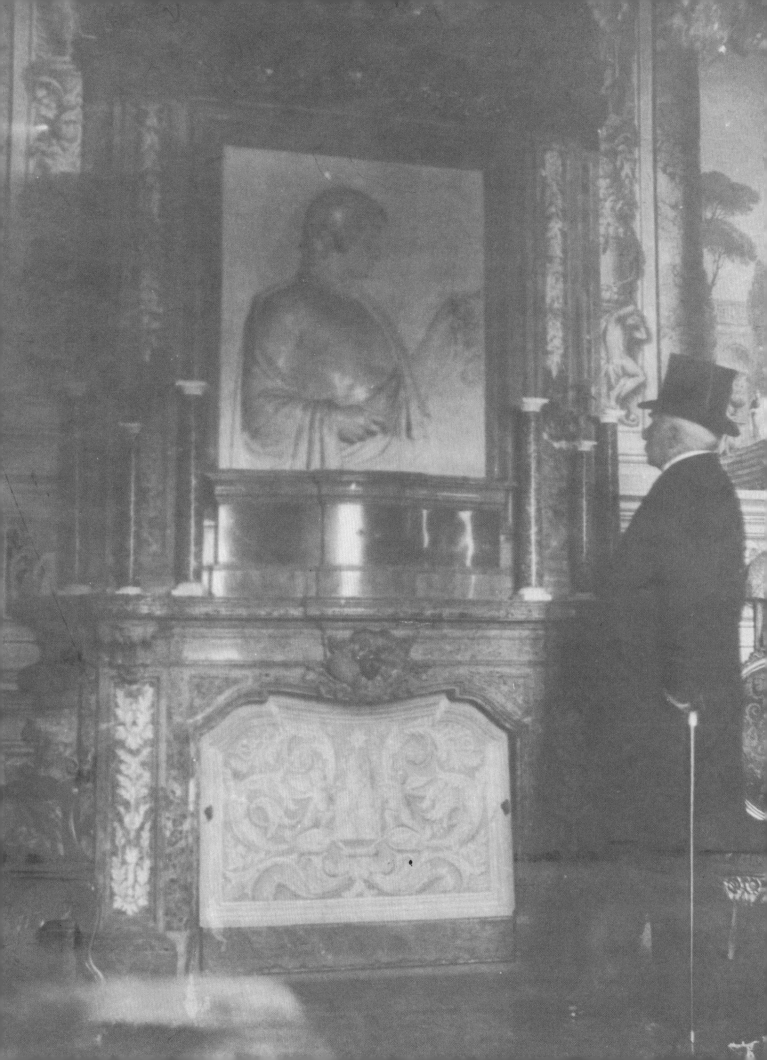

DIRECTOR'S FOREWORD

This exhibition shows how Rome became the City of the Soul—how it touched the hearts and minds of those who visited it during the nineteenth century. The title comes from a passage in *Childe Harold's Pilgrimage* in which Byron's hero seeks consolation and finds meaning in the poignant beauties of the once mighty metropolis. Byron was not the only one to be inspired by magnificent ruins amid these surroundings of splendor and decay. Artists and writers went there to contemplate the downfall of ancient empires while witnessing a resurgence of nationalism and patriotic pride. Here they could view European history in a microcosm of medieval monuments, Renaissance palaces, Baroque churches, and other civic structures embedded in the past yet endowed with vitality and charm. From Byron, tourists learned how to see the Colosseum; from Hawthorne, the Trevi Fountain; and from Goethe, the Pantheon and the Palatine. Watercolors by Turner, pencil drawings by Ingres, and oil sketches by Corot helped cognoscenti to visualize landmarks and understand them in terms of a deeply personal, highly subjective experience. Over the course of a hundred years—from around 1770 to 1870—the city became a vantage point where one could cultivate a new cultural perspective, a new mode of perception guided by instinct and emotion.

Rome stood at the crossroads of the Romantic movement. In this respect *City of the Soul* builds on a previous Morgan exhibition, *Romantic Gardens: Nature, Art, and Landscape Design* (2010), which demonstrated how the precepts of this movement were implemented in public parks and private estates throughout Europe and America. That exhibition took a survey approach, this one focuses on a single locale, but both elucidate the Romantic spirit with vivid examples taken from Morgan holdings in art, literature, and history. We are fortunate indeed to be able to trace the stylistic and intellectual crosscurrents of the period through master drawings, first editions, literary manuscripts, autograph letters, diaries, and journals. For our most evocative views of Rome we are profoundly grateful for the continuing generosity of Eugene V. Thaw, whose gifts to the Metropolitan Museum of Art and the Frick Collection are also represented in this publication. Likewise we acknowledge the growing importance of photography during this period and express appreciation for the loans of W. Bruce and Delaney H. Lundberg. Early photographs from their collection have made it possible to reinterpret familiar scenes and discover new attractions in the city at the cusp of the modern era. We are also indebted to Roberta J. M. Olson and Alexander B. V. Johnson for loans of superb paintings and drawings as well as to Vincent J. Buonanno for Piranesi's print of the Castel Sant'Angelo, which prefigures a photograph of the same subject from around 1868. Each of these collectors has built a visual archive of Rome as have the directors of Studium Urbis and the Avery Library at Columbia University, who have also loaned material on this occasion.

The curator of the exhibition and the author of this catalogue is John A. Pinto, Howard Crosby Butler Memorial Professor of the History of Architecture, Emeritus, at Princeton University. He has written several books on this subject, including *The Trevi Fountain* (1986) and *Speaking Ruins: Piranesi, Architects,*

and Antiquity in Eighteenth-Century Rome (2012). He has worked closely with Morgan staff members John Bidwell, Astor Curator of Printed Books and Bindings, the organizing curator of the exhibition; John Marciari, Charles W. Engelhard Curator of Drawings and Prints; and Jennifer Tonkovich, Eugene and Clare Thaw Curator of Drawings and Prints. Publications Manager Karen Banks and Senior Editor Patricia Emerson oversaw the production of the catalogue, ably assisted by Eliza Heitzman. Marilyn Palmeri and Eva Soos obtained the catalogue illustrations, most of which are from photographs by Graham Haber. Conservators Maria Fredericks, Frank Trujillo, and Reba Snyder prepared material for the installation, which was supervised by John D. Alexander, Senior Manager of Exhibition and Collection Administration, and Paula Pineda, Registrar. The exhibition designer was Stephen Saitas, and the gallery lighting was provided by Anita Jorgensen. I should also recognize the contributions of Jerry Kelly, who designed the catalogue, and two steadfast friends of the Morgan who helped to publish it: Michael P. Burton, Director of the University Press of New England, and Elizabeth Barlow Rogers, President of the Foundation for Landscape Studies.

Funding for *City of the Soul* has come from several donors committed to preserving and promoting the history of Rome. We acknowledge Roman luxury house Fendi as corporate sponsor of the exhibition and note its recent restoration of the Trevi Fountain, indicative of its longstanding commitment to Roman arts and culture. Through the good offices of Arete S. Warren, the Arthur F. and Alice E. Adams Charitable Foundation has covered a significant portion of the exhibition expenses. Barbara G. Fleischman has also provided invaluable assistance. The production costs of the catalogue have been underwritten by the Franklin Jasper Walls Lecture Fund, the Foundation for Landscape Studies, and the Barr Ferree Foundation Fund for Publications, Department of Art and Archaeology, Princeton University.

Finally I should note that the founder of our institution plays a part in this account of Rome in the Romantic era. Pierpont Morgan visited the city on numerous occasions and died there in March 1913. Like collectors in previous generations, he made the traditional pilgrimage to study artifacts of classical antiquity and admire the artistic achievements of the Renaissance. The photograph of him before the bas-relief of Antinous at the Villa Albani (pp. 8 and 24) is the only known picture of him regarding a work of art. He supported scholarship on site by purchasing the Villa Aurelia property for the American Academy in Rome (p. 50), which occupies a building designed by his favored architects McKim, Mead and White. Under Morgan's direction, Charles F. McKim sought to re-create a High Renaissance Roman villa in his client's personal library on East 36th Street in Manhattan, constructed between 1902 and 1906 with architectural elements derived from the Villa Giulia, the Villa Madama, the Villa Medici, and the Casino Pio IV. McKim's masterpiece was a factor in the decision to preserve the library collection after the death of Morgan and then establish a public institution with a larger mission and additional facilities—now the Morgan Library & Museum. The aesthetic experience and cultural resonances invoked by the Eternal City—the sense of place—are the fundamental themes of the exhibition and the catalogue that accompanies it.

Colin B. Bailey
Director

ROME: CITY OF THE SOUL

"Now, at last, I have arrived in the First City of the World!" So exclaimed Goethe upon entering Rome in 1784. "All the dreams of my youth have come to life."[1] Writing a generation later, Byron claimed the Eternal City as his adopted homeland: "Oh Rome! my country! city of the soul!"[2] By the closing decades of the eighteenth century, Rome had already begun to function as a common cultural fatherland that transcended national boundaries. Painters and poets as well as architects and antiquarians from Europe and abroad took the measure of one another as they came to grips with Rome's extended artistic legacy. The records of these encounters—in the form of letters and diary entries, poems, prints, drawings, watercolors, oil sketches, and photographs—collectively constitute the portrait of a very particular place. The italophile writer Vernon Lee (Violet Paget, 1856–1935) declared, "Poets really make places," but, as this exhibition shows, places also make poets and artists.[3]

To present that portrait, *City of the Soul* draws on the Morgan's unique resources, including manuscripts, books, and visual images of Rome in the century between 1770 and 1870. The exhibition is further enriched by loans from generous donors and other New York institutions. This rich trove allows *City of the Soul* to explore Rome in all its complex, moving, amusing, and heartbreaking splendor during the extended era of international Romanticism. From its roots in the work of Piranesi and Goethe to its later echoes in the writings of Hawthorne and James, the Romantic movement cast a long shadow, the reach of which still influences us today.

This is an exhibition about the inherently dynamic relationship between perception and projection. One of its premises is that the act of seeing is never unmediated. Responses to a site like Rome are always inflected by the intellectual and emotional experience of the viewer. For example, Goethe's expectations of Rome were formed by his readings in classical literature as well as by the prints (probably by Piranesi) that hung in his family's house. George Eliot, too, based her ideas of what the city would be on prints and classical literature.

A second premise is that artists and writers, by transforming what they saw in Rome into paintings or verse, inevitably changed the image itself. In this reading, Byron's Romantic vision of Rome established new expectations, prompting later visitors to the Eternal City to seek out not just the places that figure in his poetry but to replicate or test their own emotional responses against those of his protagonist, Childe Harold. Nathaniel Hawthorne, writing a generation later, introduced a group of English-speaking tourists visiting the Colosseum by moonlight, "exalting themselves with raptures that were Byron's, not their own."[4] Later still, William Wetmore Story remarked, "Every Englishman carries a Murray for information and a Byron for sentiment, and finds out by them what he is to know and feel at every step."[5]

All the artists and writers in the exhibition dealt with both the tangible fact of the city and the intangibles of history. Time, with its ravages and poignancies, is more palpable in Rome than in most other cities. The layers of history are never far from the eye. The consciousness of time's passing is never far from

the mind. This extra dimension of the experience of Rome affected the work of the artists and writers who depicted the city, whether overtly or by implication. The dilapidated ruin with vibrant green vines covering its weathered brick, the half-buried column incorporated into the gleaming new palazzo, the rise in street level as millennia of accumulated debris filled in the arcade of an ancient theatre: all proclaimed the marriage of venerable and of the instant. Everywhere the visitor encountered the evidence of the city's duration, evolution, and even revolution.

Rome and its environs are beautiful and evocative. In the hundred years between 1770 and 1870, the city, with its encircling hills, river valley, rising promontories, ancient ruins, and Christian shrines, was an artist's dream. Many distinguished, innovative, and observant artists and writers of the era documented both the physical city and its hive of human activity. Rome provided the most compelling images—of nature, of art and artifice, and of humanity—any artist could ask for. And a single iconic image, the Colosseum, for instance, could resonate across generations. Piranesi's highly theatrical prints of the Colosseum would in time give way to Byron's Romantic vision of the monument bathed in moonlight, which would still work its magic on the young American protagonist of Henry James's *Daisy Miller*.

Throughout its millennial history, Rome has enjoyed a dual existence, at once an intensely physical reality as well as a construct in the imagination of artists and writers. This was especially true in the turbulent century preceding 1870, which saw the city's metamorphosis from papal enclave to the capital of a unified Italy. In this period, the most creative responses to Rome's protean image came from foreigners. Some, like Piranesi and Caffi, hailed from other parts of the Italian peninsula. Some, like Goethe, came from Germany, and others, like David, Ingres, Corot, and Degas, were from France. Turner, Lear, Dickens, and Byron came from Britain, while Hawthorne, Thomas Cole, and Margaret Fuller were among the Americans. This exhibition, however, features some equally trenchant, if lesser known, observers of the Roman scene. They too played a part in fashioning the Eternal City's image during this period.

City of the Soul provides us with the perspective of travelers, of part-time residents, and of tourists. The mid-nineteenth century saw a radical transformation in how most foreign visitors experienced Rome. Since the days of the empire, it had been a destination for travelers of all stripes. It was an administrative and economic center in antiquity; it was a pilgrimage site throughout the Middle Ages; it provided the stimulus for the revival of antiquity during the Renaissance; and it was the sine qua non attraction for the cultured gentleman of the eighteenth century. But it was during the latter half of the nineteenth century that a different form of tourism took hold. The meditative, measured pace of the Grand Tour gave way to the demands of organized tourism following Thomas Cook's first group excursion in 1864. The mass-appeal guidebook and the readily available photo souvenir made Rome accessible and comprehensible to a wider range of travelers than ever before (No. 66).

Rome was, in certain respects, a strikingly democratic place. It was not necessary to belong to the aristocracy to love the ruins. It was not necessary to possess great wealth to appreciate the passing show of street life. It was not necessary to be highly educated to savor the play of light on the Tiber. A keen eye, a receptive mind, a scintillating imagination were the only currency required by the writers and artists featured in this exhibition. Rome could be the City of the Soul for anyone who appreciated the soul of the city, anyone receptive to how Rome stirred the human spirit.

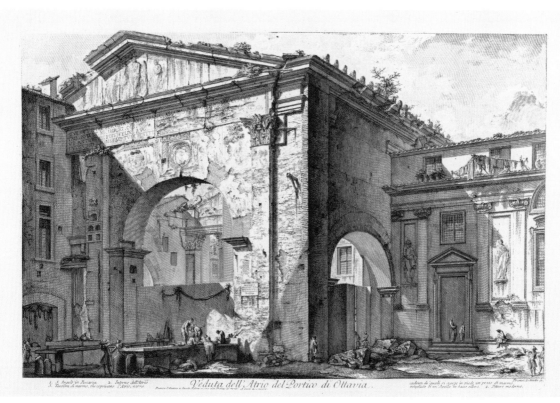

FIG. 1. Giovanni Battista Piranesi, *The Portico of Octavia,* Princeton University Art Museum

THE EYES ARE ALL POWERFUL OVER THE SOUL

Romanticism (the very term invokes Rome) found fertile ground in the City of the Soul. The defining features of the Romantic movement—passion, imagination, individuality, transcendence, nonconformity— thrived in the artistic enclaves of Rome from the late eighteenth through the mid-nineteenth centuries. The city readily lent itself to fervid imaginings and visionary renderings of itself and its past. In previous generations, in other places, the cool clarity of neoclassicism had prevailed but not in the era that saw the growth of Romanticism in the Eternal City. The writers and artists who went there during that period found themselves liberated from one set of expectations (restraint, adherence to prescribed norms, strict logic) and thrown into another (emotionalism, revolution, flights of fancy). The city was the perfect site for the individual and collective transformation of the Romantic mindset.

Rome had long served as the preeminent cultural reservoir of classicism, the font of order and reason. When, for example, late in the seventeenth century, the French Academy sought to clarify and codify the rules governing classical architecture, it sent Antoine Desgodetz to Rome to measure—yet again, and with greater precision—its ruined monuments. Over the course of the eighteenth century, however, we begin to see evidence of an opposing view, one that approaches the past in more emotional terms. The works of Giovanni Battista Piranesi provide a case in point. Whether we consider one of his tenebrous prints representing imaginary prisons (*Carceri d'invenzione*) or one of his views of Rome enriched by dramatic cast shadows, it is impossible to deny that they appeal to the imagination in ways that a generation later would be associated with Romanticism (Fig. 1). The ruins famously

spoke to Piranesi, and through the alchemy of his etchings he gave expression to the mute poetry of their ivy-clad masonry.

Much as the direct experience of the ruins spoke to Piranesi in ways that their abstraction, in the form of measured drawings, did not, so the academic study of the past paled before the impressions produced by fragments of antiquity. Looking out over the remains of the Roman Forum, Madame de Staël's protagonist Corinne muses:

> *The eyes are all powerful over the soul; after seeing the Roman ruins, we believe in the ancient Romans as if we had lived in their day. Intellectual memories are acquired by study. Memories of the imagination stem from a more immediate, more profound impression, which gives life to our thoughts and makes us, as it were, witnesses of what we have learned.*[6]

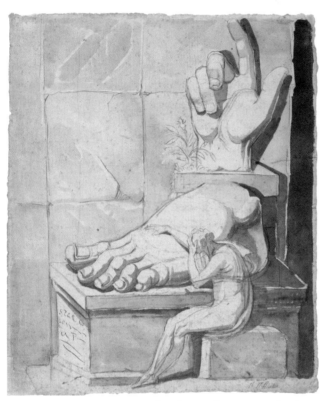

FIG. 2. Johann Heinrich Füssli, *The Artist's Despair Before the Grandeur of Ancient Ruins*, Kunsthaus, Zurich

Perhaps it was precisely because Rome was the touchstone of classicism that it stimulated such moving and powerful emotional responses from artists and writers. Byron, in discussing the Romantic and classical in Italian literature, shrewdly observed, "For a stranger to steer impartially between them is next to impossible."[7] The experience of Rome intensified the creative friction between reason and the emotions. The Swiss artist Johann Heinrich Füssli's drawing entitled *The Artist's Despair Before the Grandeur of Ancient Ruins* of circa 1778–80 conveys a highly personal response to the past, especially in its fragmented state (Fig. 2). The *disiecta membra* of a colossal statue of the Emperor Constantine, preserved in the courtyard of the Capitoline Museum in Rome, loom over the artist. A meditation on the transient nature of life and art, Füssli's drawing also invites interpretations of melancholy and the challenge posed by the art of the past to present-day practitioners.

As Leonard Barken observed, fragmentary remains aren't deficient, rather "they are open . . . they admit the historical imagination as a genuinely collaborative force."[8] This exhibition poses the question of how artists and writers transformed what they saw and experienced in Rome into the emotions that they felt. It also examines the opposite: how their feelings conditioned what they saw and how they perceived it.

Romanticism was closely bound up with the quest for national identity that swept over Europe in the aftermath of the French Revolution and the Napoleonic Wars. Nowhere was this longing felt more intensely than on the Italian peninsula, which remained a mosaic of small city-states, many of them occupied by foreign powers. Among these were the Papal States, which had been invaded by Napoleon, who had exiled the pope and incorporated Rome into his empire. In 1815 the Congress of Vienna restored

the pope to power, and successive pontiffs vigorously resisted all efforts to make Rome the capital of a unified Italy.

In spite of this, the city played a powerful role in the Risorgimento, the movement that eventually led to unification. This role was doubly potent. Ancient Rome embodied Republican values, laws, and a shared cultural legacy of great symbolic value for those who sought to restore Italy to its rightful place among sovereign nations. At the same time, the concrete physicality of Rome was no less significant, providing the urban backdrop to one the most stirring events of the Risorgimento, Garibaldi's heroic defense of the Roman Republic during the summer of 1849.

History and politics—largely urban phenomena—were significant to parts of the Romantic experience, but so was the natural world. In literature and the visual arts, the Romantic era placed particular emphasis on man's relationship to nature. The allied arts of poetry, landscape painting, and garden design were all invigorated by a transcendental vision of nature that asserted the primacy of the spiritual over the empirical. Landscapes, whether artificial or natural, were viewed as sanctuaries offering the individual opportunities for renewal and self-discovery.

Prior to 1870, much of Rome within the circuit of the Aurelian Walls was given over to nature as formal gardens and vineyards, and many of its ancient monuments were overgrown with vines and wildflowers. The painter F.-M. Granet commented on the picturesque variety of vegetation enveloping the ruins of the Colosseum. "You find growing on it yellow wallflowers, acanthus with its handsome stems and its leaves so beautifully edged, honeysuckle, violets—in short, such a quantity of flowers you could put together a guide to the plants from them."[9] In fact, botanists with a more scientific bent compiled catalogues of the flora growing on the Colosseum, one listing over four hundred different species.[10] The decision in 1870 to lay bare the masonry of the Colosseum by removing its mantle of verdure marked the passage from a Romantic view of ruins to one driven by the new imperatives of scientific archaeology.

Beyond the city walls stretched the campagna, whose undulating fields and hidden valleys were studded with ruins reclaimed by nature. The associative potential of this combination of nature and ruined monuments was seized upon by generations of artists and writers. The long tradition of landscape painting in Rome—extending back to the seventeenth century and the works of Annibale Carracci, Nicolas Poussin, and Claude Lorrain—attracted artists to many of the same sites depicted by their predecessors. They, however, brought new sensibilities and approaches to the depiction of nature. The plein-air oil sketch, watercolor, and the new medium of photography yielded fresh interpretations of familiar subjects. The drama of gathering clouds and the electric charge of an impending storm enrich our experience of Monte Mario as depicted by Granet (No. 40). Early photographers creatively employed technology to represent the invisible: the passage of time, what the historian John Stiligoe evocatively called "permanent evanescence."[11]

The Romantics would have loved that characterization. Flux, with a hint of the melancholy, was at the heart of many Romantic works of imagination. Rome answered the Romantic longing for the ambiguous, the mystical, the ineffable, the transcendent. It provided the mise-en-scene for personal interpretation of what was simultaneously unceasing and what was fleeting. Rome, eternal and metamorphic, charged the imaginations of these artists and writers exactly because it *was* both eternal and ephemeral.

SPEAKING RUINS

For many visitors, and certainly for the Romantics, ruins are what make Rome *Rome*. The ubiquity, scale, and resonance of the ruins give the city its identity. This is a bittersweet phenomenon. The ruins are majestic, but they also give rise to melancholy. They are both the evidence of astonishing human achievement and the reminder of the frailty of our accomplishments.

Fresh from the experience of seeing Rome for the first time, Giovanni Battista Piranesi remarked, "Speaking ruins have filled my spirit with images."[12] Over the course of his career, Piranesi would translate those images, through his virtuoso use of the etching needle, into well over a thousand plates. The cumulative result constitutes nothing less than a virtual Rome on paper, one that was diffused throughout Europe and abroad. His friend Robert Adam wrote that Piranesi seemed "to breathe the Antient air."[13] Piranesi's contemporary Giovanni Ludovico Bianconi noted the artist's lifelong preoccupation with this theme and referred to him as "the Rembrandt of the ancient ruins."[14] What allowed Piranesi to respond to the poetry of mute masonry and to capture for his age—as well as ours—the romance of ruins?

Piranesi's extraordinary ability to express the emotional power of ruins derived, in significant part, from the emphasis he placed on experiencing them firsthand. He distinguished between such direct, on-site encounters and others mediated through measured drawings of ancient monuments, such as those published by Palladio, Desgodetz, and others. In doing so, he stressed the fundamentally creative role played by the ruins in stimulating his own imagination, and, by extension, those of others.

The dichotomy between the direct, emotional experience of ruins, inspiring flights of inventive fantasy, and the rational experience of measuring and accurately recording their appearance is by no means unique to Piranesi; indeed, it characterizes responses to the past by many of the writers and artists whose works appear in this exhibition. For example, the disjunction between reason and emotion posed by Piranesi was echoed by Goethe in 1787, in his account of visiting the Greek temples at Paestum: "Reproductions give a false impression; architectural designs make them look more elegant and drawings in perspective more ponderous than they really are. It is only by walking through them that one can attune one's life to theirs and experience the emotional effect which the architect intended."[15]

Piranesi literally "breathed the Antient air" by entering newly discovered sepulchral chambers and groping his way through the half-buried passageways of imperial villas. His subterranean explorations extended to cisterns, drainage channels, and other works of Roman engineering, which he characterized as magnificent. One aspect of the complex artistic persona he cultivated cast him in the role of an ancient Roman addressing a modern audience. Felice Polanzani's portrait of the artist depicts him in the guise of a classical bust, the right arm of which is shattered (Fig. 3). The edges of the plinth on which the bust appears to stand, with its inscription identifying Piranesi as a Venetian architect, are cracked and eroded by time. A book, alluding both to Piranesi's erudition and activities as printmaker, illusionistically (and anachronistically) projects into the viewer's space. Vine tendrils wind around all of these features, enveloping art in nature. The subject's piercing eyes directly engage the observer, and the charged atmosphere swirling around his head conveys an aura of agitated genius.

If the ruins spoke to Piranesi and through Piranesi, their eloquence also made their mark on Shelley, Byron, and other Romantic poets. Joseph Severn's painting of Shelley writing while perched atop one

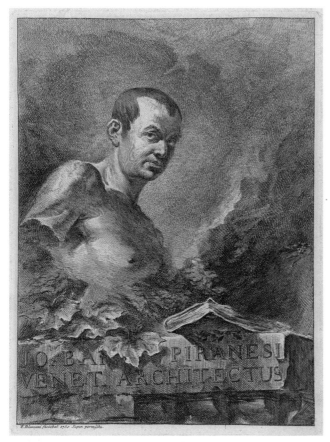

FIG. 3. Felice Polanzani, *Portrait of Piranesi*, Vincent J. Buonanno Collection

of the piers of the Baths of Caracalla distills the Romantic ethos (Fig. 4). One of Shelley's letters provides a richly detailed description of the poet's bower set amid the ruins.

> In one place you wind along a narrow strip of weed-grown ruin; on one side is the immensity of earth & sky, on the other, a narrow chasm, which is bounded by an arch of enormous size, fringed by the many coloured foliage & blossoms, & supporting a lofty & irregular pyramid, overgrown like itself by the all-prevailing vegetation. Around rise other crags & other peaks all arrayed & the deformity of their vast desolation softened down by the undecaying investiture of nature. Come to Rome. It is a scene by which expression is overpowered: which words cannot convey.[16]

Writing in this setting was a total sensory experience for Shelley, who observed that the wildflowers "scatter through the air the divinest odour, which, as you recline under the shade of the ruin, produces sensations of voluptuous faintness, like the combinations of sweet music."

Severn's painting consciously plays on Wilhelm Tischbein's well-known portrait of Goethe set against the expansive backdrop of the Roman campagna (Fig. 5). Both portraits depict modern authors amidst ruins. In the case of Goethe, the Tomb of Cecilia Metella and the arcade of the Claudian Aqueduct appear in the distance. Goethe reclines on what appears to be the broken shaft of an Egyptian obelisk, while other fragments, including a capital and a bas-relief, occupy the right foreground of the composition. The figures composing the classical frieze may allude to Goethe's play *Iphigenia in Tauris,* which he was writing while in Rome. As in Polanzani's portrait of Piranesi, ivy tendrils curl over the relief, linking art and nature. The unmistakable profiles of Monte Cavo and the Alban Hills close the horizon.

In Severn's portrait of Shelley, the same mountains rise in the distance. While Tischbein's Goethe is clearly inspired by his classical setting, Severn's portrait takes such inspiration one step further and depicts Shelley in the act of writing, with pen in hand and notebook open on his thigh. Wildflowers bloom at the base of the wall on which he casually sits, while other blossoms appear behind him. A gnarled tree trunk rooted in the ancient masonry divides the composition in half, further enveloping the poet in a rich and suggestive nature.

The associations of ruins entailed much more than crumbling masonry and fields strewn with marble fragments. Nature, in the form of dense thickets of brambles, vines, and wildflowers, formed an integral part of the experience of ruined monuments like the Colosseum, where, in Byron's words, "dead walls rear / their ivy mantels."[17] The organic cycle of growth and decay intensified the elegiac

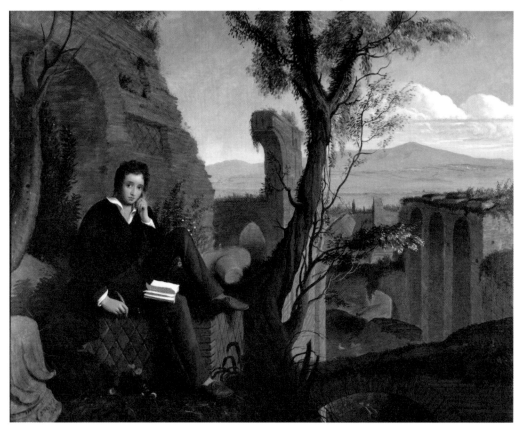

FIG. 4. Joseph Severn, *Shelley in the Baths of Caracalla,* Keats-Shelley Memorial House, Rome

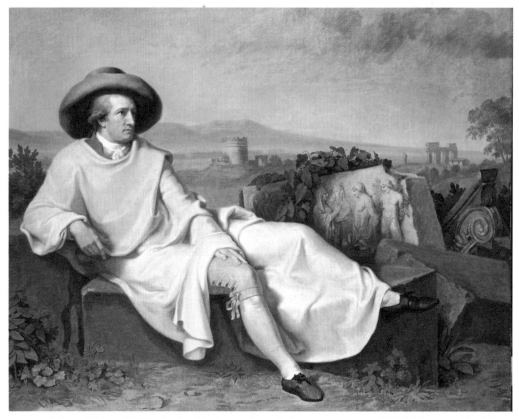

FIG. 5. Johann Heinrich Wilhelm Tischbein, *Goethe in the Roman Campagna,* Städel Museum, Frankfurt am Main

message encoded in ruined architecture, prompting reflection on mortality and the transience of human accomplishment. Shelley's "Ozymandias" captures the vanity of assuming that great men and their accomplishments will endure.

> *My name is Ozymandias, King of Kings:*
> *Look on my Works, ye Mighty, and despair!*
> *Nothing beside remains. Round the decay*
> *Of that colossal Wreck, boundless and bare*
> *The lone and level sands stretch far away.*

Although "Ozymandias" was written before Shelley came to Italy and is set in Egypt, its message is nonetheless Roman in spirit.

For Shelley, lamenting the death of Keats, Rome is "at once the Paradise, / The grave, the city and the wilderness."[18] Of Keats's resting place in the Protestant Cemetery, Shelley wrote, "It might make one in love with death to think that one should be buried in so sweet a place."[19] (The reader might also hear the echo of Keats's "half in love with easeful Death," from *Ode to a Nightingale.*) The mourning figures in Domenico Amici's view of the Protestant Cemetery offer silent testimony to the abiding presence of mortality in this Arcadian setting (No. 47). Death and tragedy, ever-present in the Romantic imagination, haunt the city of Rome. And yet there is always something else, something beyond the macabre or melancholy.

For Byron and his contemporaries, the ruins of the Colosseum were a "still exhaustless mine / of Contemplation." In the famous "moonlight stanza" of *Childe Harold*, Byron invested the Colosseum with magic powers:

> *But when the rising moon begins to climb*
> *Its topmost arch, and gently pauses there;*
> *When the stars twinkle through the loops of time,*
> *And the low night-breeze waves along the air*
> *The garland-forest, which the grey walls wear,*
> *Like laurels on the bald first Caesar's head;*
> *When the light shines serene but doth not glare,*
> *Then in this magic circle raise the dead:*
> *Heroes have trod this spot—'tis on their dust ye tread.*[20]

Through the medium of Byron's verse and the agency of moonlight, the Colosseum is transformed from a ruined edifice into a "magic circle" capable of raising the dead (No. 45). Of course the dead abide everywhere in Rome; their animating presence affects anyone who visits the Eternal City. Ancient heroes live on, as do the writers and artists who flourished in Rome over the centuries. They inhabit it and are reborn in the minds of its visitors. These ghosts all contribute to the soul of the city, making Rome a perpetually renewing source of artistic inspiration.

THE GREATEST THEATRE IN THE WORLD

Giuseppe Garibaldi characterized the view over Rome from the Janiculum Hill as the greatest theatre in the world.[21] Poets, artists, and architects had long extolled the sweeping panorama from the Janiculum. An epigram by the ancient Roman poet Martial praised the view from a relative's villa situated on

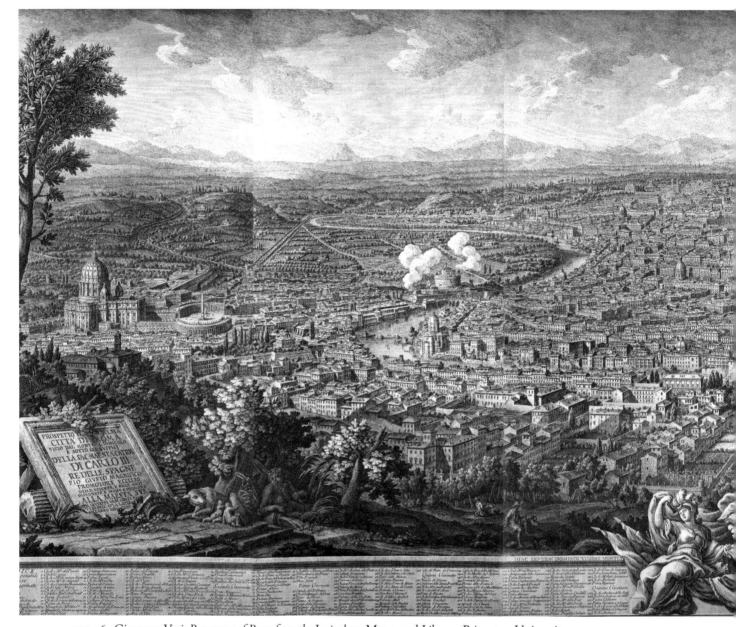

FIG. 6. Giuseppe Vasi, *Panorama of Rome from the Janiculum*, Marquand Library, Princeton University

the crest of the Janiculum: "on this side may you see the seven sovereign hills, and take the measure of all Rome."[22] Over a millennium later, a Renaissance cardinal sought to replicate the view described by Martial, and had the poet's lines inscribed in the loggia of the Villa Lante. Printed views of the panorama from the Janiculum were repeatedly issued over the course of the ensuing centuries. The most spectacular example, etched by Giuseppe Vasi in 1765, also includes the quotation from Martial (Fig. 6). George Housman Thomas's panorama of 1850, depicting the destruction inflicted by the 1849 siege, consciously plays on this tradition (No. 51).

The theatre of Garibaldi's metaphor conflates time and space. It comprehends the floodplain of the Tiber, the celebrated Seven Hills, and the natural amphitheatre of mountains. At the same time, it embrac-

es the full sweep of Roman history, from the city's traditional founding in 753 B.C. through the stirring events of Garibaldi's day. An acute awareness of such continuities is evident in many responses to Rome. The American journalist Margaret Fuller, writing to her brother Richard only a few months before Garibaldi's defense of the Janiculum, captures the way in which the physical fabric of Rome embodies the countless figures—real and fictional—who have played prominent, if passing, roles on this majestic stage:

> Yesterday as I went forth I saw the house where Keats lived in Rome where he died. I saw the Casino of Raphael. Returning I passed the Villa where Goethe lived when in Rome, afterwards the houses of Claude and Poussin. I live myself in the apartment described in Andersen's Improvisatore.... I have the room I suppose, indicated as being occupied by the Danish sculptor.[23]

The actors—past and present—constitute but one aspect of Garibaldi's theatre. What of the stage and its backdrop? Rome's multilayered topography contributes to the rich interplay of past and present, of memory and monument. It even prompted Freud, in *Civilization and Its Discontents*, to propose an analogy between Rome's stratified subsoil and the subconscious.[24] (Freud reasoned that much as long-forgotten structures that once molded human actions and beliefs are revealed by archaeology, so, in mental life, everything is preserved and may be brought to light through the judicious application of psychoanalysis.) While the artists and writers featured in this exhibition were innocent of psychoanalysis, they were acutely sensitive to Rome as an urban palimpsest reshaped by successive epochs.

Over the centuries, buildings in Rome have been repeatedly constructed over the ruins of their predecessors, preserving the memory of the past in an angled wall or a despoiled column. Many ancient structures survive, embedded in the modern city and adapted to different functions. The foundations of the churches and palaces defining the Piazza Navona, for example, incorporate walls that once supported the seating of the ancient Stadium of Domitian. In this way the footprint of a long-vanished monument is preserved in one of the city's great piazzas (No. 16). To take another example, the papal fortress of the Castel Sant'Angelo rises from the massive cylinder of Hadrian's Mausoleum (Nos. 58 and 59). Even the Baroque exuberance of St. Peter's interior respects the orientation of its early Christian predecessor, which, in turn, was determined by the location of the ancient necropolis where the apostle Peter was interred and subsequently venerated (No. 7). The high altar in the crossing, marked by the spiral columns of Bernini's great baldachin, is in precise vertical alignment with the presumed burial site thirteen feet below the pavement of the modern basilica.

If the architectural fabric of this multilayered city defines the stage of Garibaldi's theatre, nature provides the scenic backdrop. This is particularly evident in Giuseppe Vasi's panorama (Fig. 6), in which gardens and vineyards cascade down the slopes of the Janiculum, forming a leafy, picturesque frame for the city below. The winding course of the Tiber is there too, as are the cultivated fields and meadows of the Prati di Castello, visible beyond the clouds of smoke billowing from the Castel Sant'Angelo. The height of Monte Mario appears in the distance behind St. Peter's and the Vatican (Nos. 2 and 3).

Vasi's panorama shows how Rome's garland of villas blurred the distinction between city and countryside. Many, like the Villa Borghese, were situated just outside the Aurelian Walls, but others, like the neighboring Villa Ludovisi, occupied generous portions of the city within their circuit. It is worth noting in this regard that most of the fighting during Garibaldi's defense of the Janiculum took place on the grounds of villas, particularly those belonging to the Corsini, Pamphili, and Spada families. Much damage to Rome's green belt had been inflicted by the defenders before the siege so as to provide clear fields of fire for their guns. Writing to Ralph Waldo Emerson, Margaret Fuller lamented these losses:

> Then Rome is being destroyed; her glorious oaks, her villas; haunts of sacred beauty, that seemed the possession of the world forever,—the Villa of Raphael, the villa of Albani, home of Winckelmann, and the best expression of the ideal of modern Rome, and so many other sanctuaries of beauty—all must perish, lest a foe should level his musket from their shelter.[25]

The Roman campagna, studded with ruins, begins outside the circuit of the ancient Aurelian Walls. To the south, along the Appian Way, Vasi depicted the cylindrical Tomb of Cecilia Metella and beyond, the

majestic arcades of the Claudian Aqueduct. Closing the prospect are the peaks of the Sabine Hills (at center), the Alban Hills (on the right), and the solitary prominence of Monte Soratte (on the left). Vasi took pains to indicate the location of many of the surrounding hill towns, like Tivoli. In addition to playing an important part in the economic life of the papal capital, such towns provided the power bases of the feudal nobility and sites for imposing villas. They also attracted artists and writers based in Rome who trekked on foot and muleback to seek out their classical associations and picturesque ruins.

Some, like Henry James, delighted in experiencing what he called "the luxury of landscape" while riding horseback over the campagna.[26] In *Roman Rides*, James commented on the contrast between city and countryside and the closeness of the two.

> *...to be able in half an hour to gallop away and leave it [Rome] a hundred miles, a hundred years, behind, and to look at the tufted broom glowing on a lonely tower-top in the still blue air, and the pale pink asphodels trembling none the less for the stillness, and the shaggy-legged shepherds leaning on their sticks in motionless brotherhood with the heaps of ruin, and the scrambling goats and staggering little kids treading out wild desert smells from the top of hollow-sounding mounds; and then to come back through one of the great gates and a couple of hours later find yourself in the "world," dressed, introduced, entertained, inquiring, talking about* Middlemarch *to a young English lady or listening to Neapolitan songs from a gentleman in a very low-cut shirt—all this is to lead in a manner a double life and to gather from the hurrying hours more impressions than a mind of modest capacity quite knows how to dispose of.*[27]

The long shadow of Romanticism extended far into the nineteenth century. In *Portrait of a Novel*, Michael Gorra describes *Roman Rides* as James's "most deliberate attempt to create a picturesque landscape," with echoes of the Romantics, especially Wordsworth and the Shelley of "Ozymandias."[28] From Martial and Giuseppe Vasi to Margaret Fuller and Henry James (not a mind of modest capacity, as he slyly suggests), Rome's complex melding of urban and rural, past and present, gave scope to meditations on what *civitas* and *civilization* meant.

THE HUM OF MIGHTY WORKINGS

In the century between 1770 and 1870, Rome exerted little control over its own destiny and was largely the pawn of foreign powers. Italy, as a unified political entity, came into being only in 1870. The occupation of Rome that year and the city's subsequent designation as the new nation's capital represent a watershed in its history. With the single notable exception of Garibaldi's defense of the Roman Republic in 1849, the events that ultimately led to the unification of Italy took place beyond the boundaries of the Papal States. Nonetheless, what Keats presciently termed "the hum of mighty workings" in 1817 was audible within Rome and exerted a powerful influence on its history.[29]

During the last decades of the eighteenth century, the Papal States constituted but one of many small principalities and city-states into which Italy was divided. Rome was an economic backwater, and its characterization by Charles de Brosses of 1739 continued to be echoed for over a century by visitors from northern Europe and the United States: "Imagine a population, one fourth of which consists of priests, one fourth of statues, one fourth people who hardly do anything, and the remaining fourth who do nothing at all."[30]

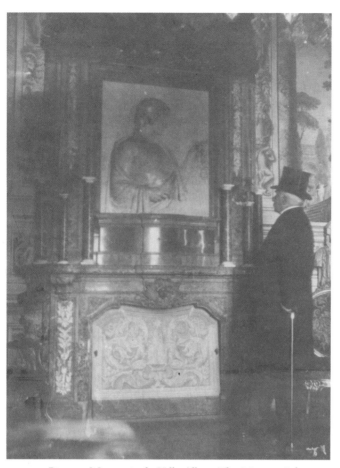

FIG. 7. *Pierpont Morgan in the Villa Albani*, The Morgan Library & Museum, New York

For three decades, the tumultuous events of the French Revolution and its aftermath shook the papal capital to its core. With the Treaty of Tolentino in 1797, the pope submitted to the new authority in Italy, Napoleon Bonaparte. Among the stipulations of this treaty was the transfer of hundreds of works of art from Roman collections to the Louvre. While some of these masterpieces were eventually returned following Napoleon's defeat, many still remain in France. In 1798 the French army occupied Rome to support the recently declared Jacobin Republic. Pope Pius VI was taken into custody and forced into exile, where he died. The French withdrew from Rome in 1799, causing the collapse of the republic, only to return in 1808. This time the Papal States were annexed to France, and in 1811 Napoleon's son by Maria Luisa of Austria was crowned king of Rome. The French administration in Rome carried out a number of archaeological excavations and urban planning interventions but left little lasting impression on the city.[31]

In 1815 the Congress of Vienna restored the pope to his throne, and Austria became the dominant power on the Italian peninsula. Pope Pius VII lost little time in returning to the old dispensation, reimposing censorship and the Inquisition. In the decades that followed, patriots joined in a movement to unify Italy, part of a more general process of political change in Europe. The Risorgimento, as this movement came to be called, carried with it connotations of resurrection, for which Rome and its empire served as potent symbols of national identity.

In the wake of the events of 1848, the year of European revolutions, Rome briefly came to play an active part in the struggle for independence. A nationalist movement had been gathering strength. When, in the following year, popular unrest obliged Pope Pius IX to flee the Vatican, one of the movement's exiled leaders, Giuseppe Mazzini, became the catalyst for the short-lived Roman Republic. In response, France landed an expeditionary force to reinstate the pope, while the army of the conservative Bourbon monarchy of Naples threatened Rome from the south. Into this desperate situation marched Giuseppe Garibaldi and his small band of legionaries from the north of Italy. Over the next two months, Garibaldi would defeat the Neapolitan army while holding off successive French assaults on the city. In the end, however, overwhelmed by superior numbers and armaments, he was obliged to withdraw, surrendering the city to French occupation and the return of the pope.

Margaret Fuller, who had met Mazzini in England, chronicled these dramatic days in her letters and dispatches to Horace Greeley's *New-York Tribune,* all the while caring for the wounded (No. 50). George Housman Thomas, the artistic correspondent of the *Illustrated London News,* was also in Rome, producing sketches that captured the patriotic fervor of the defenders and the destruction of battle (No. 51). The movement was redolent of romance, and as G. M. Trevelyan noted, "Garibaldi's claim on the memory of men rests on more than his actual achievements. It rests on . . . his appeal to the imagination. He was a poet, in all save literary power. . . . He is perhaps the only case, except Byron for a few weeks in Greece, of the poet as man of action."[32] In the end it was the not the Rome of bricks and mortar that nourished the Risorgimento over the next two decades, but a Rome of the imagination, of what could be, that inspired them to cry *"Roma o morte"* as they marched into battle.

Pius IX returned to the Vatican, his rule in Rome and the much-diminished Papal States sustained by a French garrison (No. 54). In the two decades between 1850 and 1870, the Risorgimento gathered force throughout the Italian peninsula. In the words of "Garibaldi's Hymn:"

> *To arms! To arms! The tombs are uncovered, the dead come from far,*
> *the ghosts of our martyrs are rising to war.*
> *With swords in their hands and with laurels of fame*
> *and dead hearts glowing with Italy's name.*
> *Come join them, come follow, O youth of our land.*
> *Come fling out our banner and marshal our band.*
> *Come all with cold steel and come all with hot fire.*
> *Come all to the flame of Italia's desire.*
> *Be gone from Italia, begone from our home.*
> *Go from Italia, go from Italia! O stranger, begone.*[33]

When the French troops were withdrawn as a result of the Franco-Prussian War, the opportunity finally came for the army of King Victor Emmanuel of Savoy to claim Rome as the capital of a unified Italy. On 20 September 1870, following a brief and largely symbolic bombardment, Italian troops entered the city, causing the pope to retreat into the Vatican (No. 17).

The liberation of Rome in 1870 and the city's designation as the nation's capital led to its transformation, as much of Rome's picturesque charm was swept away to provide space for new avenues, government ministries, and the infrastructure appropriate to a modern metropolis. This exhibition ends with the transformation of *Roma papale* into *Roma capitale.* William Wetmore Story, in the preface to the eighth edition of *Roba di Roma* (1887), captured this moment.

> *The character of Rome has very much changed from what it was. It is no longer the peaceful and tranquil place where the pilgrim might wander and muse over the past, far from the busy traffic of the world, and its worry and its interests. The contemplative and almost monastic charm of retirement, which once made it a city apart from all others, is gone or going, and it is gradually drawing into line with all other cities. Life is astir in its crowded streets. It is awaking from its long dream. But one cannot but sigh in remembering how pleasant and soothing that dream of life was, and despite all reasoning there lingers a fond regret for the olden time, when Rome was sleeping.*[34]

DAGUERREOTYPED ON MY HEART

Visitors to Rome had long been drawn to the physical city, composed of churches and palaces, streets and piazzas, fountains and ruins. Over centuries, pilgrims had also come to venerate a spiritual city, an earthly reflection of the heavenly Jerusalem. Upon their departure, many such visitors wished to take back with them portable distillations of the city in the form of paintings, prints, and photographs. These images collectively came to constitute a virtual Rome in which the competing goals of accuracy and artistic license yielded fresh interpretations of the Eternal City.

While there continued to be a market for unique painted views and drawings of familiar Roman monuments, the introduction of new artistic media and techniques also contributed to the shaping of the city's image. Drawings, prints, and other traditional media proved flexible in adapting to new expressive needs. Over time, engraving, etching, lithography, and photography—all of which were capable of producing multiple images—met the increasing demand for city views. Giovanni Battista Piranesi, arguably the most inspired interpreter of Rome in any age, cast a long shadow that extended temporally well beyond his death in 1778 and into the new century. Piranesi's use of large copperplates to produce etchings of unparalleled detail and chiaroscuro richness was continued in the nineteenth century by Luigi Rossini (No. 37).

The medium of watercolor took on greater prominence as improved papers, pigments, and brushes became commercially available. These easily accessible artist's supplies encouraged the practice of plein-air painting, in the form of watercolors and oil sketches, the immediacy of which would in turn influence early photography. Watercolor constituted an ideal Romantic medium, offering as it did a rapid, even impulsive, means of expressing emotions and fleeting thoughts that can not be corrected. Watercolor became the preferred medium of topographical artists such as Edward Lear, whose unique field sketches were then transformed into color lithographs that could be reproduced in large numbers (No. 38).

Long before the invention of photography, a variety of optical devices were employed by artists and topographers as aids in the production of accurate city views. A 1778 inventory of Piranesi's studio mentions a camera obscura. Joseph Mallord William Turner's earliest engravings of Rome, made several years before his first visit there, were based on drawings made by James Hakewill using a camera obscura. The antiquarian Sir William Gell employed a camera lucida to produce accurate renderings of archaeological sites (No. 33).

The new medium of photography offered astonishing potential for a new kind of verisimilitude as well as for individual interpretation of city scenes. Following hard on the announcement of the daguerreotype process in 1839, early photographers, such as Alexander John Ellis and Joseph-Philibert Girault de Prangey brought what John Ruskin termed this "noble invention" to Rome (No. 22).[35] Writing in 1839, the Roman poet Giuseppe Gioacchino Belli commented on the revolutionary implications of Daguerre's discovery, which allowed "nature to portray herself," thus calling into question the role of the artist.[36] Joel Tyler Headley internalized Daguerre's process, linking image, emotion, and memory. Describing the incomparable view from the dome of St. Peter's in 1845, Headley wrote, "It is daguerreotyped on my heart forever."[37]

While daguerreotypes were capable of recording the finest details and were highly valued for their documentary accuracy, they were severely limited in that each image was unique and could not readily be reproduced. These limitations led to experiments in mixed media, in which engravings were made

after daguerreotypes (often destroying the plate in the process) with figures added by the engraver. Henry Fox Talbot's calotype process, introduced in 1841, allowed early photographers like the Reverend Calvert Richard Jones and Frédéric Flachéron to print multiple images from a single paper negative (Nos. 13, 23, and 24). The early 1850s saw the introduction of collodion glass-plate negatives, which allowed for much shorter exposure times and were used to print many of the photographs in the exhibition.

Many early practitioners, like Gioacchino Altobelli, Gustave Le Gray, and Robert Macpherson, came to photography from backgrounds in painting and the graphic arts. Much as is the case today with new digital media, technical developments influenced what early photographers could do with the tools available to them, with consequences for how they perceived and represented the city. Some, like Altobelli, consciously played on the compositions of Piranesi and earlier masters of the *veduta* tradition, while exploiting novel possibilities photography offered (Nos. 58 and 59). Macpherson photographed many of the monuments that appear in Piranesi's *Vedute di Roma,* and his images often convey a comparable sense of monumentality but without his predecessor's manipulations of scale and dramatic chiaroscuro effects. Macpherson's best images achieve a luminous clarity and sublime grandeur unique to photography (No. 36). A review of a photographic exhibition published in 1862 observed:

> *It has been left to photography to picture Rome in such detail as it is not the province of painting to attempt....*
> *In the light and shade of these ruins there is a sentiment which, with the stern truth of the photograph, affects the*
> *mind more deeply than a qualified essay in painting.*[38]

The "stern truth" of photography, its documentary value, naturally lent itself to the field of archaeology, which by the middle of the nineteenth century was developing along more scientific principles. Photographers commissioned by John Henry Parker set out to record systematically Rome's ancient monuments and collections of classical sculpture as well as much new evidence brought to light by excavations and construction work. The resulting photographs often display a directness and absence of artistic intention that yield a fresh view of familiar subjects. Some photographers applied this approach to the postclassical city, seeking new subjects off the beaten track and presenting familiar ones from different and engaging perspectives. Gustave Le Gray and Firmin-Eugène Le Dien, for example, chose to shoot Bernini's Triton Fountain from above and to crop their image in a way that both reveals and renders mysterious its urban setting (No. 32). In much the same way, Adriano de Bonis eschewed a frontal view of S. Maria Maggiore, preferring to obscure partially the facade of the basilica so as to emphasize the play of vertical elements linking fore, middle, and background (No. 63).

By the middle of the nineteenth century, photography competed openly with more traditional media in providing souvenir images for the increasing numbers of tourists who visited Rome. Some photographers, like Gioacchino Altobelli, Pompeo Molins, and Robert Macpherson, marketed their images directly from studios and shops situated near the tourist quarter around the Spanish Steps (Nos. 57, 59, and 65). Others, like James Anderson, sold their photographs through the bookseller Joseph Spithöver, whose shopfront opened directly onto the Piazza di Spagna. Eugène Constant's work was marketed by Edouard Mauche on the via del Corso.

Shortly before his departure from Rome in 1859, Nathaniel Hawthorne made the following notes in his pocket diary:

May 5: Mamma & Julien went out shopping for photographs.
May 6: I went with Mamma & Rosebud to look at photographs.[39]

Hawthorne had finished drafting his romance *The Marble Faun* three months earlier and no doubt wished to acquire photographs of monuments that figure in his narrative. When the Tauchnitz edition of *The Marble Faun* was published the following year, it was profusely illustrated with a hundred photographic plates.[40] This edition could be customized, with purchasers illustrating the printed text with photographs of their own selection. In this connection the relationship between literature and photography was reciprocal. Prior to 1860, the medieval tower that figures prominently in Hawthorne's novel as Hilda's Tower did not count among Roman monuments thought worthy of particular notice. Reflecting this, an image of the tower is not included in Macpherson's 1858 and 1863 lists of photographs. With the international success of *The Marble Faun*, however, Macpherson added Hilda's Tower to his 1871 list (No. 57).[41]

Photography had displaced prints and paintings as popular souvenirs of Rome by 1870, at precisely the time when other new technologies—the railroad and the steamship—were making it possible for increasing numbers of tourists to visit Rome. Paper photography facilitated other popular souvenirs, notably the postcard. The increased demand for images prompted the Alinari firm to provide high-quality reproductions of works of art and architecture throughout Italy. The availability of such images, in turn, transformed the nascent field of art history, making it possible for connoisseurs, collectors, and dealers to make comparisons between works situated in different cities.

A WORLD GIVEN LIFE BY FEELING

The Romantic image of Rome was as much the product of writers as of visual artists. The Morgan's collection of books and manuscripts attests to the remarkable range of literary responses to Rome—from private letters and diaries to poetry and fiction to news dispatches and travel guides. As with the visual artists, the writers often knew each other, or knew of each other, and their work influenced that of other writers. Similarly, the forms they employed often bled into each other: observations in diaries or letters became, in time, stories, poems, or travel essays. Goethe's *Italian Journey*, written long after his stay in Rome, was based on his journal and letters.

Time and again, a writer's personal observation of the city fostered the fictions of poetry and novels. Hawthorne, for instance, kept a travel journal that was never intended for publication. Many of the entries are merely descriptive, but some reveal the ways in which particular objects and settings stimulated his imagination. In the middle of an account of the ancient sculpture in the Capitoline Museum he wrote, "I likewise took particular note of the Faun of Praxiteles, because the idea keeps occurring to me of writing a little Romance about it."[42] As Hawthorne began to write what would become *The Marble Faun*, other entries show him repeatedly visiting settings that would figure in the novel. Other objects stimulated his imagination: after viewing a gold bracelet he wrote that it "would make a good connecting link for a series of Etruscan tales, the more fantastic the better." On another occasion he proposed to write "a story based on the spirit of a dead woman encased in a gem."[43]

The prompting of the imagination by physical objects and surroundings was crucial to the artists discussed here. Dual strands of reality and imagination characterize all the works that emerged from Rome dur-

ing this period. The writers took what they saw and transmuted it into the feelings and experiences of their fictional characters, not always glowingly. George Eliot, on a visit to Rome in 1860, wrote in disappointment:

> *A weary length of dirty uninteresting streets had brought us within sight of the dome of St. Peter's which was not impressive, seen in a peeping makeshift manner just above the houses; and the Castle of St. Angelo seemed but a shabby likeness of the engravings.*[44]

A dozen years later, this early dispiriting impression must have colored Eliot's depiction of Dorothea's disastrous Roman honeymoon in *Middlemarch*. It's worth noting that Eliot came to appreciate Rome over the course of her visit, but the intensity of feeling she first experienced stayed with her, to be rendered again later in her fiction.

Many writers saw the city through a more Romantic lens. In fact, the image of Rome conjured by the Romantic poets proved to be as powerful and enduring a construct as any of the city's great monuments. These writers took as their sources both what they saw and what history recorded. Shelley's tragic verse drama *The Cenci* (1819) was prompted by the presumed portrait of Beatrice Cenci ascribed to Guido Reni. This dark tale of incest and parricide within a noble Roman family was loosely based on historical accounts and trial records. In much the same way, Browning's verse novel *The Ring and the Book* (1868–69) takes as its point of departure a bound volume of documents relating to a 1698 murder trial the poet happened upon. Browning also constructed fantastic reveries from his close observation of Roman monuments. His dramatic monologue *The Bishop Orders His Tomb at Saint Praxed's Church* (1845) is set within an actual early-Christian basilica. The dying Renaissance prelate and the sumptuous sepulchral monument he describes are elaborate fictions, albeit based on historical examples.

The literary genre of the romance contributed greatly to the Romantic image of Rome. In 1804–5, while in exile imposed by Napoleon, Madame de Staël was inspired to write *Corinne*. As the narrative unfolds, Rome is revealed through the imagination. At the end of a day visiting Roman monuments in the company of Madame de Staël's heroine, Corinne, Lord Nelvil exclaims, "Rome shown by you, Rome interpreted by imagination and genius, *Rome, a world given life by feeling, without which the world itself is a desert.*"[45] After another day spent visiting the celebrated hills of Rome, Corinne remarks, "I have rushed you through some of the landmarks of ancient history … but you will understand the pleasure to be found in these researches, which are both scholarly and poetical, and appeal to the imagination as well as to the mind."[46]

The real and the magical intertwine in the other great romance set in Rome, Nathaniel Hawthorne's *The Marble Faun* (1860). In the preface, Hawthorne described the value of the foreign setting "as affording a sort of poetic or fairy precinct, where actualities would not be so terribly insisted upon as they are, and must needs be, in America."[47] He went on to remark, "Romance and poetry, ivy, lichens, and wall-flowers, need ruin to make them grow." For Hawthorne, the weighty mantle of Rome's millennial history necessarily inflects his view of the present: "Side by side with the massiveness of the Roman Past, all matters that we handle or dream of nowadays look evanescent and visionary alike."

Evanescent and visionary, as well as immediate and concrete, could also describe the personal evocations of Rome found in letters. One from Charles Dickens to his sister-in-law conveys the author's childlike delight in the exuberance of the Roman carnival (No. 48). Wilkie Collins, writing to his friend Charles Ward, provides a vivid description of Pope Pius IX taking snuff, an intimate scene of compelling

immediacy (No. 55). Margaret Fuller, in a letter to Caroline Sturgis Tappan, describes the charms of Rome's numerous fountains: "It is full moon and I go forth. As you have never been in Rome moonlight nights, don't fancy yourself well enough off—this is the city of fountains and they talk a great deal nights. None of the nymphs are dead."[48]

A letter Fuller wrote to her friend Elizabeth Hoar back in Concord, Massachusetts, is entirely different in tone. She wrote it a few months later, during the 1849 siege of Rome (No. 50). Fuller was then actively engaged in caring for soldiers wounded while defending the city. The letter begins, "I feel an inexpressible weariness of spirits today," and ends "Adieu, dear Lizzie, prize the thoughtful peace of Concord." With Fuller we are reminded that the writers were not always middle-class white men. Some of the most telling depictions of Rome during this turbulent period come from women such as Fuller, Charlotte Eaton, and Mrs. Anna Jameson, who witnessed both the beauty and the brutality of Rome.

Books composed of letters written from Rome, while not conveying the immediacy of personal correspondence, nonetheless allowed considerable scope for informal observation and critical commentary. Charlotte Eaton visited Rome in 1817–18; the letters comprising her *Rome in the Nineteenth Century* were written at virtually the same time as Byron's *Childe Harold*. While Eaton is susceptible to Romantic sentiment, she is far more grounded in the factual, and her book served for many years as a guide to the antiquities and monuments of Rome. She also gives free play to her critical opinion. Of the Basilica of S. Maria Maggiore (see Nos. 62 and 63), she commented:

> *Nobody could suspect it of being a church, but for the deformity of an old brick belfry, which sticks up in a singularly awkward position from the roof. It has more faces than Janus, and they resemble each other in nothing but their ugliness. In the advance of one of these, stands the solitary marble column, brought from the Temple of Peace, and erected by a pious Pope on a disproportioned pedestal.*[49]

William Cullen Bryant, too, sent letters back to the *New York Evening Post* during successive visits to Europe around the middle of the nineteenth century. They were subsequently published in two volumes as *Letters of a Traveller* (No. 54). Bryant had a keen eye for detail, and was particularly sensitive to civic improvement:

> *Within a few years past, the small round stones with which the streets of Rome were formerly paved, and which were the torture and terror of all tender footed people, have been taken up and the city is paved throughout, with small cubic blocks of stone, which present a much smoother and more even surface.*[50]

Some writers intended their letters and diaries to be published eventually; others wrote only for themselves, but their personal jottings have survived for all to read. Letters presuppose an audience, though not necessarily that of posterity served by the Morgan's collection. The private or playful nature of diaries and letters allowed a tone that might not be appropriate for public consumption. The diary, in particular, could be assumed to act as the writer's personal emotional or intellectual outpouring as well as an aide-mémoire.

But the diary format, with its assumptions of intimacy and immediacy enriched with a frisson of gossip, could lend itself to manipulation. Stendhal's *Promenades dans Rome* (1829), for example, was written in Paris long after the author's sojourn in Rome in 1811 and represents the distillation of long hours spent in the library as much as the author's firsthand impressions.[51] It is therefore not the product of spontaneous musings or impressions, but presents itself as such.

One of the most delicious examples of calculated fabrication uses the form of the travel diary as a structure upon which to hang a largely fictional tale. In 1826 Mrs. Anna Brownell Jameson produced *A Lady's Diary*, ostensibly by an anonymous author who had died by the time of the book's discovery. The entries reflect Mrs. Jameson's actual travels and her observations of Rome. One of them describes a nocturnal visit to the Colosseum (yet again, that iconic monument under the moon's glow):

> Last night we took advantage of a brilliant full moon to visit the Coliseum by moonlight.... In its sublime and heart-stirring beauty, it more than equaled, it surpassed all I had anticipated ... but it happened that one or two gentlemen joined our party—young men too, and classical scholars, who perhaps thought it fine to affect a well-bred nonchalance, a fashionable disdain for all romance and enthusiasm, and amused themselves with quizzing our guide, insulting the gloom, the grandeur, and the silence around them.... I returned home vowing that while I remained at Rome, nothing should induce me to visit the Coliseum by moonlight again.[52]

But Mrs. Jameson's account of her melancholic heroine—with her trials in love, her meeting with Byron, and her ultimate demise—was highly fictionalized. Her readers were distressed to discover that *Diary of an Ennuyée* (as it was later called) was a fake. This conflation of private and public literary genres, of reality and fantasy, is only a more exaggerated form of what many authors practiced when they wrote about Rome. The city invited an easy transition from what was observed to what was imagined.

The last decades of the nineteenth century saw the publication of a particularly rich stream of stories and novels with Rome as the setting. Henry James, George Eliot, and Edith Wharton exploited the city's evocative presence to depict ardent, ambitious young men and (notably) young women seeking something beyond themselves, something large and meaningful. The City of the Soul resonated with the characters in these books and with their readers.

Upon his arrival in Rome in 1869, at the age of twenty-six, Henry James echoed Goethe's words of a century earlier: "At last—for the first time—I live! It beats everything; it leaves the Rome of your fancy— your education—nowhere."[53] Much as Goethe's mental image of Rome proved to be only a pale reflection of the actual city, so too did James's preconceived ideas. James, who had been reading Stendhal, was overwhelmed by Rome's physicality, which, he remarks, makes Venice, Florence, Oxford, and London "seem like little cities of pasteboard." His initial response to the Eternal City illuminates the tension between the concrete reality of Rome and the imaginative projections of it that characterize many of the works in this exhibition. And so we come full circle: for artists and writers from Goethe to James, Rome was a never-ending cycle of perceiving and projecting, receiving and representing anew.

CONCLUSION

The objects in this exhibition bear vivid testimony to the fact that there are many Romes, that the City of the Soul exists not only on the Tiber but in the collective imagination of artists, architects, writers, and visitors. One such manifestation of Rome is the collection and library established by Pierpont Morgan. We are fortunate that his interests included art objects and examples of the written word; his manuscripts, books, *and* works of art constitute a unique link between literary and visual evocations of Rome in the Romantic imagination.

Rome's influence on Morgan is clear both in his collection and the architecture he chose to house it.

The library Morgan built in 1902-6, designed by Charles Follen McKim, is itself a reflection of Rome in a city that increasingly took on Roman garb in the Gilded Age. A key example of the so-called American Renaissance, McKim's design includes multiple references to Roman monuments, including the Villa Giulia, the Villa Madama, and Raphael's Vatican Stanze. Morgan's preference for classical architecture and its symbolic resonance affected the way he and untold others perceived the values that Rome represented. That interest endures in his legacy.

The city of Rome figured prominently in the last decade of Morgan's life. A photograph taken in 1907 shows him admiring the celebrated bas-relief of Antinous in the Villa Albani (Fig. 7). Morgan certainly was aware that in the eighteenth century, Cardinal Alessandro Albani, with the assistance of Johann Joachim Winckelmann, had assembled one of the great private collections of ancient sculpture as well as a magnificent library. The cardinal's villa had been carefully designed to set off specific works of art, like the Antinous relief. Morgan also would have known that the relief was one of the villa's prizes—it was expropriated by Napoleon in 1798, and returned to Rome from Paris only in 1815. It was natural that a collector of Morgan's stature, who during the preceding year had erected a classical edifice for the display of his own treasures, would wish to muse on the Albani Antinous.

At this time Morgan was the driving force behind the foundation of the American Academy in Rome, an institution that for generations to come would stimulate the imaginations of American artists and architects, writers, and scholars. Construction of a new building to house the academy and its library, designed by the firm of McKim, Mead and White, had begun shortly before Morgan's death.[54] He died in Rome, not long after inspecting the recently acquired site of the academy on the Janiculum Hill. Like so many observers before him, many of whom figure in *City of the Soul*, Morgan greatly prized the view from the Janiculum. From there he could survey the sites that inspired the many writers and artists who had embraced Rome as their own city, one that would always have a place in their soul.

John A. Pinto and Meg Pinto

NOTES

1. Goethe 1970, pp. 128–29.

2. Byron 1818, stanza 78, line 694.

3. Lee 1906, p. 111.

4. Hawthorne 1899, 1, p. 172.

5. Story 1887, 1, pp. 6-7.

6. de Staël 2008, p. 64.

7. Byron 1818, dedication.

8. Barkan 1999, p. 207.

9. New York, Cleveland, and San Francisco 1988–89, p. 21.

10. Deakin 1855. Also see Rome 2000–1 and Caneva 2004.

11. Stiligoe 1995, p. xiv.

12. Piranesi 1743, introduction. See Pinto 2012.

13. Fleming 1962, p. 166.

14. Scott 1975, p. 320.

15. Goethe 1970, p. 218.

16. Jones 1964, pp. 84-85.

17. Byron 1818, stanza 138, lines 1238–39.

18. Shelley 1821, stanza 49.

19. Shelley 1821, preface.

20. Byron 1818, stanza 144, lines 1288–96.

21. Trevelyan 1908, p. 2.

22. Martial 1919, 1, pp. 275–77.

23. Hudspeth 1988, p. 181, no. 791.

24. Freud 1989, p. 17.

25. Hudspeth 1988, p. 239, no. 830.

26. Henry James, "Roman Rides," in James 1979, p. 159.

27. James 1979, pp. 156–57.

28. Gorra 2012, p. 153. For an opposing view of James and the Romantics, see Edel 1978, p. 100.

29. Keats 1817.

30. De Brosses 1931, 2, pp. 5–6.

31. Ridley 1992 and Nicassio 2009.

32. Trevelyan 1911, p. 297.

33. Trevelyan 1911, pp. 299–303.

34. Story 1887, 1, pp. ix-x.

35. "Photography is a noble invention, say what they will of it." Ruskin in a letter of 1843 to his father; cited in Gernsheim 1965, p. 72.

36. Giuseppe Gioacchino Belli, *Zibaldone;* cited in Rome and Copenhagen 1977, p. 33.

37. Headley 1845, p. 163.

38. *The Art Journal* 1862. Quoted by Helsted 1978, p. 346.

39. Hawthorne 1980, p. 664.

40. Hawthorne 1860.

41. The 1871 list is reproduced in Becchetti and Pietrangeli 1987, pp. 49–52. Hilda's Tower is no. 314 on the list.

42. Nathaniel Hawthorne, French and Italian notebook, The Morgan Library & Museum, MA 589, p. 13.

43. Nathaniel Hawthorne, French and Italian notebook, The Morgan Library & Museum, MA 591, p. 4, and MA 589, p. 28.

44. Eliot 1885, 2, pp. 178–79.

45. de Staël 2008, p. 57.

46. de Staël 2008, p. 72.

47. Hawthorne 1899, 1, p. vii.

48. Hudspeth 1988, p. 200, no. 800.

49. Eaton 1820, 2, p. 267.

50. Bryant 1859, pp. 253–60, letter 23.

51. Stendhal 1959, p. xvii.

52. Jameson 1836, p. 58.

53. James 1920, p. 24, written to his brother, William.

54. Rome 2014.

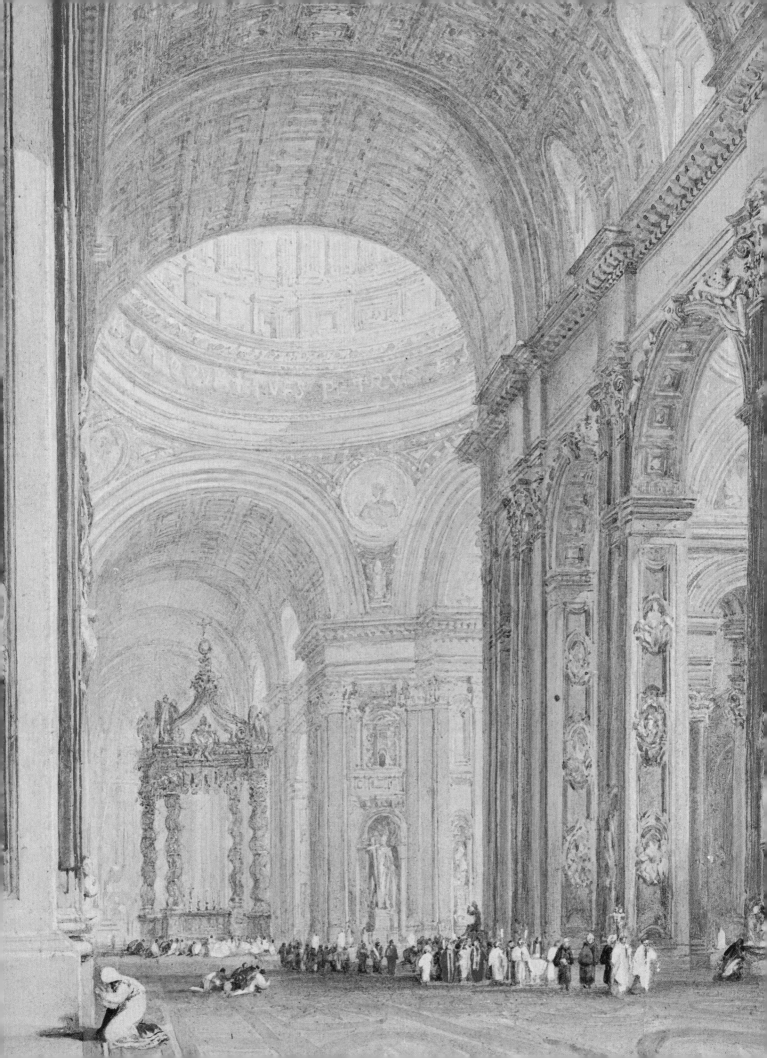

THE GREATEST THEATRE IN THE WORLD

PAUL MARIE LETAROUILLY

Coutances 1795–1855 Paris

1 *Plan of Rome,* 1841

Engraving

30 x 21½ inches (770 x 545 mm)

Avery Library of Architecture and Art History, Columbia University

Before traveling to Rome in 1820, Letarouilly trained with Percier and Fontaine (see No. 26).[1] During his initial four-year sojourn, Letarouilly began his lifelong project of providing precisely measured drawings of Renaissance architecture in Rome. These were gathered in his monumental *Édifices de Rome moderne,* issued in three folio volumes between 1825 and 1860.[2] A second survey, devoted to St. Peter's and the Vatican, was published posthumously in 1882.[3]

Letarouilly's publications did for Rome's Renaissance architecture what Piranesi's had done for the city's monuments of classical antiquity. His use of thin lines of unvaried weight, devoid of dramatic chiaroscuro, however, was in stark contrast to Piranesi's atmospheric effects. Letarouilly's images were clear, precise, and drawn to scale. The *Édifices* provided a portable distillation of Renaissance architecture that proved immensely influential. Copies found their way into the libraries of every major architectural firm; Letarouilly became the Bible for designers working for McKim, Mead and White.[4]

Accompanying the *Édifices* was a detailed plan of Rome, dated 1838. In conception and detail Letarouilly's plan is based on an earlier masterpiece of urban cartography, Giambattista Nolli's 1748 *Pianta di Roma.*[5] The densely built-up portion of the city, nestled into the bend of the Tiber, appears to have hardly changed in the century since Nolli undertook his survey. Where there were changes, as at Piazza del Popolo and in the area of Trajan's Forum, Letarouilly's plan makes them clearly visible. An earlier version of this plan, dated 1838, was bound into the *Édifices,* which went through several editions. It lacks the allegorical figures present in the 1841 plan.[6]

The vignettes in the two lower corners are equally indebted to Nolli. The selection of sculpture and architectural monuments is practically identical. One notable exception is the addition of a sarcophagus from the Tomb of the Scipios, uncovered in 1780 and visible at left in front of the personification of Roma. Letarouilly introduced other changes to the allegorical figures, most notably on the right, which in Nolli's plan is dominated by a figure of *Ecclesia,* the personification of the Catholic Church. In *Ecclesia's* place, Letarouilly substituted statues of the Renaissance Pope Paul III and Michelangelo's Moses, a shift away from the Counter-Reformational theme of the Church triumphant.[7]

The clarity and precision of Letarouilly's plan are impressive; indeed, its presumed accuracy had serious historical implications. Reliance on Letarouilly's plan appears to have led the French general Charles Nicolas Victor Oudinot into a crucial setback early in his 1849 siege of Rome. Letarouilly's plan shows the Porta Pertusa on the southern line of the walls protecting the Vatican as being open. Upon their arrival outside the gate, the French attackers were dismayed to find that this was not the case; it was walled up, and they suffered numerous casualties in a vain attempt to force an entry.[8]

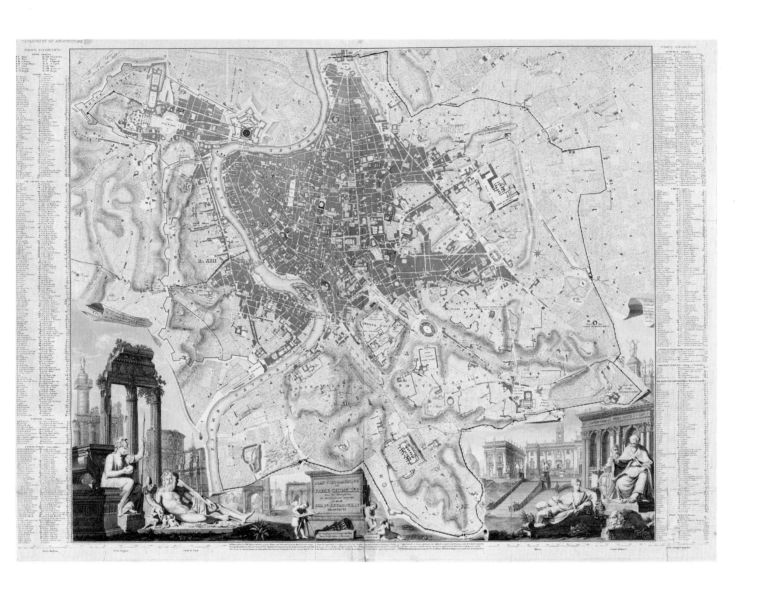

JOHN ROBERT COZENS

London 1752–1797 London

2 *Rome from the Villa Mellini*, 1791

Watercolor over graphite

20⅞ x 29¾ inches (531 x 757 mm)

Signed (?) in pen and black ink along lower edge, *Jn. Cozens* [abraded]. Inscribed on original mount, in pen and black ink, *JNO COZENS 1791 / Rome, from Near Villa Madama*; on verso, in pen and black ink at center of original mount, *Rome, from near the villa Madama*; in pen and brown ink at upper left, *Mr. Annesley's*. Other illegible inscriptions in blue ink.

The Morgan Library & Museum, Thaw Collection

John Constable remarked of Cozens that "He was the greatest genius that ever touched landscape [and] was all poetry."[1] Cozens's Russian-born father, Alexander (1717–1786), was an accomplished watercolorist and author of an influential pamphlet on inventing landscape compositions.[2] Like many contemporary landscape painters, "the little Cozens," as his friend Thomas Jones referred to him, employed compositional formulas derived from Claude Lorrain. Cozens, however, infused his landscapes with profound sentiment, spirit, and sublime associations.

Cozens had two extended Roman sojourns, the first in 1776–79, when he traveled in the company of Richard Payne Knight, and the second in 1782–83, when he was part of the entourage of William Beckford. The artist's relations with two major figures associated with the picturesque and sublime were not always easy, especially in the case of the extravagant Beckford, but the associations left their mark, particularly on his renderings of tenebrous caves and grottoes.

While in Rome, Cozens frequently went sketching *en plein air* with other artists, including Thomas Jones (see No. 35). He was extremely productive; in the course of his second Italian trip, he painted an average of three watercolors per day, on some days producing as many as nine.[3] In the decade following his return to London, Cozens painted variations on these compositions. Many of these later watercolors are characterized by a luminous palette dominated by pale blues, greens, and gray/greens, as is the case with the present drawing.

The view of Rome from the slopes of the Monte Mario was a subject favored by artists and photographers (see Nos. 3 and 40). In the early 1780s, Nicolas-Didier Boguet made repeated sketches in the vicinity of the Villa Mellini, which dominated the site.[4] In 1816 F. K. L. Sickler issued a printed panorama identifying all of the features visible from the Villa Mellini.[5] Although Cozens's watercolor accurately situates a number of Roman monuments, including the Trinità dei Monti (visible on the left between the umbrella pine and the cypress), Castel Sant'Angelo (at center), and St. Peter's (on the right), it is more a poetic evocation of place than a descriptive view. Cozens made effective use of the attenuated profiles of the trees on the left to exaggerate the scale of the landscape. The luminous sky and delicate profile of the Alban Hills in the distance envelop the city, conferring on it a dreamlike quality. This was, in fact, the first view of the city enjoyed by many travelers who approached it from the north.

JAMES ANDERSON
Blencarn 1813–1877 Rome

3 *Panorama of Rome from the Prati di Castello,* ca. 1870
Albumen print
10 x 21¾ inches (254 x 552 mm)

Collection W. Bruce and Delaney H. Lundberg

Anderson, along with Brogi and Alinari, founded one of the three dominant family dynasties of photographers specializing in Italian subjects. Anderson's work was carried on by his son Domenico (1854–1938); following the latter's death, the family's photographic archive was acquired by Alinari. Into the 1960s, it was still possible to browse among Anderson's images in the Alinari store on via del Babuino, only a few steps from where, a century earlier, tourists chose from among the same images and custom-ordered albums of photographs from Joseph Spithöver's bookshop.[1]

Prior to 1870, the ancient circuit of the Aurelian Walls clearly demarcated the limits of the built-up portions of the city. The surrounding campagna, in the form of pastoral and agricultural fields, vineyards, and gardens, extended right up to the city walls. The horizontal format of Anderson's panorama beautifully captures the relationship of the city to the surrounding countryside.[2]

Anderson set up his camera about a mile north of the city walls on the left bank of the Tiber, near the Casale Strozzi, on the lower slopes of Monte Mario.[3] Taking advantage of this modest elevation, he employed a wide-angle lens, which became more readily available in the 1860s. This allowed him to encompass the city's extended profile from the Muro Torto and the Pincian Hill to the east (at the left) to the cupola of St. Peter's in the west (at the right). At the center of the image is the imposing cylindrical mass of Castel Sant'Angelo, its crowning statue just visible in silhouette. In the far distance, the classic profile of the Alban Hills and Monte Cavo closes the view.

The air is so clear and the image so sharp that it is possible to identify many Roman monuments even from this great distance. In addition to those already mentioned, it is worth noting the following, moving from left to center: the gardens of the Pincio, the Villa Medici, the Trinità dei Monti, S. Maria Maggiore, the dome of S. Carlo al Corso, the Quirinal Palace, the Torre delle Milizie, the Colosseum, the Campidoglio, and the dome of Sant'Agnese in Agone. To the right of Castel Sant'Angelo appear the dome of S. Giovanni dei Fiorentini, the bell tower of S. Maria in Trastevere, S. Pietro in Montorio atop the Janiculum Hill, the walls of the Vatican, and the Sala Rotonda of the Vatican Museums.

Henry James, writing in 1873, described the experience of looking back on Rome from a distance:

You look back at the City so often from some grassy hill-top—hugely compact within its walls, with St. Peter's overtopping all things and yet seeming small, and the vast girdle of marsh and meadow receding on all sides to the mountains and the sea—that you come to remember it at last as hardly more than a respectable parenthesis in a great sweep of generalization.[4]

JACQUES-LOUIS DAVID
Paris 1748–1825 Brussels

4 *The Campidoglio*
Graphite and gray wash
3⅝ x 7¼ inches (92 x 184 mm)
Initialed by the artist's two sons, Jules and Eugène, at the time of the 1826 sale in pen and brown ink at lower left, *E.D. / J.D.*

The Morgan Library & Museum, bequest of Pauline Jessup; 1988.39:1

David, the preeminent painter of French neoclassicism, failed on multiple occasions to win the Prix de Rome. Having finally realized his goal in 1774, the artist traveled to Rome the following year with the Academy's director designate, Joseph-Marie Vien, with whom David had studied in Paris.[1] During his five-year stay in Rome, David closely studied ancient sculpture and Renaissance painting, especially the work of Raphael, of which his drawings provide abundant evidence. This rapid sketch of the Piazza del Campidoglio comes from one of his *albums factices* assembled from his sketchbooks.[2]

Summary as it is, David's sketch of the Campidoglio records the essential elements of Michelangelo's masterpiece of urban planning. The broad ramp, or *cordonata*, leads the eye up to the piazza proper, centered on the equestrian monument of Marcus Aurelius (see No. 13). The Senators' Palace, with its central tower, closes the composition to the rear, while the Conservators' Palace and Palazzo Nuovo define the piazza to the right and left, respectively. Marble statues and martial trophies embellish the balustrade facing the city, and the steep staircase leading up to the church of S. Maria in Ara Coeli appears in shadow at the far left. To the right of the *cordonata* is the carriage road, known as the via delle Tre Pile, curving its way up to the piazza.[3]

David and the neoclassical artists of his generation placed the highest value on the monuments of ancient Rome; with few exceptions, the buildings of "modern Rome" were deemed inferior to the remains of classical antiquity. Because of its association with Michelangelo, the Piazza del Campidoglio counted among the modern buildings considered worthy of comparison with their ancient counterparts. Over time, appreciation for the Renaissance gradually deepened—the publication of Percier and Fontaine's *Palais, maisons, et autres édifices modernes* in 1798 and Letarouilly's *Édifices de Rome moderne* in 1825–60 providing important benchmarks (see Nos. 26 and 1).

The Marquis de Sade's critical assessment of the architecture of the Piazza del Campidoglio was penned within a year or two of David's sketch:

> *The few ancient beauties that remain there* (on the Capitol) *are completely overwhelmed by the new ones, by facades, by vistas; in a word, this celebrated site has been so disfigured by all the modern beauties of Rome that it now has to be ranked as ordinary.*[4]

Goethe, by comparison, was far more generous in his assessment. On the eve of his departure from Rome he passed over the Capitol on his way through the Forum to the Colosseum, remarking that the piazza was "like an enchanted palace in a desert."[5]

LOUIS-JEAN DESPREZ
Auxerre 1743–1804 Stockholm

5 *The Girandola at Castel Sant'Angelo,* 1783–84
Etching with colored washes
27⅝ x 19 inches (702 x 483 mm)

The Metropolitan Museum of Art, Rogers Fund, 1969; 69.510

At the age of twelve, Desprez became the pupil of Charles Nicolas Cochin in Paris. Following his initial training as a graphic artist,[1] Desprez attended the Académie Royale d'Architecture from 1768 to 1776. After winning the Prix d'architecture, Desprez arrived in Rome in 1777. Shortly thereafter, he joined Louis-François Cassas and other artists engaged in providing illustrations for the Abbé de Saint Non's *Voyage pittoresque* (see No. 34).

While in Rome, Desprez also came to know Francesco Piranesi, with whom he formed a partnership in 1782 to issue a series of colored prints; the two artists published a prospectus the following year.[2] Also in 1783, Desprez met King Gustav III of Sweden, who at that time was visiting Rome incognito. In 1784 Desprez accepted the king's invitation to serve as stage designer at his court and was established in Stockholm a year later.

The 1783 prospectus, written in French, is a fascinating document.[3] It announces a series of forty-eight hand-colored prints, of which nine, including the *Girandola*, are indicated as being already available. The prints are divided into two groups: nineteen Grands Desseins consisting of views of Rome, Naples, and Pompeii, and twenty-nine Petits Desseins depicting Tivoli, Frascati, and sites in southern Italy. The audience for these *dessins coloriés* is described as "men of taste" (*hommes de goût*), and the prints are said to have received the approval of the most discerning connoisseurs. The hybrid medium of hand-colored prints lent itself to the production of relatively inexpensive views depicting sites of interest to tourists. Only a fraction of the images listed in the prospectus were actually executed, probably because of Desprez's departure for Stockholm and the demands of his position there.

Fireworks displays were staged on the Castel Sant'Angelo in the late fifteenth century, and by the 1780s they assumed an almost ritual quality. The battlements and armament of the papal fortress erected on the remains of the Mausoleum of Hadrian had been adapted to accommodate the introduction of gunpowder. The cannon discharge and fireworks shared key ingredients, which were stockpiled within the castle's vaults.

Desprez exploited the dramatic effects of pyrotechnic light and color. He also depicted the animated crowd of onlookers, some of whom have climbed up on the pedestals of Bernini's angels on the bridge in order to obtain a better view. Charles Dickens's 1845 description of the Girandola captures the spectacle in words.

The show began with a tremendous discharge of cannon; and then, for twenty minutes or half an hour, the whole castle was one incessant sheet of fire, and a labyrinth of blazing wheels of every colour, size, and speed: while rockets streamed into the sky, not by ones or twos, or scores, but hundreds at a time. The concluding burst—the Girandola—was like the blowing up into the air of the whole massive castle, without smoke or dust.[4]

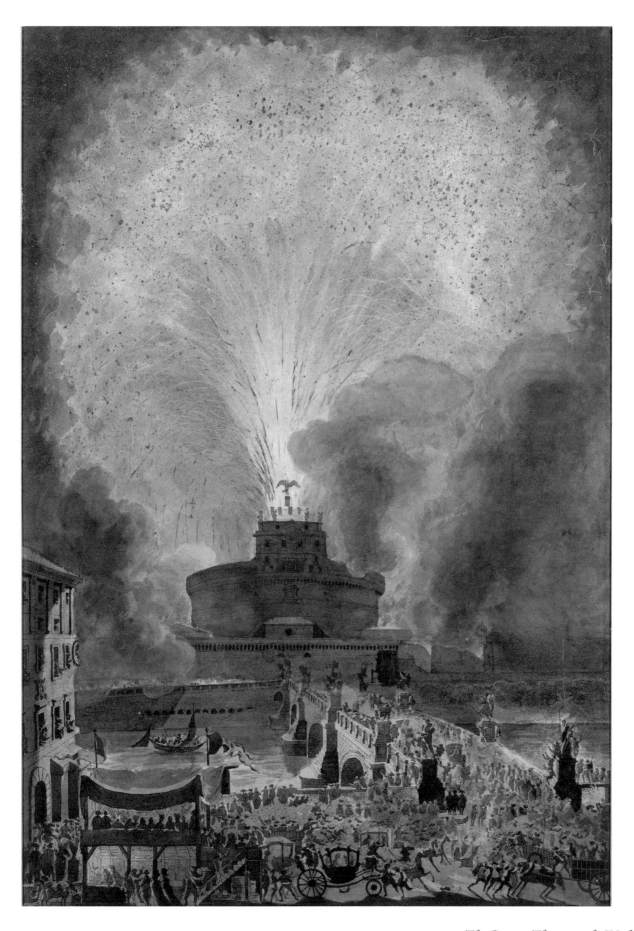

GIACOMO QUARENGHI

Rota d'Imagna, Bergamo 1744–1817 Saint Petersburg

6 *Colonnade of St. Peter's Basilica in Rome*

Watercolor, with pen and black ink, over graphite
14¾ x 9⅝ inches (375 x 295 mm)
Inscribed on verso of old mount, in pen and brown ink, *A Study from Nature by Giacomo Quarenghi. /
architect to the Empress of Russia—for Ozias Humphrey—[cut off] / The Back of the Colonnade of St. Peters in
Rome / see through one of the windows—.*

The Morgan Library & Museum, gift of Charles Ryskamp in memory of Dr. Wolfgang Ratjen; 1997.93

Quarenghi left his native Bergamo in 1763 to study painting in Rome. He subsequently turned to architecture, training first with Antoine Derizet and then with Paolo Posi.[1] Even more formative was the close study Quarenghi devoted to the Renaissance architect Andrea Palladio's treatise, which led him to become a leading exponent of the Palladian revival.

Quarenghi rapidly developed into a superb draftsman and his travels within Italy are well documented by his extensive corpus of drawings. While in Rome, he interacted with other artists and architects, including Vincenzo Brenna, Thomas Hardwick, and Thomas Jones (see No. 35). The major architectural commission of his Roman period was the renovation of the church of Santa Scolastica at Subiaco (1771–77). The

FIG. 1. Giacomo Quarenghi, *Colonnade of St. Peter's,* Civica Biblioteca "Angelo Mai," Bergamo

opportunities to build on a large scale in Rome during the last quarter of the eighteenth century were extremely limited, however, and in 1779 Quarenghi accepted an invitation to become court architect to Catherine II, Empress of Russia.

In this capacity Quarenghi gave shape to the imperial capital of Saint Petersburg, adding important buildings such as the Academy of Sciences and the Theatre of the Hermitage. He also designed neoclassical pavilions and picturesque gardens for the nearby summer palaces of Peterhof, Tsarskoye Selo, and Pavlovsk.

Quarenghi's view of the southern arm of Bernini's colonnade framing St. Peter's Square relates closely to a drawing of 1775–79 in one of his sketchbooks in Bergamo (Fig. 1).[2] The present sheet appears to be an elaboration of the Bergamo sketch, with minor additions such as the helmet and halberd of the Swiss Guard and the umbrella pine silhouetted against the sky. The perspective is unusual, eschewing the grand piazza and providing instead a more intimate view of daily life in the shadow of the basilica and Papal Palace. Much the same can be said of two other drawings in the Bergamo sketchbook that were probably made at the same time.[3]

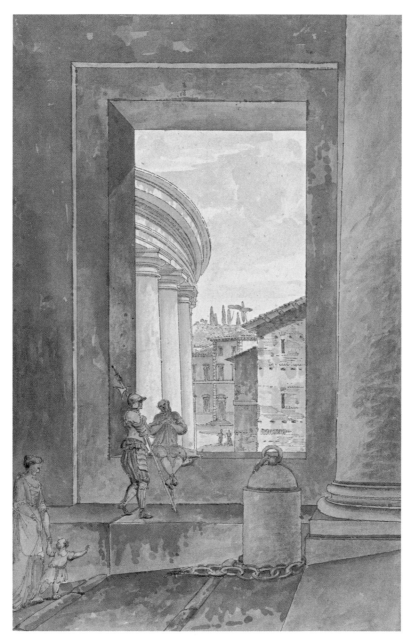

An inscription on the mat of the Morgan drawing connects it to Ozias Humphrey (1742–1810), a well-known portrait painter specializing in pastels who accompanied George Romney to Rome in 1773. Similar inscriptions appear on the mats of three other Quarenghi drawings, two in a private collection in Milan and one in the Vatican Library.[4]

During Humphrey's Roman sojourn (1773–77), he resided in the Palazzo Zuccaro (see No. 10). While in Rome, he met Quarenghi, as well as the British sculptor Thomas Banks, who would also later serve Catherine the Great.[5] The mats on Quarenghi's drawings in Milan carry the date of 1778, while that of the Vatican sheet is 1788. Assuming these dates are reliable, they postdate Humphrey's departure from Rome and may have been sent to him in England from Russia. Since the present drawing has the same provenance, it seems reasonable to date it to the very end of the architect's Roman period or to the early years of his time in Russia.

JOSEPH MALLORD WILLIAM TURNER
London 1775–1851 Chelsea

7 *Interior of St. Peter's Basilica*
Watercolor, over traces of graphite, on board
11⁷⁄₁₆ x 16⁵⁄₁₆ inches (290 x 414 mm)
Signed and dated in brown ink at lower left, *JMW Turner 18* [cut off].

The Morgan Library & Museum, Thaw Collection

Turner had long wished to make an extended tour of Italy, but the realization of this desire was delayed by the Napoleonic Wars.[1] In 1818 Turner was collaborating with James Hakewill, an architect who had traveled Italy in 1816–17 and recorded his impressions in a series of drawings.[2] Turner adapted some of these for the engravings illustrating Hakewill's *Picturesque Tour of Italy*, published in 1820. Hakewill encouraged Turner to visit Italy, providing him with practical advice on his route through the peninsula. The publication in 1818 of the fourth canto of Byron's *Childe Harold's Pilgrimage*, with its romantic evocation of Rome, provided Turner with an additional impetus (see No. 45).[3]

Over the course of six months spent in Italy in 1819–20, Turner filled twenty-three sketchbooks, eight of which are devoted to Rome and its environs. One contains six rapid studies of the interior of St. Peter's, upon which Turner's finished watercolor is partially based.[4] The drawings provide an accurate, if summary, record of the orchestration of space within the vast interior of the basilica. They also capture Turner's movements inside St. Peter's, and, taken together, provide a cumulative record of the artist's experience. No single sketch corresponds precisely to the composition of the later watercolor, which instead combines aspects of several of the preparatory studies.

Turner's direct experience of St. Peter's was but one factor influencing his finished watercolor; equally important was his familiarity with earlier efforts to convey the chromatic richness and spatial complexity of its cavernous interior. In its viewpoint and overall composition, Turner's watercolor closely resembles paintings by Giovanni Paolo Panini and one of Giovanni Battista Piranesi's prints in the series of *Vedute di Roma*.[5] Panini's views of the interior of St. Peter's exist in several versions, including one that hung in a London private collection in the nineteenth century (Fig. 1).[6]

Like Panini and Piranesi, Turner used diminutive human figures to establish the colossal scale of the basilica. Turner's watercolor, however, imparts a far more atmospheric effect than does Panini's oil painting.

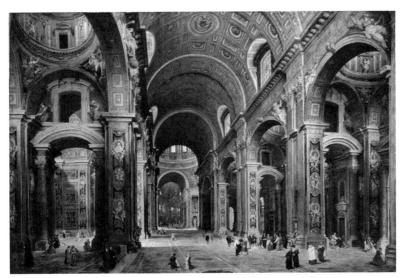
FIG. 1. Giovanni Paolo Panini, *Interior of St. Peter's*, Musée du Louvre, Paris

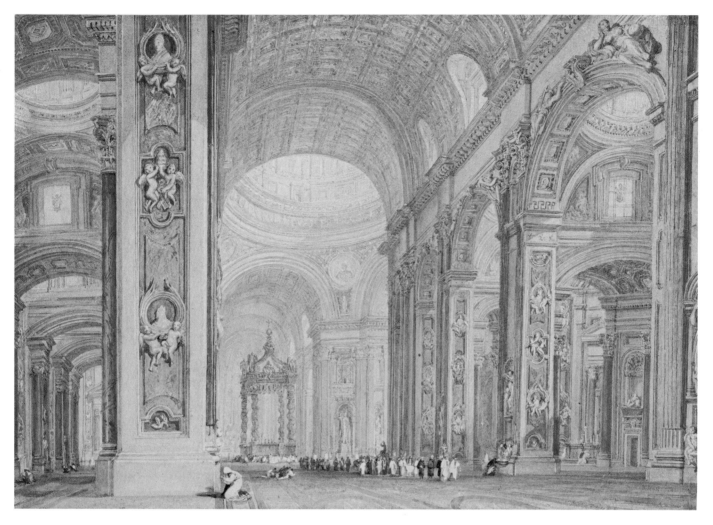

The flood of light descending from Michelangelo's dome seems almost palpable as it casts into relief the spiral columns of Bernini's baldachin in the distant crossing. Turner understood that the titanic architecture of St. Peter's is not so much an exercise in the deployment of mass and surface as it is about the molding of space, which flows freely through the nave, aisles, and crossing.

The overpowering scale of St. Peter's was much discussed and often criticized. But like Turner, Byron considered human perception to be inherently dynamic and relative; if we feel diminished by immense structures we also are capable of being aggrandized by them.

> *. . . even so this*
> *Outshining and o'erwhelming edifice*
> *Fools our fond gaze, and greatest of the great,*
> *Defies at first our Nature's littleness,*
> *Till, growing with its growth, we thus dilate*
> *Our spirits to the size of what they contemplate.*[7]

CHRISTOFFER W. ECKERSBERG
Blaalrog, southern Jutland 1783–1853 Copenhagen

8 *Piazza del Fontanone*

Pen and black ink, gray wash, over graphite
10½ x 8¾ inches (263 x 218 mm)
Inscribed in pen and black ink on wall at right, *XIII / PIAZZA DE / FONTANONE*; and below image at right, *ved. S. Pietro in Montorio . 1814. / Eckersberg.*

Roberta J. M. Olson and Alexander B. V. Johnson

Eckersberg's composition consciously avoids the monumental architectural set piece of the Acqua Paola Fountain, situated beyond the frame to the left; instead it captures the last stretch of the via Aurelia Vetus within the walls as it ascends to the Porta San Pancrazio.[1] The 1849 panorama published by the *Illustrated London News* provides a bird's-eye view of this intersection and the buildings defining it (No. 51). Anchoring the left side of Eckersberg's drawing is a corner of the pentagonal structure erected in 1703 to serve the needs of the university's botanical garden.[2]

Rising on the opposite side of the street are the Villa Aurelia and its gardens, acquired by Pierpont Morgan for the American Academy in Rome. Eckersberg's drawing documents the villa's appearance before it was virtually destroyed by French artillery during the siege of 1849 (see No. 50). Constructed on top of the ancient Aurelian Walls with an elevated position on the Janiculum Hill, the villa's east-facing windows command a superb panorama over Rome to the Apennines.

FIG. 1. Christoffer W. Eckersberg, *Piazza del Fontanone*, Kunstmuseet Brundlund Slot–Museum Sønderjyllard

On one level, the drawing is a virtuoso display of Eckersberg's "precise and sober, almost scientific observation of nature."[3] At the same time, however, it is a perfect demonstration of the artist's preoccupation with perspective, on which he later wrote an illustrated treatise.[4] Philip Conisbee remarked on "the abstract, almost cubist interplay among the many more-or-less oblique walls" evident in the drawing.[5] On close inspection, Eckersberg's composition reveals itself to be a carefully calibrated system of planes defined by a complex system of vertical, horizontal, and diagonal lines, a practical application of the theory later expounded in the artist's treatise.

This drawing served as the basis for an oil painting executed the same year (Fig. 1).[6] Only one of the four figures in the drawing—the woman walking down the via Aurelia—is in the painted version.[7] Eckersberg's method combined the di-

ved. S. Pietro in Montorio. 1814.

rect observation of nature *en plein air* with long hours in the studio to produce highly finished works far removed from the rapid oil sketches of Valenciennes and other French painters. The luminous clarity of Eckersberg's line eloquently expresses the mute poetry of this scene off the beaten track.

LUIGI ROSSINI

Ravenna 1790–1857 Rome

9 *Panorama of Rome from the Piazza Montecavallo,* ca. 1822

Graphite

20¹⁄₁₆ x 28⁵⁄₁₆ inches (510 x 719 mm)

The Morgan Library & Museum, purchased by Pierpont Morgan, 1906; 1966.13:8

Among Rossini's numerous publications is a volume devoted to the antiquities of Rome, published in 1823.[1] The title consciously recalls one of Giovanni Battista Piranesi's most influential books, the four-volume *Antichità romane* of 1756. Rossini, who lived in the house that had once belonged to Piranesi, did more than replicate his predecessor's title; he effectively extended Piranesi's conceptual and compositional approach to the graphic depiction of Roman monuments into the nineteenth century.

One of the plates comprising Rossini's book depicts a panorama of Rome from the Piazza Monte-cavallo on the Quirinal Hill.[2] A preparatory study for this print appears among seventy preliminary sketches for the *Antichità romane* that were bound together in an album acquired by the Morgan in 1906. Compositionally, the drawing corresponds in every respect to the print, except for the figures that have been added to the latter.

Comparison with Piranesi's print representing the same piazza reveals the extent to which Rossini drew inspiration from his illustrious precursor, as well as his own, distinctly nineteenth-century, view (Fig. 1).[3] Both artists anchored their compositions on the right with the Quirinal Palace. Piranesi's viewshed is wider,[4] encompassing the corner of the Palazzo Rospigliosi and the papal stables to the left of the colossal statues of the horse tamers Castor and Pollux.[5] Rossini, in contrast, moved closer to the statues of the divine twins, opening up an expansive vista over the city. This enabled him to include a number of distant monuments, notably St. Peter's, not present in Piranesi's *Veduta*. Piranesi enriched the foreground of his print with a fantastic profusion of ancient architectural fragments and a procession of richly ornamented rococo carriages. Rossini is more sober; the figures populating his piazza are less aristocratic and represent a wider cross section of society.

The principal difference between the two images, however, has to do with significant alterations in the appearance of the sculptural group of horse tamers that had occurred during the interval between the two prints. In 1786 Pope Pius VI Braschi commissioned Carlo Antinori to enrich the statues of the Dioscuri by erecting an Egyptian obelisk between them.[6] The monument was further embellished in 1816 under Pius VII, who replaced the modest Renaissance fountain visible in Piranesi's print with an ancient basin that had long provided water to cattle grazing among the ruins of the ancient Forum. This monolithic block of granite was set between the splayed statue bases, prompting the admiration of Shelley, writing three years after its installation:

> *From the piazza Quirinale ... you see the boundless Ocean of domes spires & columns which is the city of Rome. ... Before [the obelisk] is a vast basin of porphyry, in the midst of which rises a column of the purest water which collects into itself all the overhanging colours of the sky, and breaks them into a thousand prismatic hues and graduated shadows—they fall together with its dashing water-drops into the outer basin.*[7]

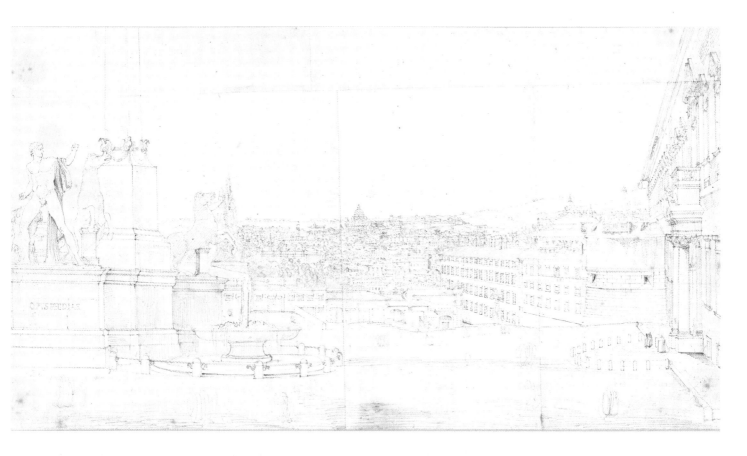

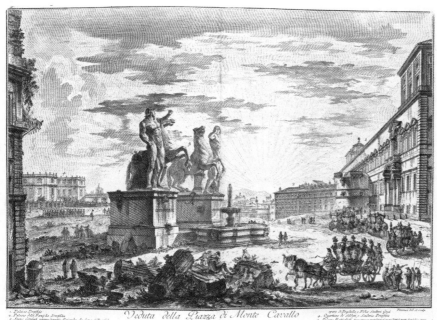

Veduta della Piazza di Monte Cavallo

FIG. 1. Giovanni Battista Piranesi, *Piazza Monte Cavallo*, Vincent J. Buonanno Collection

THOMAS HARTLEY CROMEK
London 1809–1873 Wakefield

10 *The Via Sistina and the Palazzo Zuccaro from the Trinità dei Monti*

Watercolor, over graphite, with scraping
14¼ x 9¾ inches (362 x 248 mm)
Inscribed in pen and brown ink on balustrade below capital, *Donum Ex Guarni Asiminei*; on facing page of album, *Monte Pincio Rome 1830*.

The Morgan Library & Museum, gift of the Fellows; 1967.7

Thomas Hartley Cromek's father, the engraver and illustrator Robert Hartley Cromek, died when his son was three years old. As a result of his father's death, the boy and his mother moved to Wakefield (Yorkshire) to live with his grandfather. There, encouraged by a local portrait painter, Cromek developed an early interest in drawing. In 1830 Cromek and his mother went to Italy for the sake of her health. After a brief sojourn in Florence, they moved to Rome, where Cromek met Edward Cheney, who became his patron and a lifelong friend. This watercolor of the via Sistina is one of several by Cromek mounted in one of Cheney's albums.[1] Over the course of his first Roman sojourn, Cromek produced numerous watercolors of Roman ruins, gardens, and sites in the campagna. He also visited Naples and Pompeii, where Sir William Gell showed him around the excavations (see Nos. 33 and 46).

In 1835 Cromek traveled to Greece, where he produced many of his finest watercolors. In 1843, while in England, he was invited to Buckingham Palace to show his work to Queen Victoria and Prince Albert, who purchased two of his drawings. Throughout the 1840s, Cromek continued to sojourn in Italy, receiving numerous commissions and giving drawing lessons to many distinguished visitors and artists, including Edward Lear.[2] The political unrest of 1849 prompted his definitive return to England, where he died in 1873.[3]

Cromek's view of the via Sistina is anchored at the left by an ancient Composite capital set up on the balustrade of the church of the SS. Trinità dei Monti at the top of the Spanish Steps.[4] The unorthodox design of this capital—it springs from an oval plan and has double the usual number of volutes—had attracted the interest of Piranesi and others in the eighteenth century.[5] Cromek's proximity to the capital, together with his low viewpoint, has the effect of magnifying its apparent size.

On the right is the Palazzo Zuccaro, a sixteenth-century palace built by the artist Federico Zuccaro.[6] The elegant portico at street level was added by Filippo Juvarra early in the eighteenth century, when the palace was occupied by Maria Casimira, Queen of Poland. During the first decades of the nineteenth century, the Palazzo Zuccaro was the residence of Jakob Salomon Bartoldy, the Prussian consul-general and a patron of the Nazarene painters in Rome. Since 1912 the palace has housed the Bibliotheca Hertziana, the German research institute for art history.

The receding orthogonals of the buildings lining via Sistina, one of several long, straight avenues laid out by Pope Sixtus V at the end of the sixteenth century, lead the eye to its visual terminus, the Basilica of S. Maria Maggiore. Among the cultural and literary figures who stayed on the via Sistina in the nineteenth century were Percy Bysshe Shelley, Nikolai Gogol, Luigi Rossini, and Franz Liszt.

ALFRED GUESDON

Nantes 1808–1876 Nantes

11 *Bird's-Eye View of Rome with Piazza del Popolo in the Foreground,* 1849

Lithograph

15 x 24¼ inches (381 x 616 mm)

Studium Urbis, Rome

Following his architectural training at the École des Beaux-Arts in Paris, Guesdon turned to lithography, publishing a series of views of European cities seen from above. It has been suggested that Guesdon's aerial perspectives combined the new technologies of photography and the hot-air balloon;[1] however, there is no evidence that supports this assertion.[2] Indeed, his method conforms to a tradition of perspectival views of cities that extends back to the fifteenth century.

This image is one of three Roman panoramas that appeared in Guesdon's 1849 collection of forty perspectival views of Italian cities. It is worth noting that the title, *L'Italie à vol d'oiseau,* marks the first time the term "bird's eye" was used with reference to perspectival city images.[3] Guesdon's striking images were published by the lithographer Louis-Jules Arout with a text written by Hippolyte Etiennez.

Guesdon employed a shadow, presumably cast by a passing cloud, to darken the foreground and draw the eye to Piazza del Popolo, which is brilliantly illuminated. The piazza provided the first experience of the city for most pilgrims and travelers before 1870. Its scenographic design, centered on an Egyptian obelisk with twin domed churches framing radial vistas along three streets that lead into the densely built-up quarters of the old city, is one of the grand set pieces of Baroque urban planning. Beginning in 1811, during the French occupation, Giuseppe Valadier constructed the series of ramps and terraces linking the piazza to the Pincian Hill, which overlooks it.

Just outside the Porta del Popolo, the neoclassical propylon erected by Luigi Canina in 1825–28 frames the principal entrance to the Villa Borghese. Behind this gateway the retaining wall of the Pincian Hill, the so-called Muro Torto, appears in shadow. The extensive public gardens of the Pincio, the favorite haunt of writers from Nathaniel Hawthorne to Henry James, extend all the way to the Villa Medici, the twin-towered facade of which is silhouetted against the shaded greenery of the Villa Ludovisi. To the right of the Villa Medici, the bell towers of the Trinità dei Monti atop the Spanish Steps lead the eye along the foreshortened via Sistina to the Basilica of S. Maria Maggiore in the distance.

The right foreground of Guesdon's composition is occupied by a vista down the Tiber, terminating at the Porto di Ripetta, the northern river port. A steamboat heads upstream, providing virtually the only indication of modernity in the image. The first steam-powered vessels to ply the Tiber were introduced in 1843 and Pius IX continued to encourage the commercial use of the river during the early years of his pontificate.[4] This policy went hand in hand with the pope's efforts to build railroads in the Papal States, which ultimately led to the construction of a terminus near the Baths of Diocletian.

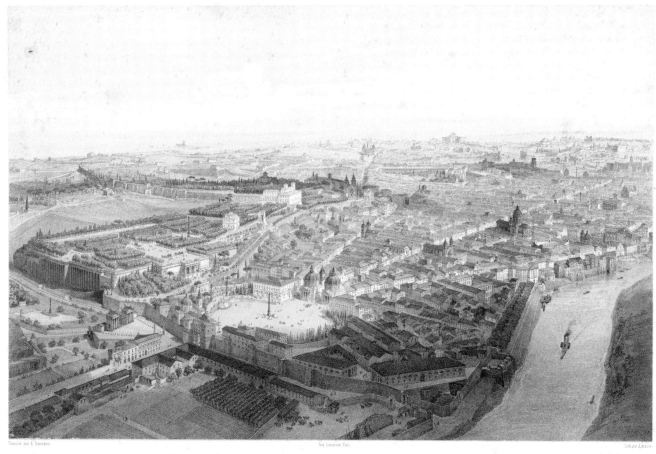

Dessiné par A. Guesdon. Imp. Lemercier, Paris. Lith par J.Arnout.

ROME
Vue prise au dessus de la Porte du Peuple

Paris publié par A. Hauser, Boul. des Italiens, 11 Rome chez M. Merelli & C.ie Via dei Condotti

FÉLIX BENOIST

Saumur 1818–1896 Nantes

and

PHILIPPE BENOIST

Geneva 1813–ca. 1905 Paris

12 *The Vatican Palace and Gardens Seen from the Dome of St. Peter's*, 1870

Lithograph

13¼ x 19¼ inches (337 x 489 mm)

Studium Urbis, Rome

The mid-nineteenth century saw the publication of numerous collections of lithographs depicting European cities and regions. Many of these collections were offered through subscription. The printer Henri-Désiré Charpentier (1806–1883) was responsible for many such works, including one entitled *Paris dans sa splendeur,* which was published in 1857–60. *Rome dans sa grandeur,* for which this lithograph was printed, followed in 1870. Charpentier's books involved close collaboration among a team of artists, including Félix Benoist, who furnished the drawing for this view, Philippe Benoist, who transferred it to the lithographic stone, and Adolphe-Jean-Baptiste Bayot, who rendered the figures.[1]

The hundred plates comprising *Rome dans sa grandeur* are divided into three sections. The first two are devoted to ancient and Christian sites; the third section consists of the secular monuments of "modern" Rome. The collection offers a vision of papal Rome on the eve of its transformation into the capital of a united Italy. Benoist's drawings were made while the city was still occupied by French soldiers, and the inclusion of monuments with close connections to Pius IX, such as the column celebrating the proclamation of the doctrine of the Immaculate Conception (erected in 1856), reflect the good relations Charpentier enjoyed with the Vatican.[2]

One of two views from the top of the cupola of St. Peter's included in *Rome dans sa grandeur,* this one looks north, over the Vatican palace complex.[3] The long nave of the basilica and the north arm of Bernini's colonnade appear in the lower right-hand corner. The lantern of one of the minor domes of St. Peter's appears silhouetted against the spare exterior of the Sistine Chapel.

Beyond the tiled roof of the chapel, the two long arms of the palace enclosing the Cortile del Belvedere climb the Vatican Hill. To the left extend the Vatican Gardens, with the Renaissance Casino of Pius IV visible at the center of four radiating allées. Set against a thickly wooded background is the rustic Fontana dell'Aquila, celebrating the water brought to the Vatican by Pope Paul V early in the seventeenth century. The lower left-hand corner of the composition is occupied by two utilitarian structures: the papal mint and bakery. An enormous pile of firewood stands ready at the center of the irregular courtyard.

To the right of the Vatican palace complex are the Prati di Castello—the open meadows, fields, and vineyards that extended north from the Castel Sant'Angelo and east to the banks of the Tiber. This area (also visible in No. 3) would be developed into a new residential quarter called Prati in the course of the rapid development that followed Italian unification in 1870. The receding orthogonals of the Belvedere Court lead the eye to Monte Mario, a favorite site for landscape painters (see Nos. 2 and 40). Across the Tiber, the northern quarter of the city is silhouetted against the Sabine Mountains.

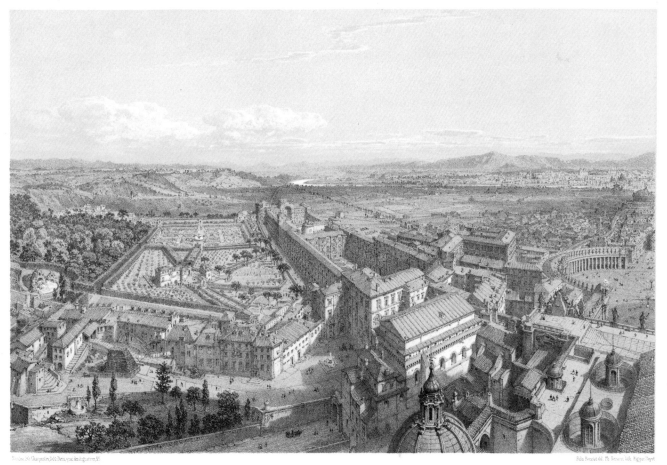

PALAIS ET JARDINS DU VATICAN
Vue générale prise de la Coupole de St Pierre.

PALAZZO E GIARDINI DEL VATICANO
Veduta generale presa dalla Cupola di San Pietro.

REVEREND CALVERT RICHARD JONES
Swansea 1802–1877 Bath

13 *The Equestrian Monument of Marcus Aurelius on the Capitoline Hill,* 1846
Salt print from a calotype negative
6½ x 8⅜ inches (165 x 213 mm)
Inscribed on verso, *LA 399.*

Collection W. Bruce and Delaney H. Lundberg

Jones received instruction in the calotype process directly from its inventor, William Henry Fox Talbot, in 1845, only four years after it had been patented.[1] An amateur watercolorist, Jones had prior experience with the daguerreotype process. In 1845–46, he took a photographic tour of the Mediterranean, over the course of which he spent four months on Malta before moving on to Sicily and the Italian peninsula. After stops in Naples and Pompeii, Jones arrived in Rome in May 1846. During his two-week stay, he photographed many of Rome's celebrated monuments, such as the Forum and Colosseum, but also recorded vernacular architecture. In at least one instance (the Forum of Trajan), he employed an innovative technique to produce a panoramic view formed by joining two separate exposures.[2]

By his own account, Jones brought a hundred large and about twenty small calotype negatives back with him to England.[3] Instead of personally printing positives from these, Jones used Fox Talbot's Reading Establishment. Set up in 1844, this laboratory had the distinction of being "the first business formed to mass produce photographs."[4] Jones became a major supplier of negatives to Fox Talbot.[5] Among the negatives purchased by Fox Talbot was the one (now in the British Library) from which this positive was printed. Other prints from the same negative survive, including one in the Metropolitan Museum of Art, New York.[6]

The subject of Jones's salt print, the equestrian monument of Marcus Aurelius, is the centerpiece of Piazza del Campidoglio. Michelangelo moved the ancient gilded bronze statue to this site in the sixteenth century, raising it on a pedestal of his own design. Jones angled and positioned the camera to silhouette the statue against the open sky at the same time as he masterfully employed Michelangelo's architecture as framing elements. In his early work, Jones did not block out the sky, as did many calotypists, to correct for the oversensitivity of the photographic salts to blue light. As a result, the speckled cloudlike effect in the sky imbues this print with a special aura.

Nathaniel Hawthorne saw the statue as the embodiment of authority:

It is the most majestic representation of the kingly character that ever the world has seen.... He stretches forth his hand with an air of proud magnificence and unlimited authority, as if uttering a decree from which no appeal was permissible, but in which the obedient subject would find his highest interests consulted; a command that was in itself a benediction.[7]

Writing to his mother in 1869, Henry James was moved, instead, by the emperor's humanity:

I like this grand old effigy better every time I see it. It commands the sympathies somehow more than any work of art I know. If to directly impress the soul, the heart, the affections, to stir up by some ineffable magic the sense of all one's human relations and of the warm surrounding frames of human life—if this is the sign of a great work of art—this statue is one of the very greatest.[8]

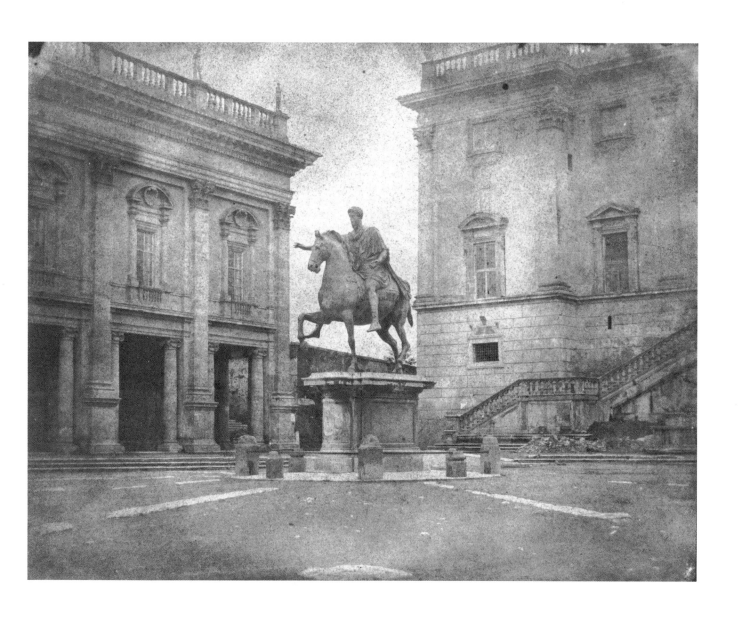

ROBERT TURNBULL MACPHERSON

Dalkeith 1814–1872 Rome

14 *The Spanish Steps*, ca. 1856[1]

Albumen print

11⅞ x 14¾ inches (302 x 375 mm)

Collection W. Bruce and Delaney H. Lundberg

The Spanish Steps are so called because they run from the Piazza di Spagna, where the Spanish Embassy is located, to the church of the Trinità dei Monti on top of the Pincian Hill. In spite of the name, the history of this monumental staircase has little to do with Spain and everything to do with France. The Trinità dei Monti belonged to a French religious order and was often used as the backdrop to spectacular ephemeral celebrations of the French crown, a not-so-subtle thumbing of the Gallic nose in the direction of France's adversaries, the Spanish, below.

The staircase, crowned by the vertical accents of the church facade and an Egyptian obelisk, constitutes an inspired exercise in architectural scenography carried out over the course of two centuries. The distinctive twin-towered facade of the Trinità dei Monti, boldly silhouetted against the Roman skyline, was finished in 1597. Next, in 1627–29, came Bernini's fountain at the base of the hillside. Plans for a grand staircase celebrating the French monarchy were under discussion as early as 1660 but were not executed until 1723–28. The final element of the composition, the Egyptian obelisk, was erected in 1789 under Pius VI.

Judging from the vertical shadows cast by the midday sun, the absence of any passing figures, and the projecting shop awnings, Macpherson's photograph was taken during the siesta hours of a hot summer's day. Macpherson, who rarely included people in his photographs, favored this time of day. The long exposure captured the effects of a passing breeze, which ruffled the drapery of the flower stall on the left. The buildings lining the via dei Condotti frame the composition.

In the foreground, the central jet of Bernini's early-seventeenth-century Fontana della Barcaccia interrupts the horizontal shadows cast by the cascading risers of the Spanish Steps. The fountain is mostly obscured by the flower stalls, as well as by its placement below the grade of the street, necessitated by the low level of its water source.

Over the course of the eighteenth century, the Piazza di Spagna became the hub around which hotels, lodging houses, and cafés catering to tourists and foreign residents were situated. In 1820 John Keats spent the last three months of his life in a house looking out over the Spanish Steps—partially visible on the right. The piazza was also the center of the artists' quarter. The Caffè Greco, where Macpherson would meet Anderson, Caneva, and Flachéron, along with other photographers and artists, is situated a short distance down the via dei Condotti, just behind the spot where this photograph was taken. In the nineteenth century, drawn by the concentration of foreigners and artists, the Spanish Steps attracted two other groups: beggars and models. William Wetmore Story describes the scene:

All day long, these steps are flooded with sunshine, in which, stretched at length, or gathered in picturesque groups, models of every age and both sexes bask away the hours when they are free from employment in the studios.[2]

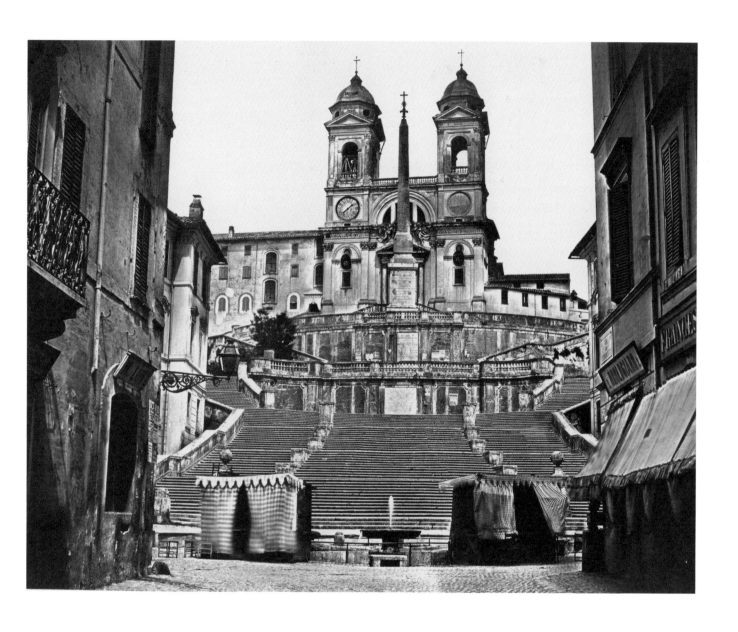

TOMMASO CUCCIONI

Padua ca. 1790–1864 Rome

15 *The Theatre of Marcellus*, ca. 1858

Albumen print

14⅞ x 10⅝ inches (378 x 270 mm)

Collection W. Bruce and Delaney H. Lundberg

Like many early photographers, Cuccioni was trained as an engraver, in which capacity he is recorded as having worked for the papal *Calcografia* in 1834–35.[1] He subsequently sold artist's materials, prints, and photographs (including some by Giacomo Caneva) from a shop located near the Spanish Steps.[2] In 1852 Cuccioni took up photography himself, specializing in views of Rome, works of art in its museums, and panoramas. He and his apprentice Giuseppe Ninci specialized in mammoth panoramas, few of which have survived.

The Theatre of Marcellus was dedicated by the Emperor Augustus in 13 or 11 B.C. to the memory of his nephew, son-in-law, and intended successor who had died prematurely in 23 B.C. During the Middle Ages, its ruins served the Pierleoni, Savelli, and Orsini families as a fortified residence. In the sixteenth century, the Savelli had Baldassare Peruzzi design a palace set into its remains; a Renaissance window frame dating from this period is visible at the upper right.

During the nineteenth century—and until the clearing of the houses pressing in on the Theatre of Marcellus in 1926–32—the surrounding area was one of the most lively and picturesque in Rome.[3] This was owing largely to the adjacent market of Piazza Montanara but also to the shops set within the lower arcade of the theatre. Because of the rise in the ground level over centuries, the archways were partially buried. As a result, the engaged Doric columns framing the lower arcade appear truncated, accentuating the slim Ionic shafts of the upper arcade.

The street name painted over the whitewashed shop opening at the lower left identifies the via de' Sugherari, the street on which the fashioners of cork bottle stoppers plied their trade. This is one of many Roman street names that derive from mercantile and preindustrial activities localized in their vicinity. In Cuccioni's photograph, the shop below the street sign is closed, but an earlier painting depicts it functioning as a wine bar.[4] The two arches to the right of this shop may have housed a smithy. Pots, pans, and other metal objects for sale are displayed in the nearer of the two openings, which may have served as a combination shop and warehouse, while a workbench with a vise, sawhorses, and other tools occupy the area in front of the further arch.

Following a walk in this area in 1858, about the time Cuccioni's photograph was taken, Nathaniel Hawthorne commented on the mercantile activity and the reuse of the ancient theatre:

> *I soon struck upon the ruins of the theatre of Marcellus, which are very picturesque, and the more so from being closely linked in, indeed identified with, the shops, habitations, and swarming life of modern Rome. The most striking portion was a circular edifice, . . . the whole once magnificent structure now tenanted by poor and squalid people, as thick as mites within the round of an old cheese.[5]*

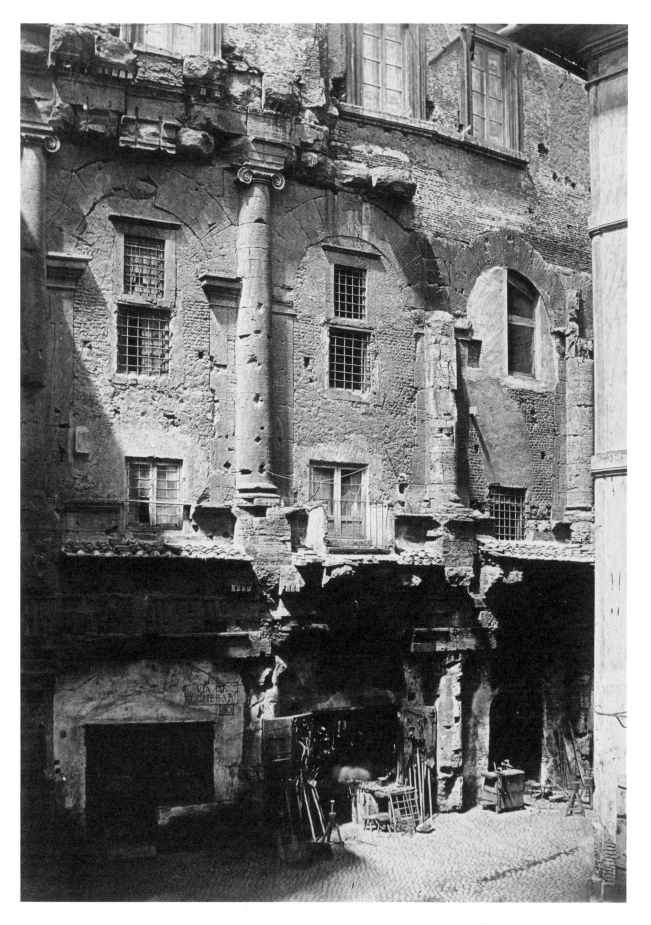

JAMES ANDERSON
Blencarn 1813–1877 Rome

16 *The Piazza Navona Flooded,* ca. 1862
Albumen print
12½ x 16⅛ inches (318 x 410 mm)

Collection W. Bruce and Delaney H. Lundberg

The Piazza Navona, seen partially flooded in this photograph, preserves the shape of the ancient Stadium of Domitian, the substructures of which were used as foundations for the buildings that enclose it. In the mid-seventeenth century, Pope Innocent X Pamphili transformed the piazza into his family enclave, employing two masters of the Roman Baroque, Francesco Borromini and Gian Lorenzo Bernini, to create one of Rome's great scenographic spaces. Anderson's photograph captures the key components of the pope's program—the family palace enclosing Borromini's domed church of S. Agnese and two fountains with sculpture by Bernini, the Fountain of the Moor in the foreground and the Four Rivers Fountain at the center of the piazza.

Anderson accentuated the serpentine pose of the Moor, which is set off against the dark, reflective surface of the water. His composition plays with the verticals of the twin bell towers of S. Agnese and the slim, needlelike silhouette of the obelisk atop the Four Rivers Fountain, with its crowning finial of a dove holding an olive sprig in its beak, one of the heraldic devices of the Pamphili family.

The Piazza Navona was the site of a lively market until 1869, when the market was moved to Campo de' Fiori. Some of the market booths are visible beyond the obelisk of the Four Rivers Fountain, where the piazza remains free of standing water. The temporary stands protected by hoarding erected in line with the facade of S. Agnese are not related to the market but to the water flooding the piazza.

William Wetmore Story described the flooding of the Piazza Navona, a popular diversion of the hot summer months since the mid-seventeenth century:

> On Saturday evening all the benches and booths are removed, and the great drain which carries away the water spilled by the three fountains is closed. The basins then fill and pour over into the square, till in a few hours it is transformed into a shallow, shining lake, out of which, like islands, emerge the fountains with their obelisks and figures, and in whose clear mirror are reflected the cupola of Sta. Agnese and St. Giacomo, the ornate facades of the Doria, Pamfili, and Braschi Palaces, and all the picturesque houses by which it is enclosed.

Story went on to describe the transformation of this tranquil scene with the setting of the sun:

> …carriages welter nave-deep in the water, and spatter recklessly about; whips crack madly on all sides like the going off of a thousand sharp India crackers; and horses plunge and snort with excitement, sometimes overturning their carriages and giving the passengers an improvised bath.[1]

The faint ghost images visible in front of the central fountain indicate that Anderson used a long exposure, taking advantage of morning light. Like many of Anderson's prints, this one carries the blind stamp of Joseph Spithöver, who offered books and photographs for sale in his shop on the Piazza di Spagna.

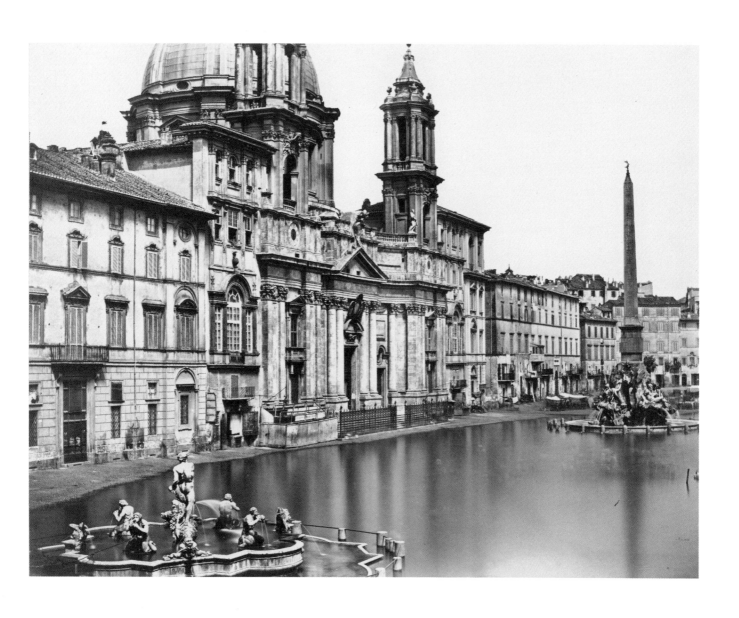

GIOACCHINO ALTOBELLI
Terni 1814–after 1878 Rome

17　*The Attack on Porta Pia,* 1870
Albumen print from glass negative
4¾ x 6½ inches (121 x 166 mm)

Collection W. Bruce and Delaney H. Lundberg

Following Garibaldi's retreat and the fall of the Roman Republic in 1849, Pope Pius IX returned to Rome supported by an occupying force of French soldiers. As other portions of Italy gradually became unified under the leadership of the House of Savoy, Rome and the Papal States became increasingly isolated. By 1870, developments on the international scene opened the way for Rome to become the capital of unified Italy. In the summer of 1870, the Franco-Prussian War erupted, prompting the recall of the French garrison in Rome early in August. Then, on 1 September, the Prussian army inflicted a crushing defeat on the French army at Sedan, capturing Napoleon III.

The forces of Victor Emmanuel II of Savoy, for decades the driving force behind efforts to realize a unified Italy, seized upon the opportunity presented by the French defeat. Following immediately upon the pope's rejection of efforts to negotiate a peaceful transfer of temporal power, the Piedmontese army crossed the border of the diminished Papal States on 11 September. Advancing unopposed, the army arrived at the gates of Rome in just over a week. They found the city defended by a small force of about 15,000 foreign volunteers. Predominantly French, they were known as Zouaves.

At 9:00 on the morning of 20 September (celebrated ever since as a national holiday) the batteries of the Piedmontese army began to bombard the walls of Rome at a number of points. After three hours, the walls were breached just north of the Porta Pia, and in short order the crack shock troops of the Piedmontese army, the Bersaglieri, stormed the city, claiming it for Italy. By the end of the day, the pope was confined to the Vatican, ending centuries of papal rule. The assault on Rome had been instigated by the pope's obstinate refusal to accept the loss of the city and his temporal authority.

Altobelli's photograph does not record the actual attack but a reenactment on the following day.[1] The plumed hats of the Bersaglieri are clearly visible. Edmondo De Amicis, a reporter attached to the Piedmontese army, described the immediate aftermath of the attack on the Porta Pia.

> *The Porta Pia was completely shattered. Only the enormous image of the Madonna, which overlooks it from within, remained intact. The statues to the left and right no longer had their heads; scattered about the surrounding ground were piles of dirt, smoking mattresses, hats of Zouaves, weapons, wooden beams, and stones. Our regiments were quickly entering through the nearby breach in the walls.*[2]

Altobelli's photograph provides visual confirmation of this eyewitness account. The walls and gateway show the impact of scores of projectiles, the headless statues of SS. Agnes and Alexander flank the central portal, and the mosaic of the Madonna serenely gazes down from her place above the inner gate. In the foreground, the earthworks that were hastily thrown up by the defenders outside the gate provide an elevated platform for the soldiers posing with their muskets pointing toward the open gate. The exterior of the Porta Pia had been completed only in the previous year, and the damaged inscription on the attic records the name of Pope Pius IX, one of the last instances of papal patronage in Rome outside the Vatican.[3]

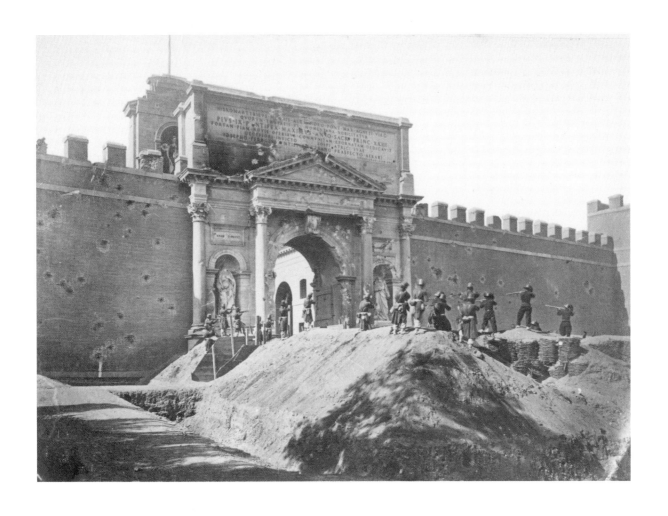

SPEAKING RUINS

JOSEPHUS AUGUSTUS KNIP
Tilburg 1777–1847 Berlicum

18 *Temple of Minerva Medica*, ca. 1810

Watercolor, over graphite, on wove paper
17 x 23¼ inches (432 x 591 mm)
Inscribed in graphite at lower left, *10 Vensters, 9 niches, 1 deur / Van den eenen hoek tot den andere is 22½ Voed / en den geheelen omtrek is 222 Voed*; at lower right, *Temple de Minerva Medica*; and with scale markings at lower center.

The Morgan Library & Museum, Thaw Collection

Knip's first artistic instruction came at the hands of his father, a wallpaper and still-life painter. In 1801 the younger Knip left his native Holland for Paris. Seven years later he won the Prix de Rome; over the course of his three-year Roman residence he produced nearly five hundred drawings and watercolors.[1] The subjects included monuments within the city walls, as well as sites in the Roman campagna, invariably rendered within a pale, muted palette. Following the artist's 1812 return to Holland, the watercolors served as models for the classical landscape compositions Knip produced throughout his subsequent career.

Temple of Minerva Medica is a misnomer; the structure was built early in the fourth century as a garden pavilion. The misidentification derived from the mistaken belief that a celebrated statue representing Minerva had been discovered there early in the seventeenth century.[2] One of the best-preserved central-plan structures surviving from antiquity, the Temple of Minerva Medica provides a revealing example of vaulted imperial architecture. Knip accurately recorded one of the massive spur buttresses, added not long after the original construction. At Minerva Medica (which differs from the Pantheon, with its heavy concrete dome), Roman engineers employed a lighter armature of brick ribs, with a weblike infill. In 1828, the central portion of the vault fell while efforts to conserve it were under way. Here Knip depicted several of the vault's ribs silhouetted against the sky.[3]

Fig. 1. Franz Innocenz Josef Kobell, *Temple of Minerva Medica*, Staatliche Graphische Sammlung, Munich

One of the attractions of the subject for artists was the way in which the structure's interior is visible through the gap in its exterior walls. Unlike the Pantheon, the interior of which is visible only from within, the Temple of Minerva Medica invited painters to capture its three-dimensional molding of space using color, light, and perspective. Knip emphasized the contrast between the deeply shaded interior surfaces and the corrugated texture of the exterior brickwork. Details sketched in graphite suggest that the composition may never have been finished.[4]

The ruin was a favorite subject for artists because of its picturesque isolation amid vine-

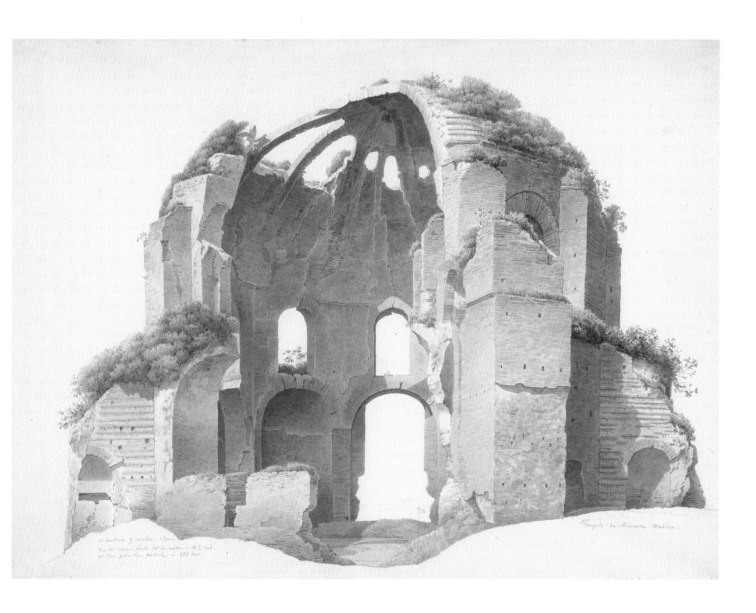

yards and gardens and its floral crown of lentiscus and other shrubs.[5] Charlotte Anne Eaton, the English travel writer, commented on the picturesque condition of the ruin in 1817-18:

> *The yawning chasms in its vaulted roof, the wild weeds that wave over it, the fallen masses that choke it up, the total destruction that threatens, and the solitude that surrounds it, give it an interest and a charm it probably never could have owned in a state of perfect preservation.*[6]

Viewed from a slightly different angle, the monument is the subject of one of Piranesi's *Vedute di Roma*. A drawing of ca. 1779-84 by Franz Innocenz Josef Kobell comes closer to Knip's perspective (Fig. 1).[7] Among the British artists who depicted the Temple of Minerva Medica are Richard Wilson and Joseph Mallord William Turner.[8]

JOHANN ADAM KLEIN
Nuremberg 1792–1875 Munich

19 *The Basilica of Constantine, Rome,* 1821

Oil on paper, mounted to cardboard
6 x 8¾ inches (152 x 222 mm)
Signed and dated at lower left, *Den 25 Juny / 1821 / JAKlein*; inscribed on reverse in pen and brown ink,
J.A. Klein / Die Basilika des Konstantin / in Rom.

Thaw Collection, jointly owned by the Metropolitan Museum of Art and the Morgan Library & Museum, gift of Eugene V. Thaw, 2009; 2009.400:78

The German printmaker and watercolorist Johann Adam Klein began his artistic studies in his native Nuremberg before moving to the Art Academy in Vienna in 1811. In 1819 the artist traveled to Italy, where he remained until his return to Nuremberg in 1821. While in Italy, Klein became familiar with Joseph Anton Koch and Johann Christian Reinhart, and, perhaps under the influence of these older artists, began to produce oil sketches.

The ruins of the colossal basilica begun under the emperor Maxentius in 308 at the southern end of the Roman Forum dominate Klein's composition. Incomplete at the time of Maxentius's defeat at the Battle of the Milvian Bridge (312), the basilica was completed by the victor, Constantine the Great. A superb example of the ancient Romans' creative use of brick-faced concrete and vaulted structures to mold vast interior spaces, the imposing remains of the basilica inspired Bramante's design for the new St. Peter's and many other Renaissance churches. In 1812–13, during the French occupation, the site was cleared of accumulated debris, making it more accessible.[1]

Klein emphasized the geometric mass of the basilica, its structure defined by broad planes of masonry cast into relief by light and shadow. He also exploited the iteration of rounded arches, seen both frontally and in foreshortening. The artist's choice of viewpoint—from the podium of the Temple of Venus and Rome to the south of the basilica—reveals the strongly foreshortened openings of three great barrel vaults. For Émile Zola, writing in 1896, these dark concavities conveyed:

> *a sensation of extraordinary vastness.... From the Palatine they look like porches built for a nation of giants, so massive that a fallen fragment resembles some huge rock hurled by a whirlwind from a mountain summit.*[2]

The surviving vaults cover only a fraction of the space originally enclosed by the basilica. Above them, the footings of the soaring cross vaults that once spanned the space now open to the sky terminate in feathery green foliage. The bell tower of the Senators' Palace on the Capitoline Hill and the dome of SS. Martina e Luca are silhouetted against the sky to the left.

Another detail seen in silhouette is easily overlooked: in the upper right-hand corner, Klein depicted an artist at work on top of the ruins of the basilica. The figure's vocation is clearly indicated by a parasol, portable paint box, and easel. While his identity cannot be confirmed, his presence, "a metaphorical self-portrait" as Ann Hoenigswald put it, becomes, along with Klein's name, a kind of double signature.[3]

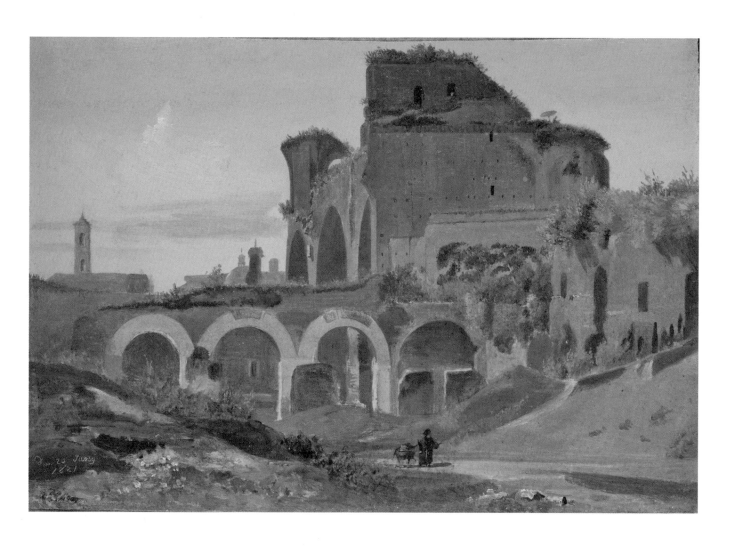

LANCELOT-THÉODORE, COMTE TURPIN DE CRISSÉ
Paris 1782–1859 Paris

20 *The Arch of Constantine Seen from the Colosseum*, 1818–38

Oil on paper, mounted to canvas
11½ x 8¾ inches (292 x 223 mm)
Signed with the artist's initials and coronet, and dated at right center, *T.T./1818/1838.*

Thaw Collection, jointly owned by the Metropolitan Museum of Art and the Morgan Library &
Museum, gift of Eugene V. Thaw; 2009.400:108

Born into an aristocratic family with military traditions, Turpin de Crissé inherited his artistic skill from his father, a marquis who was a painter and collector of note.[1] The French Revolution brought hard times to the family, causing the father to immigrate to the United States and leaving Lancelot-Théodore without means of support. In 1801, however, thanks to the patronage of Marie-Gabriel-Florent-Auguste de Choiseul-Gouffier (1752–1817), he was able to pursue his artistic education in Switzerland. Then, in 1807–8, he made his first trip to Italy, residing in Rome and Naples. Following his return to France, he engraved the illustrations for the second volume of Choiseul's travel book on Greece.[2] He subsequently became chamberlain to Empress Joséphine and, from 1821 to 1830, inspector general of fine arts.

Turpin de Crissé repeatedly traveled to Italy and in 1828 published a suite of landscape studies depicting the Bay of Naples. In 1818, during the artist's second stay in Rome, he met Jean-Auguste-Dominique Ingres, who drew his portrait.[3] In the same year, Turpin de Crissé began this oil sketch of the Arch of Constantine viewed from the Colosseum.[4] The dates inscribed on the masonry to the right of the arch indicate that while begun in Rome, this oil sketch was finished after an interval of twenty years, in 1838. Turpin de Crissé is known to have returned to finish canvases he had begun earlier in Rome; a view of the Roman Forum, for example, carries the dates 1818/44.

The exterior arcades and internal galleries of the Colosseum were often exploited by artists as framing devices. For example, Turpin de Crissé's contemporary François-Marius Granet produced numerous drawings and oil sketches based on this compositional principle. Not only do the arches frame distant objects, but the vaults cast shadows that enhance the illusion of depth as the viewer's eye moves from brilliantly illuminated foreground, to dark middle ground, and finally to bright background. This pictorial strategy also serves to intensify the blueness of the sky.

Turpin de Crissé experimented with a range of contrasting textures: the pitted surface of the large travertine blocks in the right foreground, the shiny foliage of the plants growing on the ruins, the smooth texture of the distant triumphal arch, and the wooded slopes of the Palatine Hill. Beyond the Arch of Constantine, the church of S. Bonaventura is visible on the Palatine. The grounds of this monastery, associated in antiquity with the Palace of Nero, provided an ideal position from which to view the Colosseum. In *Corrine* (1807), Madame de Staël played on these associations: "There, where so many crimes were committed without remorse, poor monks, tormented by scruples of conscience, inflict cruel tortures on themselves for the slightest failings."[5]

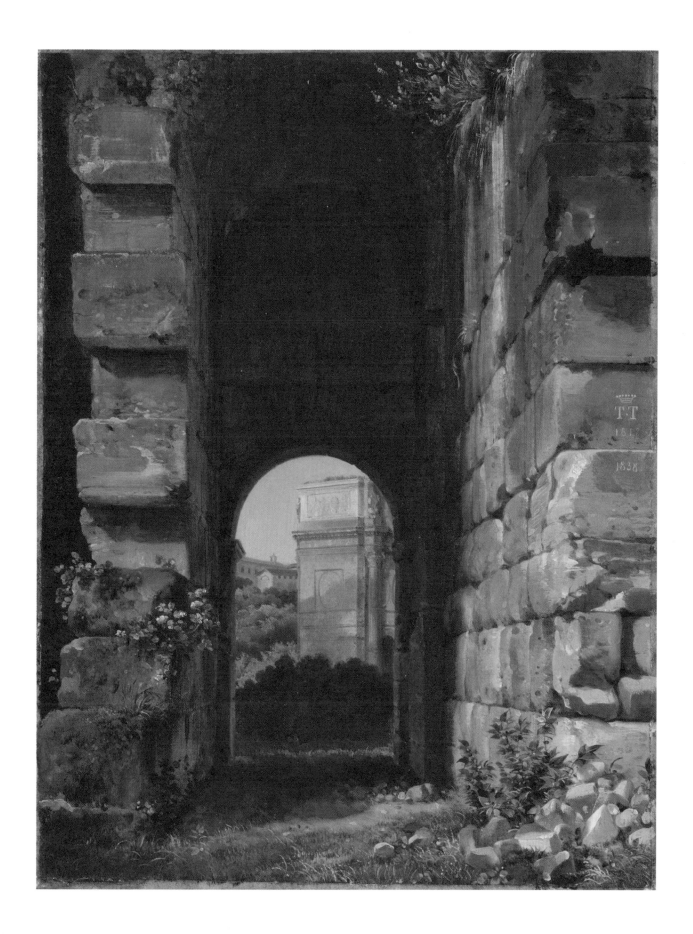

JEAN-BAPTISTE-CAMILLE COROT
Paris 1796–1875 Paris

21 *The Arch of Constantine and the Forum*, 1843
Oil on paper, mounted to canvas (lined)
10⅝ x 16½ inches (425 x 568 mm)

The Frick Collection, gift of Mr. and Mrs. Eugene Victor Thaw; 1994.1.175

Corot's unique approach to landscape painting was shaped by his early study with two followers of Pierre-Henri de Valenciennes (see No. 60). In 1822 he entered the studio of Achille-Etna Michallon, who introduced him to the technique of plein-air oil painting (see Nos. 28 and 64). Following Michallon's death later that year, Corot transferred to the studio of Jean-Victor Bertin, a master of classical landscape in the tradition of Claude, Poussin, and Vernet. Like so many artists of his generation, Corot was inexorably drawn to Italy, where he remained for three years between 1825 and 1828.[1] Much of this time was spent in Rome and its vicinity, where he refined his sensitivity to light and emphasis on structure. On his return to France, Corot continued his plein-air landscape studies, particularly in the Forest of Fontainebleau.[2] Two subsequent trips to Italy followed, but these were six-month sketching expeditions. The first, in 1834, was devoted to northern Italy. Corot returned to Rome only in 1843 after an absence of fifteen years, by which time he was a mature artist approaching age fifty. It was during this stay that he painted the Frick oil sketch.[3]

The Arch of Constantine anchors the left side of Corot's composition. The oblique view casts into bold relief the arch's projecting elements, especially the columns and Attic statues, which are brilliantly silhouetted. Balancing the arch on the right are the massive ruins of the Temple of Venus and Rome, including the southern apse, cast in deep shadow. In the foreground, the remains of a conical fountain, the so-called Meta Sudans, lead the viewer's eye diagonally back to the Arch of Titus. In the far distance, the tower of the Senators' Palace on the Capitoline Hill is silhouetted against the sky.

Judging from the direction of the sunlight and the greensward in the foreground, Corot's view of the Forum was painted on a spring afternoon.[4] Compared to the more finished views of the Forum he painted during his first stay in Rome, which look down on the ruins from the Palatine Hill, this later oil sketch suppresses details to concentrate on essential form. Indeed, in its exquisitely calibrated balance of mass and void, Corot's oil sketch calls to mind the twentieth-century architect Le Corbusier's definition of architecture: "the masterly, correct and magnificent play of masses brought together in light."[5] Corot shared certain concerns, such as the apparently casual cropping of his image and his manipulation of contrast, with early photographers. Through his careful study of the fall of light across each faceted surface, he effected a remarkable fusion of solid structure and intangible, atmospheric space—an achievement that looks forward to Cézanne and Cubism.

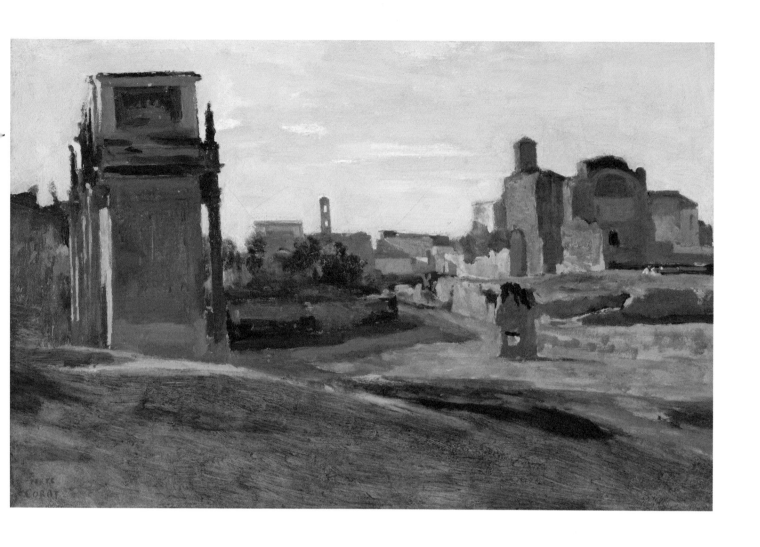

JOSEPH-PHILIBERT GIRAULT DE PRANGEY
Langres 1804–1892 Courcelles

22 Round Temple by the Tiber, 1842

Daguerreotype
3¾ x 9½ inches (95 x 241 mm)
Inscribed and dated in ink on label on verso, *22. Rome. 1842 / Temple De Vesta.*

Collection W. Bruce and Delaney H. Lundberg

Like many early photographers, de Prangey was trained as a painter. Between 1836 and 1839, he published a suite of orientalizing engravings depicting Moorish monuments in Andalusia. Soon after Louis-Jacques-Mandé Daguerre publicly demonstrated his revolutionary process in 1839, de Prangey had mastered the new medium. Between 1842 and 1845, he traveled through Italy, Greece, and the Levant, producing over eight hundred daguerreotypes documenting architectural monuments, landscapes, and local costumes. Many were the first photographic images of major ancient sites.[1]

De Prangey's accomplishment is all the more impressive when one takes into account the weight and bulk of his photographic apparatus and the difficulties posed by developing the exposed plates in the field.[2] Unlike the process perfected by Henry Fox Talbot, which allowed multiple prints to be made from a negative, each daguerreotype was a unique image recorded on the highly reflective surface of a silver-coated copperplate.[3] To produce the horizontal format of this image, de Prangey cut one of his copperplates in half along its major axis. This format lent itself to panoramic views as well as architectural details. All early daguerreotypes laterally reverse their subjects, a distortion easy to overlook in symmetrical buildings like this temple.

The present daguerreotype is one of twenty-seven images of Rome and its environs de Prangey produced early in his three-year voyage. In the nineteenth century, the circular plan of the temple led antiquarian scholars to associate it with Vesta, the goddess of the hearth, and this is how de Prangey identified it in the label on the verso.[4] Like other ancient temples in Rome, this one survived through its transformation into a Christian church. The monument's significance as an instructive example of the classical orders had been recognized since the Renaissance. Early in the nineteenth century, the temple's value as artifact came to outweigh its religious significance, and it was deconsecrated and restored by Luigi Valadier.

The picturesque appearance of the temple, situated off the beaten track, attracted the attention of many artists. The 1909 edition of Augustus Hare's *Walks in Rome* laments the site's recent transformation: "This spot, perhaps the most beautiful in Rome in the sixties, has been more ruthlessly dealt with than almost any other. . . . The prospects, where every turn was formerly a poem and a picture, backed by huge gas works and lined by modern quays, are now revolting."[5]

De Prangey's daguerreotype is unusual in its focus on the upper portion of the fluted column shafts and the Corinthian capitals encircling the cylindrical cella at the core of the temple.[6] The foreshortened upward perspective also diminishes the visibility of the tile roof, a postclassical addition. This particular composition, looking up at the post and lintel systems of ancient temples, appears frequently in de Prangey's work and anticipates Ruskin's efforts with the daguerreotype in Venice.[7]

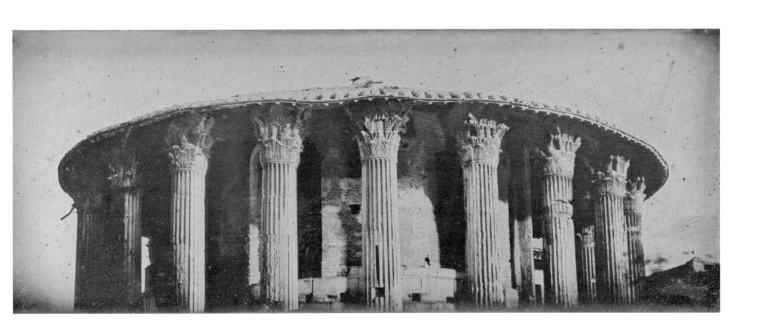

FRÉDÉRIC FLACHÉRON

Lyon 1813–1883 Paris

23 *The Temple of Castor in the Roman Forum*, 1851

Paper negative
13⅜ x 10 inches (338 x 253 cm)
Inscribed in ink at lower right, *F. Flachéron*; in ink at lower left, *5*.

Collection W. Bruce and Delaney H. Lundberg

As a student at the École des Beaux-Arts, Jean-Françoise-Charles-André Flachéron (Count Frédéric Flachéron) trained with the sculptor Pierre-Jean David D'Angers. Flachéron belonged to an artistic family: his father was an architect, and his brother studied landscape painting with Ingres. In 1839 he won the Prix de Rome and initiated his lengthy sojourn in the Eternal City, which lasted until 1866. Three years after his arrival in Rome, Flachéron married Caroline Hayard, whose portrait Ingres drew and whose father furnished papers, colors, and other necessary materials to Roman artists.

By 1849 Flachéron turned to the new medium of photography and rapidly achieved an exceptional degree of technical and artistic mastery. At this time he lived in the artists' quarter around the Piazza di Spagna and frequently met with other photographers—notably James Anderson, Eugène Constant, Alfred-Nicolas Normand, and Giacomo Caneva—at the Caffè Greco.[1] In 1851 Flachéron was awarded a medal for his seven panoramic views of Rome shown at the Great Exhibition at the Crystal Palace in London.

This striking image illustrates a crucial step in what was called the Roman method, a variant of Henry Fox Talbot's calotype process.[2] After being coated with a salting solution, paper negatives like this one were sensitized with a solution of silver nitrate and acetic acid.[3] Following a lengthy exposure time (four to six minutes), the negative was ready to be developed. Before printing a positive image, Flachéron usually saturated the negative with wax to enhance its transparency. He also frequently retouched his negatives with a variety of substances to strengthen the opacity of particular areas, such as the sky in this example.[4] Positive images were contact prints, their size identical to that of the negative.[5] Beginning in 1850, Flachéron began using larger negatives, like this one, to produce more impressive images.

Flachéron used the three standing Corinthian columns of the Temple of Castor to frame his view of the Roman Forum and the Capitoline Hill at its northern terminus. The picturesque silhouette of these columns, among the few substantial features of the Forum visible above the accumulation of debris, had dominated most views of the Forum by artists ranging from Martin van Heemskerck and Claude Lorrain through Piranesi.

The verticality of the temple's fluted marble columns, fifty Roman feet in height, is accentuated by their rich entablature.[6] In the distance, the solid, horizontal mass of the ancient Tabularium and Senators' Palace provides a calculated contrast to their slim profiles and the transparency of the intercolumniations. Flachéron positioned his camera in such a way as to create a frame within a frame emphasizing the bell tower of the Senators' Palace, which appears silhouetted against the sky. Significantly, the tower is off center, thereby underscoring the two parallel planes of the composition and accentuating the distance separating them. On the left side of the negative, the solitary shaft of the Column of Phocas rises like a sentinel before the pronounced vertical of the medieval tower at the corner of the Senators' Palace.

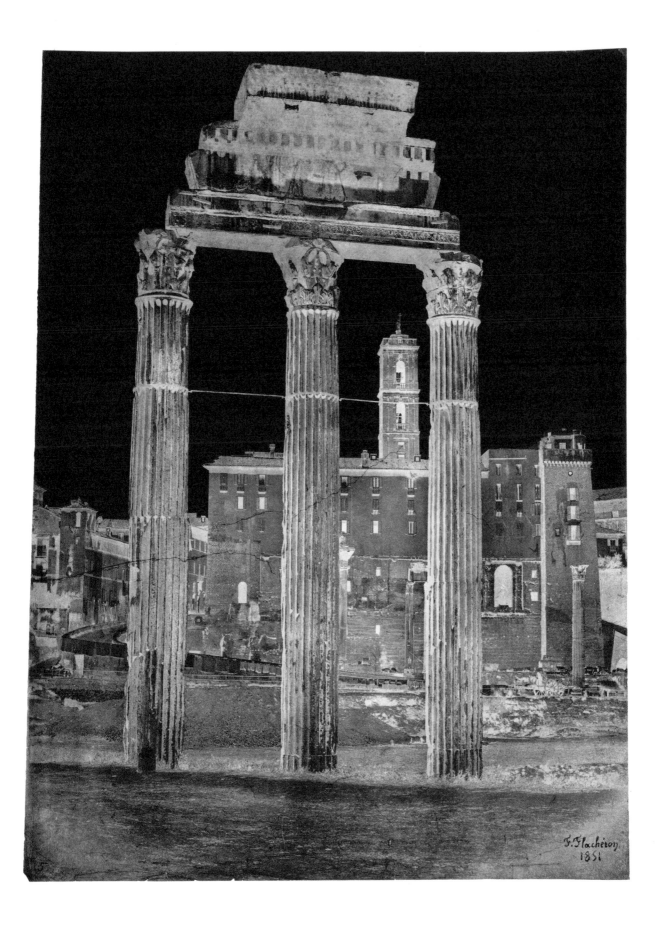

F. Flachéron
1851

REVEREND CALVERT RICHARD JONES

Swansea 1802–1877 Bath

24 *The Interior of the Colosseum*, 1846

Salt print from a calotype negative

7¾ x 9¹³⁄₁₆ inches (165 x 206 mm)

Collection W. Bruce and Delaney H. Lundberg

Among the photographs taken by Jones during his stay in Rome in the spring of 1846 are two of the Colosseum: an exterior view and this one showing the interior of the ancient amphitheatre.[1] Jones set up his camera near the center of the arena and framed his view slightly off axis, looking southeast toward the Basilica of S. John Lateran.[2] To the left of center rises the massive brick buttress erected by Raffaele Stern in 1806–7 to consolidate the outer arcade and prevent further collapse.[3]

The appearance of the Colosseum's arena in Jones's salt print differs significantly from what visitors see today. Most notably, the substructures that lie below ground level are not visible. While they had been temporarily revealed during the French occupation in 1813, they were subsequently filled in; they were not permanently exposed until 1874. The flora crowning the arches at the middle of the image was stripped away in 1871. At the precise center of Jones's composition is the memorial cross erected by Pope Benedict XIV for the Holy Year of 1750.[4] Tabernacles designed by Paolo Posi to house the Stations of the Cross were erected at the same time in an effort to counter the pagan associations of the Colosseum and transform it into a Christian site; three are visible in this photograph. Both cross and tabernacles were removed in 1874, when the substructures were excavated.

Compared to daguerreotypes, with their sharp detail, salt prints made from early calotype negatives have a softer, painterly appearance. As an accomplished amateur watercolorist, Jones no doubt appreciated this quality. This image perhaps intentionally recalls earlier painted views of the Colosseum interior, such as those of C. W. Eckersberg.[5] The penumbra of Jones's print, with its nightlike sky, creates a meditative mood reinforced by the profiled pose of the solitary figure who seems to possess the space as if he were the rightful heir to the Roman Empire.[6]

The American painter Thomas Cole's description of the Colosseum, written in 1832, touches on themes also evident in Jones's photograph:

> It is stupendous, yet beautiful in its destruction. From the broad arena within, it rises around, arch above arch, broken and desolate, and mantled in many parts with the laurustinus, the acanthus, and numerous other plants and flowers, exquisite both for their colour and fragrance. It looks more like a work of nature than of man; … crag rises over crag, green and breezy summits mount into the sky.[7]

Charles Dickens, who visited the Colosseum just one year before Jones set up his camera in the arena, observed:

> Its walls and arches overgrown with green; its corridors open to the day; the long grass growing in its porches, young trees of yesterday, springing up on its ragged parapets and bearing fruit … its Pit of Fight filled up with earth, and the peaceful Cross planted in the Centre.[8]

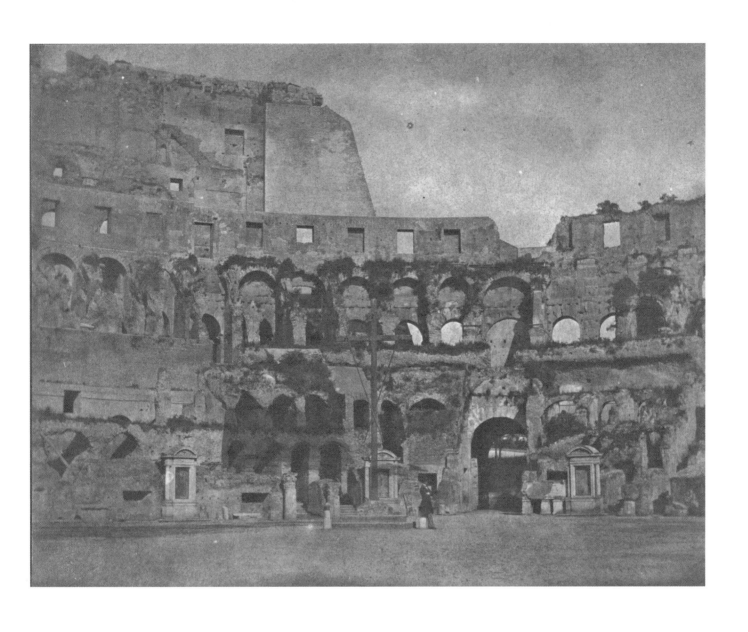

IPPOLITO CAFFI

Belluno 1809–1866 Lissa

25 The Colosseum Illuminated by Bengal Lights

Oil on canvas

11 x 17½ inches (279 x 445 mm)

Roberta J. M. Olson and Alexander B. V. Johnson

Caffi's life and artistic career were inexorably bound up with the Risorgimento, the movement that sought the unification of Italy. After two years study at the Venetian Academy of Fine Arts, Caffi moved to Rome, where he resided for over a decade. Caffi took the Venetian tradition of view painting, exemplified by Canaletto (1697–1768), and transformed it through the dramatic use of color and the exploitation of nocturnal scenes. His first great success in this genre was a depiction of the Roman carnival, the *Festa dei moccoletti*, painted in 1837.[1] Many other nighttime scenes followed, several set in Venice. Recent research has revealed striking parallels between Caffi's compositions and those of early photographers in Rome, notably Giacomo Caneva.[2] In 1843 Caffi traveled to Greece, the eastern Mediterranean, and Egypt, producing numerous views.

The revolutionary events of 1848 are reflected in Caffi's painting of the Papal Palace of the Quirinal at night, illuminated by Bengal lights in the three colors of the Italian flag.[3] Caffi's patriotic ardor led him to enlist in the army, seeking to free northern Italy from Austrian occupation. He fought in the Friuli, where he was captured, only to escape to Venice. When the Venetian Republic fell in 1849, he sought asylum in Piedmont. With the outbreak of hostilities anew in 1866, he boarded the Piedmontese battleship *Re d'Italia* to document its efforts to wrest control of the Adriatic from the Austrian navy. He drowned when the ship was sunk off the island of Lissa.

Caffi produced a number of variant views of the Colosseum illuminated by Bengal lights, the earliest dating to 1845.[4] The artist dramatically silhouetted the foreground arcade, using it to block the source of the most intense white light and to frame views of the crowd gathered in the arena as well as the tiers of arches beyond. The powerful contrasts of light and shadow recall the work of Piranesi, but Caffi's technique, which renders the massive edifice exclusively in terms of light and color, is decidedly impressionistic. The patriotic colors of the Bengal lights vest the ancient arena with a distinctly modern political identity, suggesting that the might and authority of ancient Rome will be revived in a newly unified Italy.

In 1873, three years after unification, Thomas Adolphus Trollope, brother of Anthony, described the illumination of the Colosseum:

> I had never seen that somewhat cockneyfied exhibition before; and certainly there was much that was beautiful and more that was striking in it. But I thought the Bengal lights and the coloured fire "served but to flout the ruins gray." The moon was at the full, which those who preferred firework light to hers thought was unfavourable to the show. But it inevitably suggested to one how much more lovely all that was beneath one's eyes would have been, if one could have left it to the moon to illuminate the scene in her own fashion.[5]

Trollope's quotation from Sir Walter Scott underscores the Romantic predilection for ruins—Gothic and classical—seen by moonlight.[6]

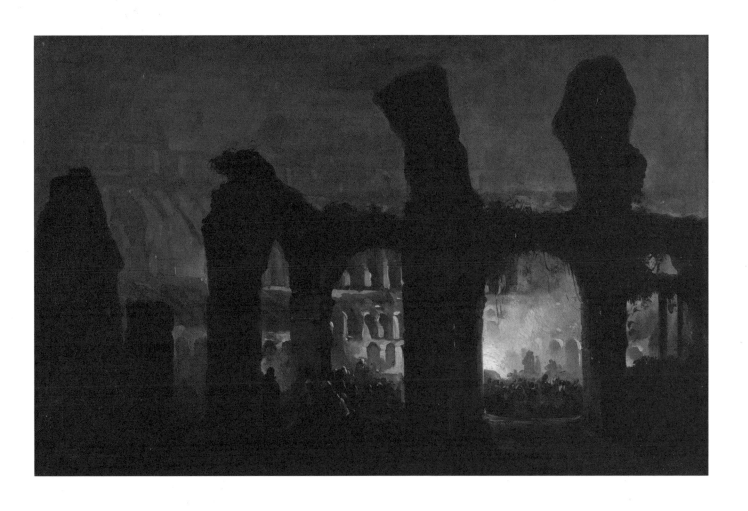

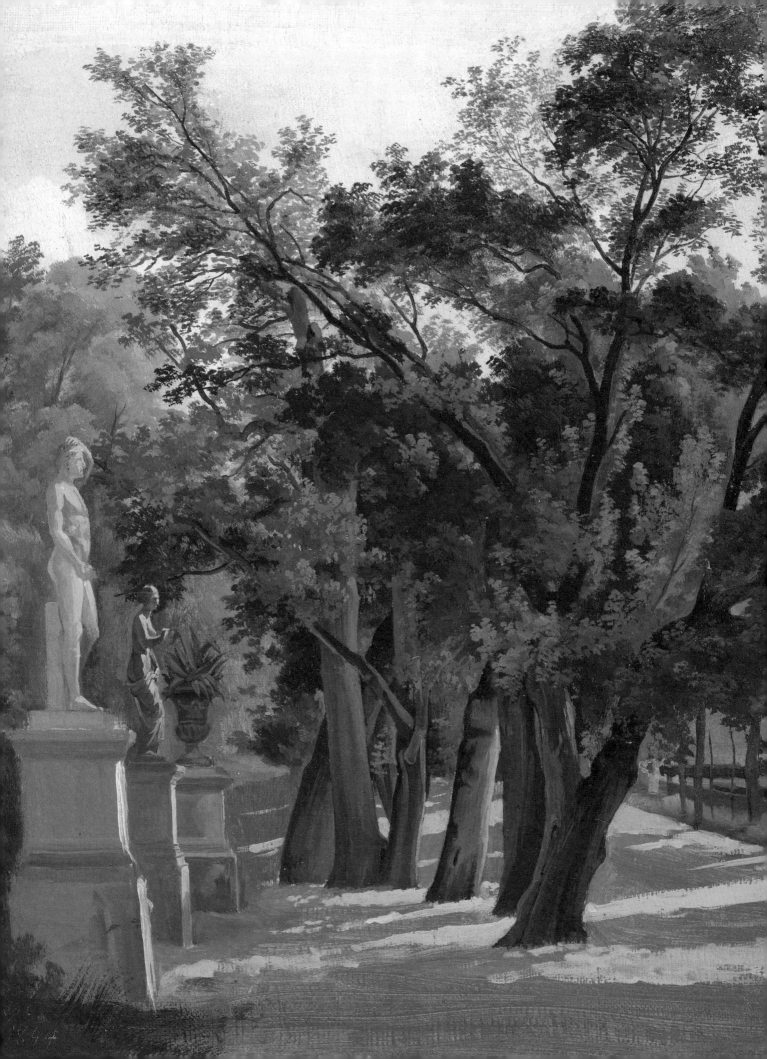

RUS IN URBE:
VILLAS, GARDENS & FOUNTAINS

CHARLES PERCIER

Paris 1764–1838 Paris

and

PIERRE-FRANÇOIS-LÉONARD FONTAINE

Pontoise 1762–1853 Paris

26 *Courtyard of the Villa Giulia,* before 1809

Pen and black ink, gray wash, over graphite

6¾ x 9¼ inches (171 x 235 mm)

Inscribed in cartouche on mat, *Percier et Fontaine / Cour de la Villa du Pape Jules III a Rome.*

Roberta J. M. Olson and Alexander B. V. Johnson

Percier and Fontaine are best known for their collaborative work as the official designers for Napoleon, in whose service they formulated what is known as the Empire style. The seeds of this style were sown in the Rome in the 1780s. Like other pensionnaires of the French Academy, Percier and Fontaine devoted their time to measuring and delineating Roman monuments considered to offer the best models for contemporary design. Unlike most of their predecessors, however, they emphasized the Renaissance rather than classical antiquity. The fruits of their study first appeared in 1798 with the publication of a selection of examples of modern (meaning postantique or Renaissance) domestic architecture: *Palais, maisons, et autres édifices modernes.*[1]

Eleven years later, encouraged by the success of that work, Percier and Fontaine brought out a second volume on Rome, this one devoted to its villas and gardens: *Choix des plus célèbres maisons de plaisance de Rome et de ses environs.*[2] Among the sites included in the book is the Villa Giulia, named after its builder, Pope Julius III (r. 1550–55). Situated just north of Rome off of the via Flaminia, it was a suburban villa, readily accessible for short stays. Designed by a committee of distinguished architects, including Jacomo Barozzi da Vignola, Bartolomeo Ammannati, and Giorgio Vasari, the Villa Giulia counts among the most celebrated examples of Renaissance villa design.[3] Within its exterior walls the visitor experiences a sequence of highly differentiated spaces visually linked along the axis of entry. The largest of these spaces is the courtyard depicted in Percier and Fontaine's drawing, which corresponds to plate 49 of the *Choix* (Fig. 1).[4]

The brightly illuminated semicircular courtyard is viewed from the shadowy interior of an annular portico. The barrel vault

FIG. 1. Charles Percier and Pierre-François-Léonard Fontaine, *Courtyard of the Villa Giulia,* Avery Library of Architecture and Art History, Columbia University, New York

of this portico is covered with illusionistic frescoes depicting a vine trellis populated by exotic birds. Ionic columns supporting the vault provide a theatrical screen that frames views out to the courtyard, where figures in nineteenth-century Roman costume play music and dance. Within the shady confines of the corridor, gesturing figures watch the performance.

At the time *Choix des plus célèbres maisons* was published, Percier and Fontaine strived to achieve a unified style that makes it difficult to differentiate their respective hands. The composition of the sheet unquestionably results from their artistic collaboration. Comparisons to autograph works by Percier suggest that he is largely responsible for the execution of the present drawing.[5]

The architectural and decorative work of Percier and Fontaine generally, and their two books on Roman Renaissance monuments in particular, exerted a powerful influence that extended from French domestic architecture during the first decades of the nineteenth century to the American "Renaissance" in the last.[6] Their student Paul Marie Letarouilly followed their lead and employed their precise use of line in his multivolume *Édifices de Rome moderne*, which began to be issued in 1825 (see No. 1). Percier and Fontaine's accurate renderings of Renaissance villas and gardens, many of which have either been altered or lost over the course of the two centuries following their publication, remain an invaluable source for historians of architecture and landscape design.

CHRISTOFFER W. ECKERSBERG
Blaalrog, southern Jutland 1783–1853 Copenhagen

27 *The Church of SS. Giovanni e Paolo Seen from the Villa Casali*, 1815

Graphite

13 x 19¹⁄₁₆ inches (330 x 485 mm)

Signed and dated in graphite at lower right, *D. 6 Martii 1815—Eckersberg*; inscribed in pen and black ink at lower center, *Et Partie af St. Giovani et Paul—taget fra Villa Casale.*

The Morgan Library & Museum, Thaw Collection

FIG. 1. Edward Lear, *Rome from the Gardens of SS. Giovanni e Paolo*, The Morgan Library & Museum, New York

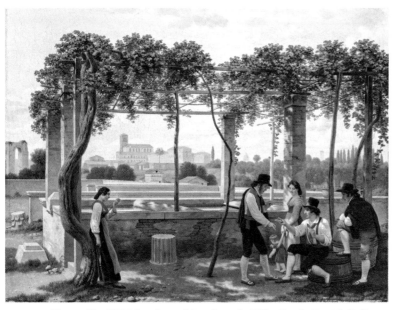

FIG. 2. Christoffer W. Eckersberg, *View from the Villa Casali*, David Collection, Copenhagen

Eckersberg studied painting before entering the Royal Danish Academy of Art in 1803. In 1809 he won the academy's gold medal, which included a travel grant. The young artist moved to Paris, where he frequented the atelier of Jacques-Louis David from 1811 to 1812. The following year Eckersberg traveled to Rome, remaining for three years. He lived on the via Sistina in the same house where his countryman, the sculptor Bertel Thorvaldsen (1770–1844), had resided since 1804.[1] Eckersberg was part of the circle of Danish artists in Rome around Thorvaldsen.[2] The precision of Eckersberg's drawing style recalls that of Ingres, but there is no evidence that the two artists ever met. Following his return to Denmark in 1816, Eckersberg took a position at the Academy of Art. His long tenure and numerous students contributed to his role as father of Danish painting.[3]

Eckersberg tended to avoid the familiar Roman monuments and sought out unusual subjects. This drawing of 1815 is a case in point. The inscription in the artist's hand identifies the site: the Villa Casali on the Caelian Hill, equidistant from the Colosseum and the Basilica of S. John Lateran. The villa and its gardens were swept away in 1885 when the site was given over to a military hospital.

In the foreground, a grape arbor provides a canopy for a laundry basin. Antiquities, including a fragment of a column shaft at center and an inverted Composite capital at the left, lean against the basin. The arbor frames a distant panorama beyond the parapet that bisects the composition horizontally. At the far left is a brick arch belonging to the branch of the Claudian aqueduct. The facade, Romanesque bell tower, and monastery of SS. Giovanni e Paolo appear at the center. At the right, the gardens of the monastery, built upon the massive substructures of the Temple of the Divine Claudius, extend toward the valley of the Colosseum. The cypresses at the far right are the same ones that appear in Edward Lear's view of 1841 (Fig. 1).

Nine years after making this drawing in Rome, Eckersberg used it as the basis for an oil painting he executed in Copenhagen, one of two pendant pictures commissioned by Mendel Levin Nathansen (Fig. 2). In the painting, the bare vine of the drawing has become a leafy bower, and six figures clad in characteristic Roman costume animate the foreground.

ACHILLE-ETNA MICHALLON

Paris 1796–1822 Paris

28 *The Ruin Folly of the Villa Borghese*, 1819

Brown wash, over graphite

10¾ x 8½ inches (273 x 216 mm)

Signed and dated in pen and brown ink at lower right, *Michallon / Rome 1819*.

Roberta J. M. Olson and Alexander B. V. Johnson

Michallon, a pensionnaire of the French Academy in Rome from 1818 to 1821, contributed to the revival of landscape painting (see No. 64). The French tradition of the classical landscape, extending back to the work of Poussin and Claude in the seventeenth century, had been revitalized by the plein-air painters of the eighteenth century, one of the last of whom was Michallon's master, Pierre-Henri de Valenciennes (see No. 60). Like his teacher, Michallon often sought out unusual points of view and subjects that did not figure among the celebrated monuments of Rome.

Such is the case with this view, set in the gardens of the Villa Borghese. The artfully contrived columns and pediment of a sham ruin frame a distant vista enriched by umbrella pines. On its outer face, this architectural folly carries an inscription identifying it as a temple dedicated to Antoninus and Faustina. Designed by Christopher Unterberger around 1790, it functions as the visual terminus of a long garden allée extending up to the entrance to the Giardino del Lago, a feature depicted by Gustav Wilhelm Palm (see No. 29).

While most artists chose to represent the temple facade from the allée, Michallon assumed a different perspective, from the shady bower behind its architectural frontispiece (Fig. 1).[1] As a painter specializing in historical landscapes, Michallon was particularly sensitive to the relationship between nature and classical architecture. He no doubt recognized those portions of the Villa Borghese laid out in the 1780s in the new picturesque style as three-dimensional, living counterparts to his ideal painted landscapes.

Within two years of Michallon's sketch, the American travel writer Theodore Dwight commented on the associations of the Villa Borghese folly:

FIG. 1. *Ruin Folly of the Villa Borghese*

> *These tall pillars and their ponderous frieze had probably been transported from some distant ruins, but at a little distance they seemed to mark the site of some ancient temple of some magnificence; and while we rambled about these delightful grounds, enjoying the warmth and serenity of the weather, they suddenly made their appearance from time to time, to call the mind to sublime ideas of the period which produced them, and of the ages that have since come and passed away.*[2]

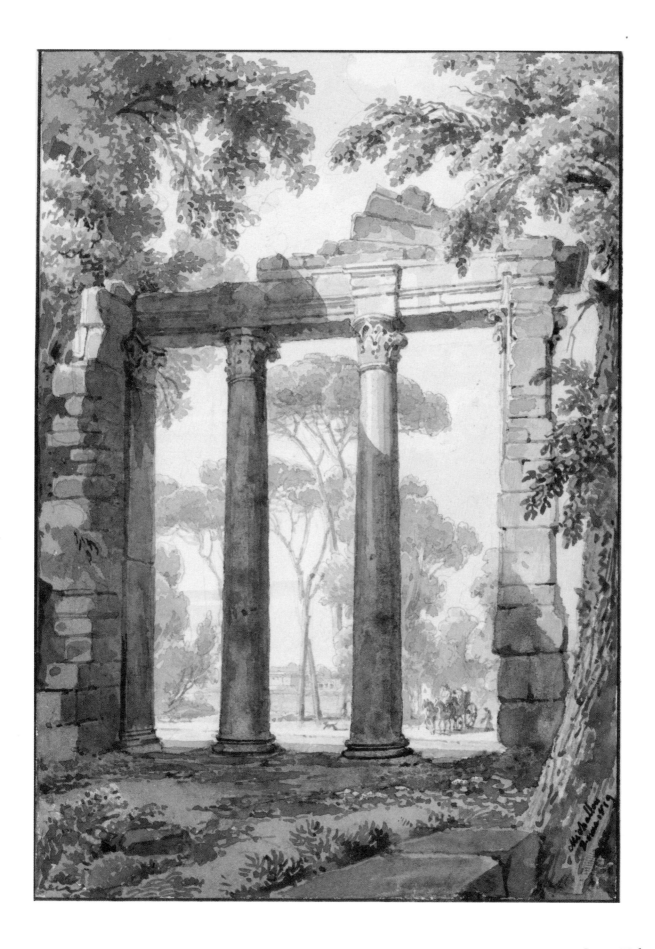

GUSTAV WILHELM PALM
Christiania 1810–1890 Stockholm

29 *Entrance to the Giardino del Lago, Villa Borghese, Rome*, 1844

Oil on paper, mounted to canvas
13 x 18⅛ inches (330 x 440 mm)
Inscribed and dated at lower left (incised into paint), *Villa Borghese / 1844.*

Thaw Collection, jointly owned by the Metropolitan Museum of Art and the Morgan Library & Museum, gift of Eugene V. Thaw, 2009; 2009.400:91

After studying at the Royal Academy of Fine Arts, Stockholm, Palm spent a year in Berlin and two years in Vienna before traveling to Italy in 1840. For eleven years he was based in Rome, often depicting sites in its vicinity, particularly the hill towns to the east. He repeatedly passed his summers in Genazzano and Subiaco, painting the surrounding mountainous landscape. Well over a thousand drawings, watercolors, and oil sketches in the collection of the Nationalmuseum in Stockholm attest to his productivity.

This view depicts an allée in the Villa Borghese, one of the great suburban villas originally laid out in the seventeenth century. Palm returned to the villa often to paint. Among his numerous oil sketches in Stockholm is one dated 1846 representing another feature of the villa, the so-called Piazza di Siena.[1] Like the present oil sketch, it is signed and dated with the butt end of the brush at the lower left. Another of Palm's oil sketches, undated but close in date to the others, depicts the sustaining wall to the south of the Giardino del Lago, containing the so-called Portico dei Leoni.[2]

Between 1784 and 1790, Prince Marcantonio Borghese commissioned Marco and Antonio Asprucci to lay out an extensive portion of the parkland surrounding the villa proper. In the course of this work, the design became increasingly picturesque, reflecting direct knowledge of the English landscape garden tradition. This expertise was provided by Jacob More (1740–1793), a Scottish landscape painter who consulted on the design.

FIG. 1. *Entrance to the Giardino del Lago in the Villa Borghese*

Other artists and architects also participated in the elaboration of the park, notably Christopher Unterberger (1732–1798), an Italian painter who designed the ruin folly masquerading as a Temple of Antoninus and Faustina. The garden temple, which incorporates genuine ancient fragments, provides the visual terminus of the allée visible in Palm's oil sketch (see No. 28). Prince Marcantonio enriched the new gardens with numerous ancient statues, several of which are visible to the left of the ilex trees in the painting. In 1854 the statue plinths were

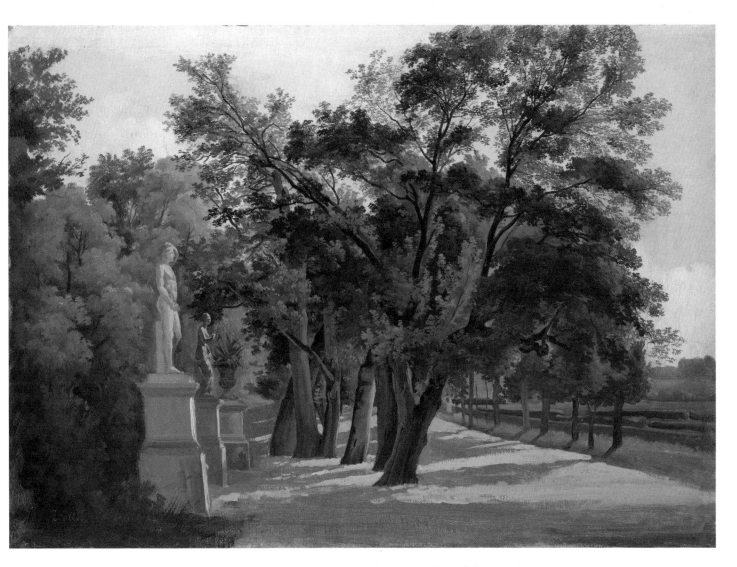

linked by an iron fence to form the eastern boundary of the Giardino del Lago (Fig. 1).[3] Passing between
the statues, the visitor enters the enclosed garden, the visual climax of which is a picturesque Temple of
Aesculapius dominating the irregular lake from which the garden takes its name.

The Scottish traveler Joseph Forsyth, writing in 1802, remarked on the accessibility of the park: "What
English Villa is open, like the Borghese, as a common drive to the whole metropolis?"[4] Nathaniel Haw-
thorne frequently visited the Villa Borghese, which provides the setting for a scene in *The Marble Faun:*
"These wooded and flowery lawns are more beautiful than the finest of English park-scenery, more touch-
ing, more impressive, through the neglect that leaves Nature so much to her own ways and methods."[5]

ALFRED-NICOLAS NORMAND

Paris 1822–1909 Paris

30 *Statue of the Goddess Roma in the Gardens of the Villa Medici*, 1851

Salt print from a waxed paper negative

8¼ x 6¾ inches (210 x 171 mm)

Collection W. Bruce and Delaney H. Lundberg

The son of an architect, Normand entered the École des Beaux-Arts at the age of twenty and won the Prix de Rome in 1846.[1] The following year, Normand took up residence at the Villa Medici, remaining in Rome until 1852. As an architect, he was required to produce sets of highly finished measured drawings of Roman monuments, represented both in their ruined and reconstructed states. These were called *envois* because they were sent to Paris for exhibition. The subject of Normand's 1851 *envois* was the Roman Forum, specifically the group of monuments situated below the Capitoline Hill.[2] Following his return to France, Normand began a successful career as an architect and inspector of public works in Paris. There he would work with his friend and fellow pensionnaire Charles Garnier, who designed the Paris Opera House.

Normand's circle of friends in Rome also included early photographers, among them Flachéron, Eugène Constant, and others who gathered at the Caffè Greco. In a letter of 1851 to his parents, Normand mentioned having taken photographic views of Rome.[3] He also referred to prints he and a friend made from negatives taken by two travelers in Egypt. It is likely that the friend who instructed Normand in photography was Constant and that the two travelers were Gustave Flaubert and Maxime Du Camp, who passed through Rome on their return from Egypt.

Twelve different views of Rome by Normand survive. Several represent the Roman Forum, suggesting that the architect may have used them in preparing his archaeological drawings. The soft focus and grainy quality of his prints produce remarkably atmospheric and painterly effects worthy of comparison with the nearly contemporary sketches of Degas (No. 31). The Villa Medici and its gardens appear frequently in Normand's photographs and constitute the largest single group of his images. Unlike Flachéron, who trained his lens on the architecture of the villa proper, Normand was more interested in the gardens, photographing the allées, fountains, parterres, and ancient sculpture displayed within its shaded confines.

The colossal statue of the goddess Roma figures in three of Normand's photographs. This ancient statue had been acquired by Cardinal Ippolito II d'Este for his sculpture garden on the Quirinal Hill soon after its discovery in the mid-sixteenth century.[4] It subsequently passed to Cardinal Ferdinando de Medici as a gift from Pope Gregory XIII. In Normand's day, the heavily restored statue of the seated goddess was situated on the central axis of the garden, directly in front of the garden facade of the villa.[5] This placement, against the parapet that separates the grounds of the Villa Medici from those of the Villa Borghese to the east, ensured that the statue was viewed silhouetted against the sky. In this image, Normand chose a three-quarter view that shows the right arm of the statue in profile.[6] In the foreground, the pensive figure of a seated man replicates the pose of the gigantic goddess, whose left hand appears to hold the umbrella pine sheltering them both from the sun.

EDGAR DEGAS
Paris 1834–1917 Paris

31 *View of the Villa Borghese from the Gardens of the Villa Medici,* 1857

Graphite on paper in a small memorandum book
4⅝ x 5¼ inches (117 x 133 mm)
Color notations on sketch, from top to bottom, *bleu incertain / violacé / bleu gris*; below the horizon, *neige*; at bottom, *vert passé* and *en lumière tout*; above sketch, *Villa Médicis devant la Villa Borghese—6 h[eures] 6 fév[rier 1857]*. At top of page, *toute la campagne dans la demi teinte / quelques lumières sur les maisons du 2e plan à / droite. Celles de gauche en silhouette.*

The Morgan Library & Museum, purchased by the Board of Trustees of the Morgan Library & Museum in honor of Mr. and Mrs. Eugene Victor Thaw; 1985.47, fol. 36 verso

Degas arrived in Italy in 1856, fresh from having executed drawings after masterpieces of painting and sculpture in the Louvre. A year earlier, the youthful artist—he was twenty-one at the time—had met Ingres, who encouraged firsthand study of Italian art. Family ties also drew Degas to Italy; he had relatives living in Naples and Florence. Half of his three years in Italy—between 1856 and 1859—was spent in Rome.

The sketchbooks Degas carried with him provide precious information about his artistic formation during this period. Thirty-seven of the artist's sketchbooks survive.[1] Their contents are essentially private and practical and span over three decades (1853–86) from his youth to maturity.

The Morgan sketchbook covers the period October 1856 to July 1857, when Degas was in Rome. Among numerous figure studies and copies after works of art are several sketches of Roman monuments, including a view of the Roman Forum looking toward the Capitol. The small size of the sketchbook, the summary quality of the drawings, and Degas's notations jotted down as aides-mémoires produce an effect of great immediacy.

Degas's view over the gardens of the Villa Medici to the Villa Borghese beyond is precisely dated: 6:00 p.m. on 6 February 1857. It is one of two such views; the other was made one hour earlier. The composition consists of three tightly compressed horizontal planes: the foreground (corresponding to the formal garden of the Villa Medici), the middle ground (depicting the Villa Borghese beyond the parapet), and the background, defined by the undulating profile of the distant mountains. The elegant silhouettes of umbrella pines and cypress trees provide vertical accents that serve both to frame the composition and to bind it together.[2]

Half the sheet is given over to the artist's notations. Apart from recording the time and subject of the sketch, the notes provide a detailed record of fugitive effects of color and light. Similar notes appear on sketches Degas made near Tivoli, and it is worth noting that on the day of his departure from Rome in the summer of 1857 Degas recorded his impressions of the countryside around the Ponte Milvio. His attention to atmosphere would characterize his 1869 pastel landscapes of the Normandy coast and the monotypes of 1892–93.[3] Henry James considered the Villa Medici "perhaps on the whole the most enchanting place in Rome." His description of the gardens reveals a sensitivity to light and color similar to that of Degas:

> The part of the garden called the Boschetto has an incredible, impossible charm; an upper terrace, behind locked gates, covered with a little dusky forest of evergreen oaks. Such a dim light as of a fabled, haunted place, such a soft suffusion of tender grey-green tones, such a company of gnarled and twisted little miniature trunks—dwarfs playing with each other at being giants—and such a shower of golden sparkles drifting in from the vivid west![4]

toute la campagne dans la demi teinte.

quelques lumières sur les maisons du 2e plan à
l'Oeste. — cela de gauche en silhouette

Villa medecin devant la villa Borghese. 6hi 6 fin

bleu incertain

violacé

bleu gris

neige

très pâle en lumière bout

GUSTAVE LE GRAY
Villiers-le-Bel 1820–1884 Cairo
and
FIRMIN-EUGÈNE LE DIEN
Paris 1817–1865 Paris

32 *Bernini's Triton Fountain*, ca. 1852–53

Albumen print
9½ x 12¾ inches (241 x 324 mm)

Collection W. Bruce and Delaney H. Lundberg

Le Gray studied painting in the studio of Paul Delaroche (1797–1859), who was an early supporter of Daguerre and his invention.[1] Young artists training with Delaroche in the late 1830s likely would have seen their first photograph in his studio. Le Gray, like the painters of the Barbizon school, worked in the forest of Fontainebleau. His landscape photographs bear comparison to the work of Camille Corot, Théodore Rousseau, and others.[2] Le Gray was an active member of the Mission Héliographique, formed to document the architectural patrimony of France. He also invented the waxed-paper negative process, which enabled photographers to prepare their negatives before going out into the field.

Firmin-Eugène Le Dien is less well known than Le Gray, with whom he appears to have studied before traveling to Italy in 1852–53.[3] While in Rome, Le Dien lodged on the Salita di San Sebastianello and, using Le Gray's waxed-paper negative technique, took numerous photographs within its walls and the surrounding countryside. Upon his return to Paris, he began printing his calotypes with Le Gray, who had set up a photographic printing house.[4] Their photographs share a number of similarities, including a common interest in landscape and approaching a monument from a variety of different viewpoints, without figures.

Le Dien's view of Bernini's Triton Fountain is striking precisely for its unusual angle of vision, looking down from an upper-story window on the north side of the Piazza Barberini. Margaret Fuller would have enjoyed something very close to this perspective when she lived across the piazza from the Palazzo Barberini. The fictional protagonist of Hans Christian Andersen's *The Improvisatore* grew up on the same side of the piazza.[5]

Bernini's fountain was a popular subject for both artists and photographers, many of whom depicted the muscular torso of the Triton clad in layers of ice, which formed during occasional bouts of severe winter weather.[6] Robert Browning, writing in 1868–69, played on this image in his long narrative poem *The Ring and the Book:*

> *O' the Barberini by the Capuchins;*
> *Where the Old Triton, at his fountain-sport,*
> *Bernini's creature plated to the paps,*
> *Puffs up steel sleet which breaks to diamond dust,*
> *A spray of sparkles snorted from his conch,*
> *High over the caritellas, out o' the way*
> *O' the motley merchandizing multitude.[7]*

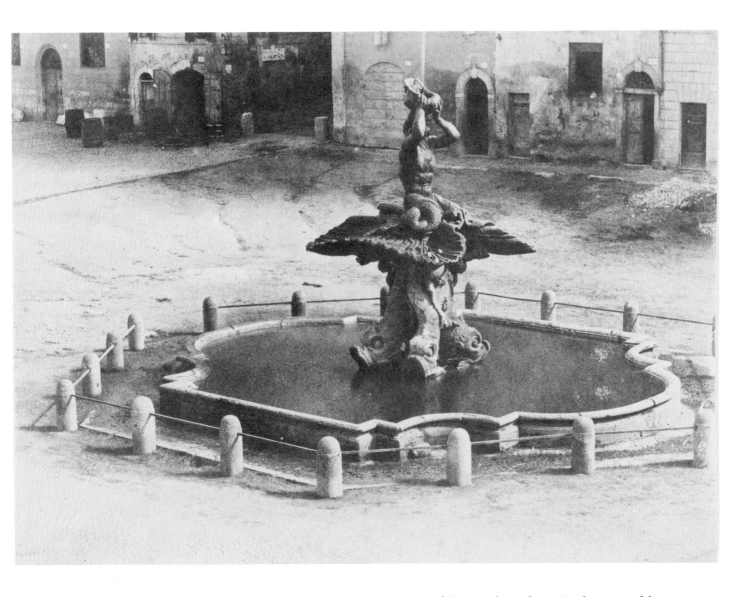

The Triton Fountain was designed to announce the presence of the nearby Palazzo Barberini and lay claim to the piazza, which, in the seventeenth century, was an enclave of the family. The heraldic bees of the family escutcheon face the Strada Felice (the modern via Sistina), the direction most traffic would have come from.[8] Le Dien's composition cuts off the Triton's tall water jet and provides only a tantalizing glimpse of the buildings defining the southern side of the piazza and the opening of the now vanished Colonnette di Barberini.[9]

Ruins of Mecenas's Villa & the Villa d'Este at Tivoli

MAGICK LAND

SIR WILLIAM GELL
Hopton 1717–1836 Naples

33 *Map of Rome and Its Environs*, 1834
Engraving
29 x 39 inches (737 x 991 mm)

Private collection

Gell began his topographical examination of classical sites with studies of Greece and Troy (see No. 46). He subsequently turned to Italy, paying particular attention to the remains of Pompeii and sites in the vicinity of Rome. Over a period of ten years, between 1822 and 1832, he devoted himself to the arduous survey work preparatory to an accurate map of the environs of Rome. Gell employed modern scientific instruments, including one of Matthew Berge's sextants, to produce the first map of the area based on the principles of triangulation. On many of these visits, he was accompanied by his Italian colleague Antonio Nibby, with whom he had earlier collaborated on a book devoted to Rome's ancient walls.[1]

Gell's map is oriented with north to the left, which allows the Apennine Mountains and the Tyrrhenian coast to serve as irregular borders at top and bottom, respectively. To the north the map is bounded by two prominent features, the Lago di Bracciano and Monte Soratte, while the Alban Hills and the coastal city of Anzio define its southern boundary. The valley of the Tiber roughly bisects the map, running through Rome at the center and emptying into the Mediterranean just past the ancient port of Ostia. The carefully rendered contour lines clearly define mountains and valleys, providing convincing topographical relief.

The publication of *The Topography of Rome and Its Vicinity* was supported by the Society of Dilettanti, with whom Gell maintained an extensive correspondence.[2] His map was accompanied by a two-volume gazetteer of the area's ancient remains. In the preface to this work, Gell explained his method, which involved climbing the mountain peaks surrounding Rome to take multiple bearings and carefully recording every feature:

> During the construction of the map, numberless expeditions were made to the summits of these mountains; and in every excursion, each eminence, rivulet, and bridge, were carefully noted, and every object of antiquity or topography examined; so that whatever is seen upon the Map, is the result of actual observation. Where the details were not investigated, the Map has been left blank.[3]

A few areas of the map are indeed designated in Latin *Regio non explorata* and *Regio non satis explorata*.

Gell also furnished illustrations for his text, again using modern instruments, in this case a camera lucida. Patented by William Wollaston in 1806, this device was a forerunner of the photographic camera, which would be introduced only three years after Gell's death. The archaeologist Andrew Wallace-Hadrill considers Gell a technological pioneer, "a topographer who mapped the area around Rome before modern cartography, and who documented antiquities accurately before modern photography."[4] In addition to advancing the study of classical archaeology, Gell's map also provided an accurate guide to artists and visitors interested in exploring the hinterland of Rome.[5]

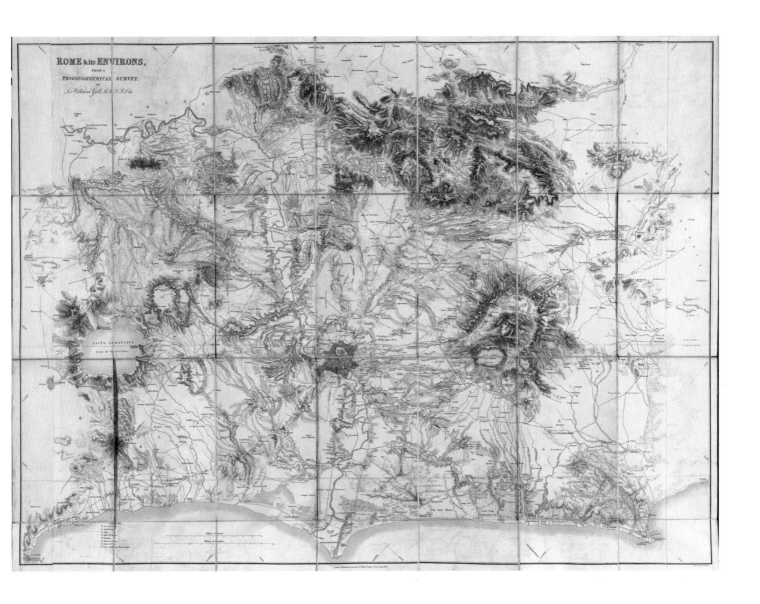

LOUIS-FRANÇOIS CASSAS
Azay-le-Ferron 1756–1827 Versailles

34 Landscape with Arch of Drusus

Pen and brown ink and watercolor, over black chalk
9⁷⁄₁₆ x 13¾ inches (240 x 348 mm)
Signed, dated, and inscribed by the artist in pen and brown ink at lower left, *L.F. Cassas f. 1778 a Rome.*

The Morgan Library & Museum, purchased by Pierpont Morgan, 1909; III, 112b

At the age of fifteen, Cassas became an apprentice draftsman with the Corps of Bridges and Roads (Ponts et Chaussées), where his father was employed as an artisan.[1] He subsequently studied with Jacques-Louis David's teacher, Joseph-Marie Vien.[2] In 1778 Cassas made his first trip to Rome, where he joined the group of artists providing illustrations for the Abbé de Saint Non's *Voyage pittoresque*. In the following years, Cassas traveled extensively throughout the Mediterranean basin, producing drawings and watercolors that provided the basis for richly illustrated publications. He followed in the footsteps of Wood and Dawkins, Stuart and Revett, and Robert Adam, whose sumptuous folio volumes had created a market for illustrated books on remote archaeological sites.[3] Cassas created a unique blend of archaeological site description with local color and dramatic reconstructions of ancient sites.

In 1782 Cassas made his way down the Dalmatian coast, devoting particular attention to the Palace of Diocletian at Split.[4] Three years later, he visited Egypt and the Holy Land.[5] The drawings he brought back from this trip greatly impressed Goethe when the two met in Rome.

The French architect Cassas had returned from his journey to the Orient with drawings of the places he visited. Some showed them as they are at present, destroyed or in ruins; in others, tracing with ink or in water colour, he graphically reconstructed them as they must originally have looked.[6]

Goethe provided a lengthy and detailed description of ten drawings by Cassas that particularly struck him, commenting on a view of Palmyra that "It was a happy idea to show a caravan passing through it." Goethe went on to record a walk on the Palatine he took that evening. The impression made by the artist's drawings clearly lingered. Of the sunset, Goethe wrote, "Drawn and coloured by someone with Cassas's taste, it would arouse universal enthusiasm."

The present work dates from early in the artist's first stay in Rome. The subject is an arch situated just inside the Porta San Sebastiano, the monumental gateway through which the Appian Way passes on its way out of the city. The association with Drusus is erroneous; antiquarians confused this arch on the via Appia with another no longer surviving but known from an ancient text. The lost arch honored Nero Claudius Drusus, father of the Emperor Claudius, for the victories he won over the Germans. The arch depicted by Cassas was erected much later, probably in A.D. 212, to embellish the arcade of the branch aqueduct that carried the waters of the Aqua Marcia over the via Appia to the Baths of Caracalla.

Cassas took liberties in depicting the setting of the arch. In his rendering, the Arch of Drusus stands isolated within an extensive landscape that suggests the open campagna beyond the city walls, while in reality it is tightly hemmed in by walls lining the last urban stretch of the Appian Way.

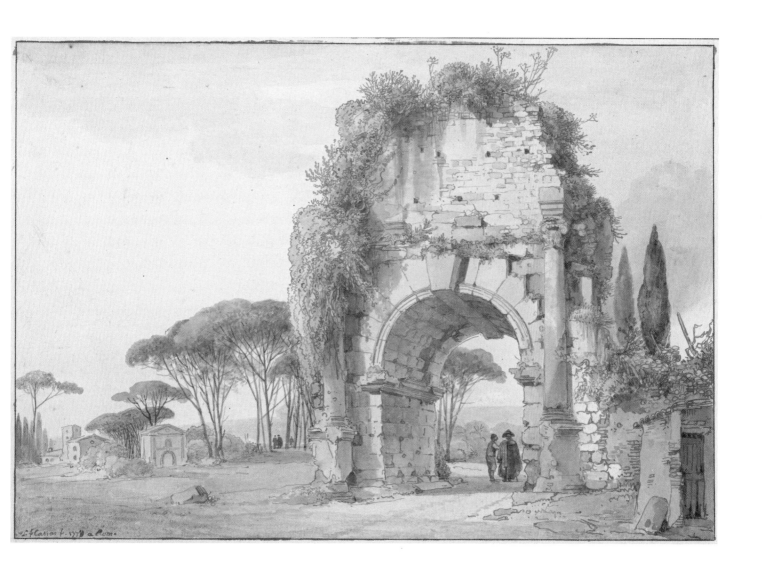

THOMAS JONES

Aberedw, Radnorshire, Wales 1742–1803 Penkerrig, Radnorshire

35 *View of the Villa of Maecenas at Tivoli and the Villa d'Este at Tivoli*, 1777
Watercolor, with gouache, over graphite
11½ x 16¹⁵⁄₁₆ inches (286 x 429 mm)
Inscribed in graphite at upper center, *Ruins of Mecenas's Villa & the Villa d'Este at Tivoli. T. Jones 1777;*
additional color notations.

The Morgan Library & Museum, purchased on the Sunny Crawford von Bülow Fund 1978; 1990.15

One of the great masters of classical landscape painting, Jones studied first with Henry Pars and then with Richard Wilson in London.[1] While in Italy in the early 1750s, Wilson had produced many landscape studies, including views of Tivoli, which he encouraged Jones to copy. Although Wilson's influence is evident in the work of his pupil, Jones employed different media and an unmediated directness in depicting nature that distinguishes him from his master.[2]

Jones arrived in Rome in 1776, where he resided until 1780, when he moved to Naples. His diary, known as the *Memoirs*, provides a remarkably direct and detailed account of his experience.[3] In the fall of 1777 Jones spent a week in Tivoli, during which he "went to see Mecaenas's Villa," the subject of this watercolor.[4] While in Tivoli, he met up with Giacomo Quarenghi, the architect who would later serve Catherine the Great, Empress of Russia (see No. 6). "Attended by our Cicerone with a basket of provisions" they sketched at Hadrian's Villa.[5] Such expeditions illustrate how sites such as Tivoli and Hadrian's Villa functioned as venues of artistic exchange.

As early as the seventeenth century, artists such as Claude Lorrain came to Tivoli in order to depict the picturesque combination of natural beauty and classical ruins, what Jones poetically termed "Magick Land."[6] The so-called Villa of Maecenas, an imposing complex of ruins traditionally associated with the patron of Horace and Virgil, was not correctly identified as the Sanctuary of Hercules Victor until 1849. The sanctuary, dating from the middle of the first century B.C., also appears in other compositions by Jones as well as in views by Robert Macpherson and Edward Lear (Nos. 36 and 38).[7]

Beyond the Villa of Maecenas, at the base of the bell tower silhouetted against the sky, is the Villa d'Este. In the 1560s, the cardinal of Ferrara, Ippolito II d'Este, laid out one of the great water gardens of the Renaissance. The cardinal's engineers diverted a portion of the Anio River to supply the numerous fountains within the gardens. After plunging over the falls closer to town, the Anio passes through the valley dominated by the Villa of Maecenas. A minor cascade (the so-called *Cascatelle*) appears to issue from the base of the villa. The potent combination of nature and antiquity drew many artists and writers to the site. Charlotte Eaton's 1817–18 description of this view corresponds closely to Jones's composition:

> The remains [of the Villa of Maecenas] are very extensive, and the situation singularly fine. It stands on the
> highest ridge of the height, overlooking, on one side, the far-extended plains of the Campagna, with Rome in the
> distance, bounded by purple mountains; and on the other, the deep romantic dell of the rushing river, with all its
> waterfalls, its woods, its rocks, its ruins, and its caves.[8]

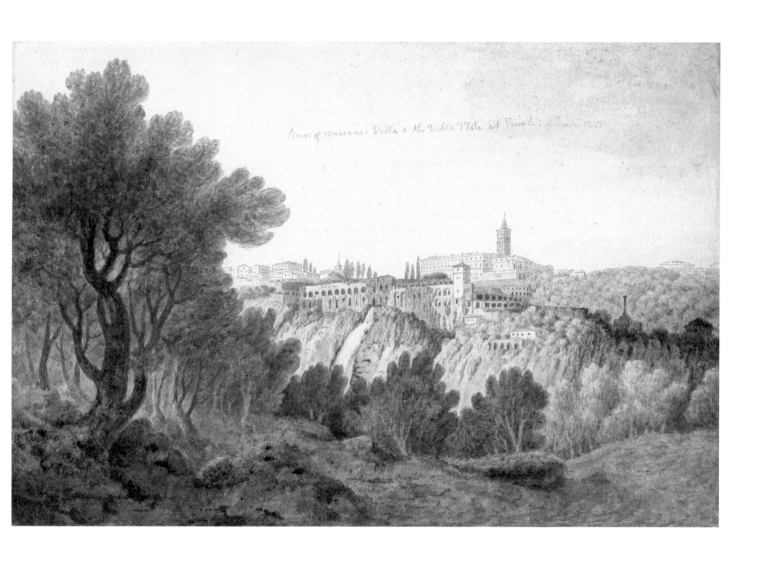

Ruin of Mecenas's Villa & the Villa d'Este at Tivoli. 1785

ROBERT TURNBULL MACPHERSON

Dalkeith 1814–1872 Rome

36 *Panorama of Tivoli and the Falls of the Anio River,* before 1858

Albumen print

11¾ x 15⅓ inches (297 x 391 mm)

Collection W. Bruce and Delaney H. Lundberg

As a young man, Macpherson gave up the study of medicine to pursue painting at the Scottish Royal Academy in Edinburgh. In 1841 he traveled to Rome, where he cut a picturesque figure, occasionally wearing a kilt and playing bagpipes. After a decade working without notable success as a painter and trying his hand in the antiquarian trade, he turned to photography. Macpherson operated out of a series of studios in the area of the Spanish Steps and frequented the Caffè Greco. His social circle was extensive, including William Makepeace Thackeray and William Wetmore Story. He was active in promoting his photographic practice, placing advertisements in guidebooks and local newspapers and periodically publishing lists of his subjects, one of which appears in this exhibition (No. 57). The last list, issued the year before his death, catalogues 421 images.

The present panorama appears in the first of Macpherson's lists, dated 1858.[1] Its oval format and wide-angle perspective combine to render a spectacular image. The point of view is carefully chosen to include both the major and minor cascades as well as the river itself. The so-called Villa of Maecenas is seen in silhouette above the *Cascatelle,* with the campagna extending to Rome at the far right. The lengthy exposure of Macpherson's photographic plate, evident in the opaque, brilliant white highlights of the waterfalls, also captures a rich gradation of textures—from the lush foliage to the rough masonry and tile roofs of the architectural elements.

Macpherson depicted several of the features recorded by Lear in his drawing of Tivoli (No. 38), but from a different perspective. In order to anchor his composition with the large falls in the left foreground and maximize the sense of spatial recession, Macpherson set up his camera on a bluff to the northeast of town. From this angle, the diagonal slope of the hillside leads the eye into the distance with the same authority evident in earlier landscape compositions by Claude Lorrain, Nicolas Poussin, and Richard Wilson. Augustus Hare's description mentions many details captured by Macpherson's lens:

> *On the opposite height rises the town with its temples, its old houses and churches, clinging to the edge of the cliffs, which are overhung with such a wealth of luxuriant vegetation as is almost indescribable; and beyond, beneath the huge piles of building known as the Villa of Maecenas, the thousand noisy cataracts of the Cascatelle leap forth beneath the old masonry, and sparkle and dance and foam through the green—all this is only the foreground to vast distances of dreamy campagna seen through the gnarled hoary stems of grand old olive trees—rainbow-hued with every delicate tint of emerald and amethyst, and melting into sapphire, where the solitary dome of S. Peter's rises, invincible by distance, over the level line of the horizon.*[2]

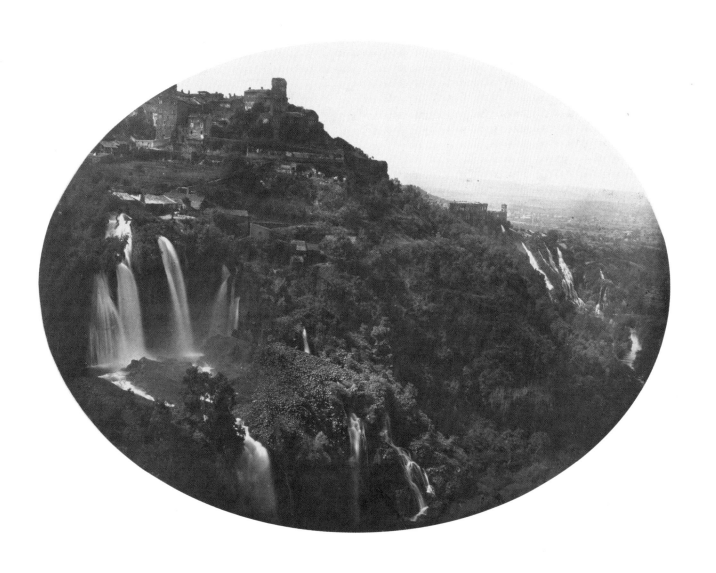

LUIGI ROSSINI

Ravenna 1790–1857 Rome

37 The Serapeum at Hadrian's Villa

Pen and brown-black ink, with brown wash, over graphite, on three joined sheets of paper
20¹⁄₁₆ x 28⁵⁄₁₆ inches (510 x 719 mm)

The Morgan Library & Museum, purchased by Pierpont Morgan, 1906; 1966.13, fol. 34

Born in Ravenna and trained in architecture in Bologna, Rossini came to Rome in 1814, the year papal rule was restored following the collapse of the Napoleonic occupation.[1] From the outset of his career, Rossini was mindful of Piranesi's legacy; the title of his first major series of large-scale prints, *Le antichità romane*, acknowledges the great work of the same title published by his illustrious predecessor in 1756.[2] In 1826 Rossini published the second volume of his study devoted to archaeological sites in the vicinity of Rome. The volume contains nine views of Hadrian's Villa below Tivoli, including one for which this drawing is preparatory (Fig. 1).[3] Rossini adapted the composition of one of Piranesi's *Vedute di Roma* with only minor adjustments.[4] Significantly, Rossini muted Piranesi's dramatic chiaroscuro effects, aiming instead for a more balanced range of tonalities that results in a more clear and distinct—if less spectacular—image.

Rossini's drawing depicts the interior of a monumental dining pavilion, or *triclinium*, at Hadrian's Villa.[5] Since the Renaissance, this feature has been identified as the Canopus or Serapeum, references to an ancient shrine to the Egyptian god Serapis situated along a canal running between Alexandria and Canopus. The temple was one of several celebrated monuments of the Greco-Roman world mentioned in a late antique biography of the emperor Hadrian and associated with his Tiburtine villa.[6]

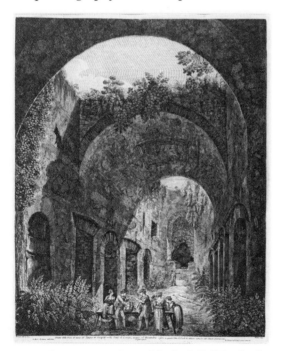

FIG. 1. Luigi Rossini, *View of the So-Called Temple of Canopus at Hadrian's Villa*, private collection

The album containing this drawing, one of two in the collection of the Morgan, gathers sixty-one preparatory studies for his 1826 publication on ancient sites near Rome.[7] It is immediately evident that the figures grouped in the fore and middle ground were only summarily sketched in. This is because Rossini worked closely with Bartolomeo Pinelli, who was responsible for providing the figures that appear in many of his finished plates (see No. 49).[8] Although Pinelli's figures play nearly identical compositional roles to those of Piranesi, their appearance and actions are worlds apart. In place of Piranesi's attenuated figures whose dramatic gestures recall the theatre, Pinelli introduced sturdy peasants solidly grounded in reality. The group occupying the foreground in the print corresponding to this drawing includes two men engaged in the game of morra, a hand game dating back to classical antiquity, and closely resembles one of Pinelli's own compositions.[9]

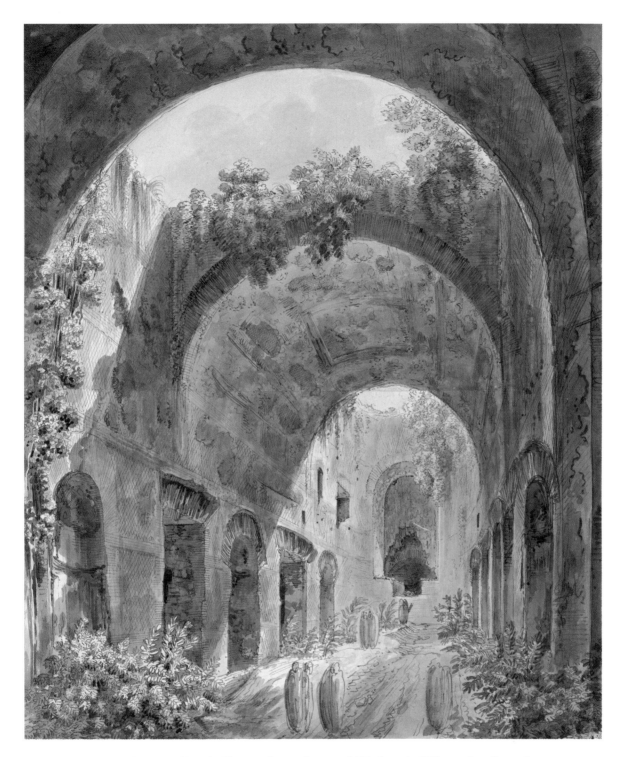

In 1803 François-Auguste-René Chateaubriand visited Hadrian's Villa and reflected on its ruins, including the Serapeum:

There is indeed a double vanity in the remains of the Villa Adriana: for it is known that they were only imitations of other remains, scattered through the provinces of the Roman empire. The real temple of Serapis and Alexandria, and the real academy at Athens no longer exist; so that in the copies of Hadrian you only see the ruins of ruins.[10]

EDWARD LEAR

Holloway, London, 1812–1888 San Remo

38 *Panoramic View of Tivoli, with Group of Peasants in Foreground,* 1839

Black chalk, heightened with white tempera, over preliminary indications in red chalk, on gray wove paper

11⅜ x 17⁵⁄₁₆ inches (291 x 441 mm)

Inscribed in black chalk at lower left, *Tivoli*; signed and dated at lower right, *Edward Lear del. / 1839.*

The Morgan Library & Museum, Thaw Collection; 1972.12

Renowned as the author of "The Owl and the Pussycat" and other nonsense verse, Lear was also an accomplished landscape artist, producing thousands of sketches and watercolors over a period of five decades. Indeed, as a topographical artist he is unsurpassed. Many of his drawings were subsequently used to produce lithographs that were issued as illustrated travel volumes. For a decade, Lear devoted himself to Italy, before moving on to Greece and the Levant.

Lear arrived in Rome on 3 December 1837, lodging at via del Babuino, 39, in the heart of the artists' quarter. Almost immediately, he began to make forays into the mountainous country to the east of Rome and depicted Tivoli in the spring and fall of the following year.[1] Lear returned to Tivoli in 1839, when he executed the present drawing. He later adapted it for one of the lithographs in his *Views of Rome and Its Environs,* the first of his travel books, which was published in 1841 (Fig. 1).[2]

The town, framed by an olive grove, is viewed at a distance, from the northwest. A group of peasants anchors the foreground, which slopes steeply down to the valley of the Anio. One woman balances a *conca,* a copper amphora for carrying water characteristic of the Ciociara region, on her head. In the distance, on the opposite bank, the medieval town enfolds the serried ranks of dark cypresses that occupy the terraces of the Villa D'Este. Below and to the left of the villa are the picturesque ruins that were called the Villa of Maecenas in the nineteenth century and today are identified as the Sanctuary of Hercules Victor (see No. 35). To the right, the fourth-century A.D. mausoleum known popularly as the Tempio delle Tosse

FIG. 1. Edward Lear, *View of Tivoli,* The Morgan Library & Museum, New York

is clearly visible. Other features of the town can be identified, such as the cylindrical towers of the castle dominating the summit of the hill at the right. The most impressive natural feature, the minor falls of the Anio known as the *Cascatelle,* are hidden by the trees below the Villa of Maecenas.

The combination of natural beauty and antiquity had long attracted artists to Tivoli, notably Claude Lorrain in the seventeenth

century. A passage in Augustus Hare's *Days Near Rome,* written over three decades after Lear depicted Tivoli, captures many of the features recorded by the artist, including the olive groves and the peasant women with their *conche:*

> And the beauty is not confined to the views alone. Each turn of the winding road is a picture; deep ravines of
> solemn dark-green olives which waken into silver light as the wind shakes their leaves … and peopled by groups
> of peasants in their gay dresses returning from their work … or returning with brazen conche poised upon their
> heads like stately statues of water-goddesses wakened into life.[3]

EDWARD LEAR
Holloway, London, 1812–1888 San Remo

39 Ruins of the Villa Sette Bassi, near Rome, ca. 1838–45
Watercolor, with pen and brown ink, over graphite
6¾ x 9 inches (171 x 230 mm)
Inscribed in pen and brown ink at lower left [partly cut off], *…ma Vecchia. (Sette bassi) / …April 3, …*

Private collection

In the decade following his arrival in Rome at the end of 1837, Lear took numerous sketching trips in the area of the Roman campagna. This view of the extensive ruins of the Villa Sette Bassi is similar in style to other autograph watercolors made in the late 1830s and early 1840s. The collection of over 3,500 Lear drawings at the Houghton Library, Harvard University, includes several revealing comparisons. The rendering of the clouds and the precise representation of the masonry patterns closely resemble those on two sheets, one depicting the Temple of Venus and Rome and the other the Ponte Nomentano.[1] The ink inscription is strikingly similar to the notations on a series of drawings Lear made in April 1845.[2]

The Villa Sette Bassi is situated southeast of Rome, about five miles along the ancient via Latina, within sight of the imposing arcade of the Claudian Aqueduct. One of the largest and best preserved imperial luxury villas in the vicinity of Rome, Sette Bassi dates from the middle of the second century A.D.[3] In antiquity it was supplied with water from the main line by means of a branch aqueduct, which terminated in a cistern, both of which are visible at the right of Lear's composition. Since the later Middle Ages, the site has been known by two names, both of which appear in Lear's inscription: *Roma Vecchia* and *Sette Bassi*, the latter a corruption of Septimius Bassus, the presumed owner.

The left of Lear's composition is anchored by the well-preserved walls of one of the three distinct complexes comprising the villa. The artist accurately recorded the villa's richly textured masonry structure: squares of volcanic stone (tufa) laid in a reticulate pattern, alternating with horizontal courses of brick. In the distance the gently curving profile of Monte Cavo, the most prominent peak of the Alban Hills, dominates the surrounding campagna. Lear's landscape is an idealized composite of several perspectives, but his principal viewpoint, southwest of the main complex of ruins, can be identified (Fig. 1).

FIG. 1. *View of the Villa Sette Bassi*

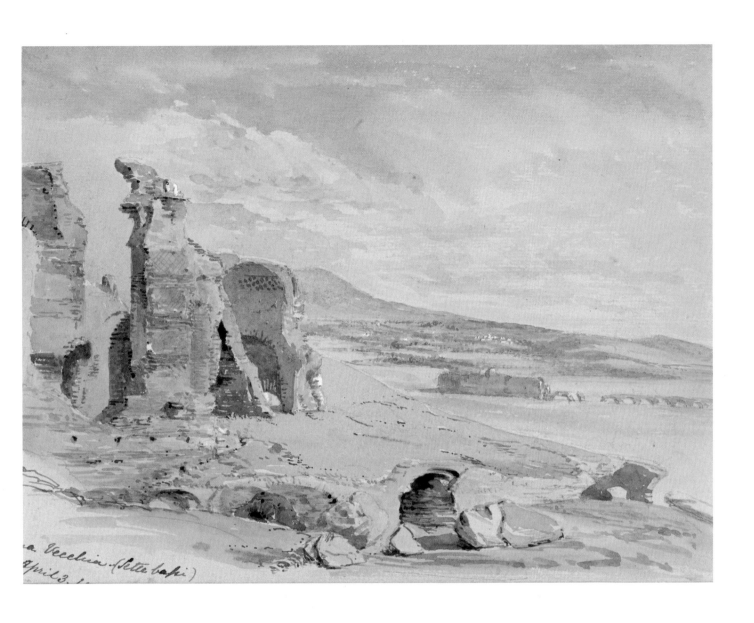

a Vecchia (Sette bassi)
April 3.

FRANÇOIS-MARIUS GRANET

Aix-en-Provence 1775–1849 Aix-en-Provence

40 *Dusk, Monte Mario, Rome,* 1804

Oil on paper, mounted to cardboard

8 x 12½ inches (203 x 311 mm)

Artist's signature in brown ink on label affixed at upper right, *Granet*; on paper affixed to verso, a red wax seal with impression of a painter's palette, inscribed, *Etude par Granet / Rome-1804 / provenant du legs fait à Bin Martin. Art. Peintre / Testament du 16 9bre. 1849. N.re Aude a Aix / Malavallat. 1895 / Gin Martin.*

Thaw Collection, jointly owned by the Metropolitan Museum of Art and the Morgan Library & Museum, gift of Eugene V. Thaw, 2009; 2009.400:70

The son of a mason, Granet studied in Aix with the painter Jean-Antoine Constantin, who had recently returned from Rome. Granet then moved to Paris, where he gravitated to the atelier of Jacques-Louis David (see No. 4). In 1802 the young artist traveled to Rome with his childhood friend and patron, the Comte Auguste de Forbin. Deeply impressed by this first visit, Granet returned to Rome the following year, residing there for nearly two decades. His residence coincided with the lengthy sojourn of Ingres, who painted his portrait in 1807. In 1824, Granet returned to France, where, two years later, his friend Forbin appointed him curator of the Louvre.[1]

During his time in Rome, Granet produced an extraordinary body of work that ranks among any era's great artistic responses to the Eternal City. Granet's powers of observation were extraordinary, but his depictions of Roman subjects invariably take the viewer beyond topographical exactitude to an artistic realm in which Rome's very atmosphere is captured and distilled. This is particularly evident in this small oil sketch, produced when the artist was twenty-nine years old. Granet's subject, the Monte Mario, rises from the floodplain of the Tiber north of the Vatican. Its unmistakable profile closed the view to the northeast from the Villa Medici on the Pincio and was beloved by landscape painters, such as Nicolas-Didier Boguet.[2] Granet depicted the Monte Mario on a number of occasions, including another study of it set against a stormy sky.[3]

Granet's brilliant command of silhouette bears comparison with Rembrandt's landscapes. He confidently molded the billowing profile of an umbrella pine and the rounded shafts of cypress trees with single brushstrokes. Moreover, these silhouettes appear animated by a breeze that carries with it the clouds advancing on the city from the sea to the west. The bright band of sky closest to the horizon captures the lingering effects of the sun after it has set, highlighting dissonances of tone and color. Granet clearly took to heart the advice of Valenciennes, who encouraged painters to study storms. Corot's early Italian work shows an awareness of Granet's concern for atmospheric effects.

Granet's direct engagement with natural forces in this oil sketch recalls the artist's comments on the campagna in his *Memoirs,* in which he has nature directly address the painter: "Here I am in all my simplicity; if you want to do something that resembles me, think like an innocent and observe me closely."[4] Granet's observation, linking nature and simplicity, calls to mind Goethe's earlier remarks on the enduring value of nature and truth:

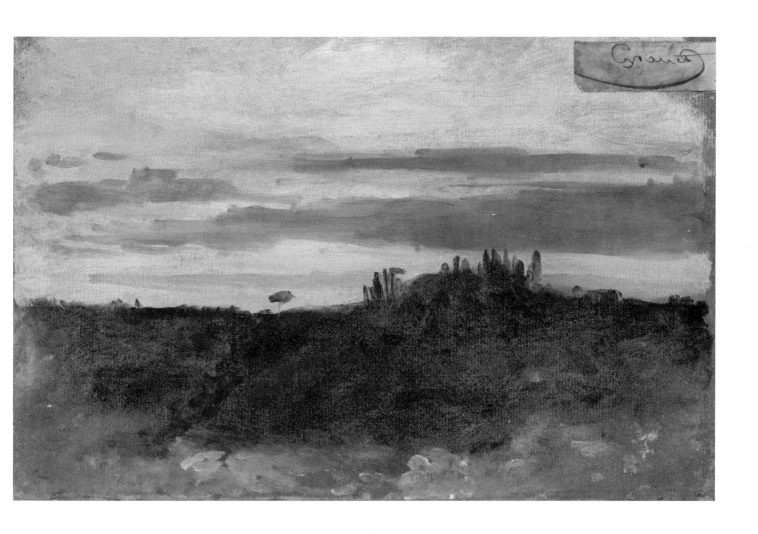

I again felt that I am too old for anything but truth. Rites, operas, processions, ballets, they all run off me like water off a duck's back. But an operation of nature, like the sunset seen from the Villa Madama, or a work of art, like my revered Juno, leaves a deep and lasting impression.[5]

JAMES ANDERSON
Blencarn 1813–1877 Rome

41 *The Arch of Nero*, ca. 1867
Albumen print
11⅛ x 14½ inches (282 x 366 mm)

Collection W. Bruce and Delaney H. Lundberg

Two lines of ancient aqueducts converge in a valley just over a mile beyond Tivoli. The larger of the two arches, popularly known as the Arch of Nero, carried the Anio Novus; the smaller arch framed by it carried the Aqua Marcia.[1] The picturesque composition of the ruined arcades, enriched by a crumbling medieval tower perched atop the Anio Novus, was a favorite with artists; Thomas Cole, George Inness, and Sanford Gifford, among others, depicted it.

Charlotte Eaton responded to the associations and dramatic scenery of the site.

> *Here the noble arches of the Aqueduct of Claudius, thrown over the river and the road, built of immense blocks of Tiburtine stone, overgrown with ivy and wild brushwood; the lower and still more ancient arches immediately behind them, on top of which stands a ruined gothic tower, the remains of bloody feudal wars; the river rushing amid rocks and crossed by a rustic bridge, forming a most piquant contrast to the stupendous arch of the great aqueduct, which also spans its bed; the road passing beneath another of its arches; the dark ivy, the ruined tower, the distant hills, the rocks, the woods, lighted up by the brilliant tints of the evening sky of Italy; with the groupe of ourselves, our asses, and our peasant guides, formed altogether one of the most picturesque scenes I ever beheld.[2]*

Thomas Cole's oil painting of 1832 provides an instructive comparison to Anderson's photograph (Fig. 1). In place of the crystalline clarity and stillness of the photograph, Cole's work explores fleeting atmospheric effects, particularly evident in the skeins of mist partially shrouding the distant mountains. In spite of its apparent immediacy, *A View Near Tivoli* was not executed on site, but months later in Cole's studio in Florence. This is confirmed by the inscription on the back of the canvas and by a letter the artist wrote from Florence during the summer of 1832: "I am now engaged on a view of some ruined Aqueducts in the Campagna of Rome."[3] Like Granet's oil sketch of Monte Mario (No. 40), Cole's painting captures the evanescent atmosphere of the campagna, unifying sky and earth, nature and antiquity.

FIG. 1. Thomas Cole, *A View Near Tivoli (Morning)*, The Metropolitan Museum of Art, New York

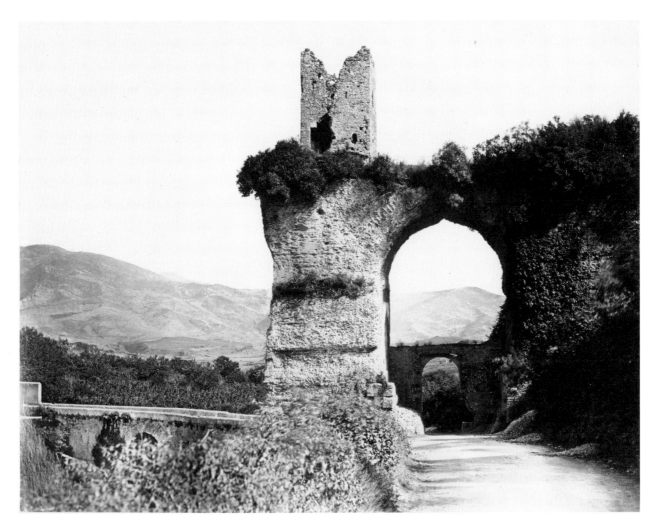

It is, of course, the dialogue between ruins and landscape that particularly interested Cole. Together, they prompt meditation on a favorite Romantic theme—the transience and mutability of all phenomena. Cole's series *The Course of Empire*, painted four years after *A View Near Tivoli*, provides a well-known example. In a journal entry written not long before executing this painting, Cole mused:

> *I sat under the ruins of an old Etruscan wall, and gazed long and silently on the great scene of desolate sublimity.... Brief, thought I, are the limits of mortal life: man measures time by hours and minutes, but nature by the changes of the universe.*[4]

FRIEDRICH PRELLER THE ELDER

Eisenach 1804–1878 Weimar

42 *The Ponte Nomentano, near Rome,* 1859

Graphite, one of 26 drawings in a sketchbook bound with an embroidered panel on the front cover bearing the artist's initials
9¼ x 20 inches (235 x 508 mm)
Inscribed, at lower center, *Ponte Nomentano*; at lower right, *Camp. di Roma 8 Novbr. 185*[9]. Partially legible inscription in the center foreground of the image.

The Morgan Library & Museum, purchased as the gift of Mrs. Sumner Pingree and Mrs. Samuel P. Reed; 1981.31, fols. (7) 8 verso and (8) 9 recto

Preller began his studies at the Freies Zeichen-Institut in Weimar.[1] In 1821, on the advice of Goethe, he traveled to Dresden, where he spent two years studying the paintings of Poussin, Jacob van Ruisdael, and others in the Gemäldegalerie. He then moved to Antwerp, where he studied with the Belgian history painter Mathieu Ignace Van Bree. In 1828 he traveled to Rome, residing there for three years. In Rome, Preller came under the influence of Joseph Anton Koch, an older Austrian painter who espoused a heroic form of landscape painting that fused the classicism of Poussin with the more rugged natural forms of Salvator Rosa and Jacob van Ruisdael. On his return to Germany, Preller executed landscapes combining his own version of Romantic Classicism, including a celebrated cycle based on Homer's *Odyssey*. He returned to Italy on several occasions, including 1859–60, the period from which this sketchbook dates.

The present sketchbook contains twenty-six drawings, the majority landscapes near Rome and in the mountains surrounding Olevano. One sheet depicts the picturesque farmhouse of La Crescenza, famous for having been painted by Poussin and Claude Lorrain. Preller was also attracted to bridges; there are three views of the Ponte Nomentano made on three separate occasions as well as one each of the Ponte Mamolo and the Ponte Salario. The Ponte Nomentano, with its crenellated superstructure, had long drawn the interest of artists.[2]

Three miles outside of Rome, the ancient via Nomentana passes over the Anio River. The travertine voussoirs of the single arch spanning the Anio are all that remain of its ancient structure. The bridge's superstructure was repeatedly destroyed and rebuilt over the course of the Middle Ages and the Renaissance, notably under Pope Nicholas V. According to tradition, it was at the Ponte Nomentano that Pope Leo III met Charlemagne when he came to Rome to be crowned Holy Roman Emperor in A.D. 800.

Preller employed the full two-page spread of his sketchbook in order to situate the Ponte Nomentano within an expansive landscape extending all the way to the Apennine Mountains to the east and the Alban Hills to the south. The young composer Felix Mendelssohn, writing in 1831, captured the same scene in words:

Ponte Nomentano is a solitary dilapidated bridge in the spacious green Campagna. Many ruins from the days of ancient Rome, and many watch-towers from the Middle Ages, are scattered over this long succession of meadows; chains of hills rise towards the horizon, now partially covered with snow, and fantastically varied in form and colour by the shadows of the clouds. And there is also the enchanting vapoury vision of the Alban hills, which change their hues like the chameleon, as you gaze at them.[3]

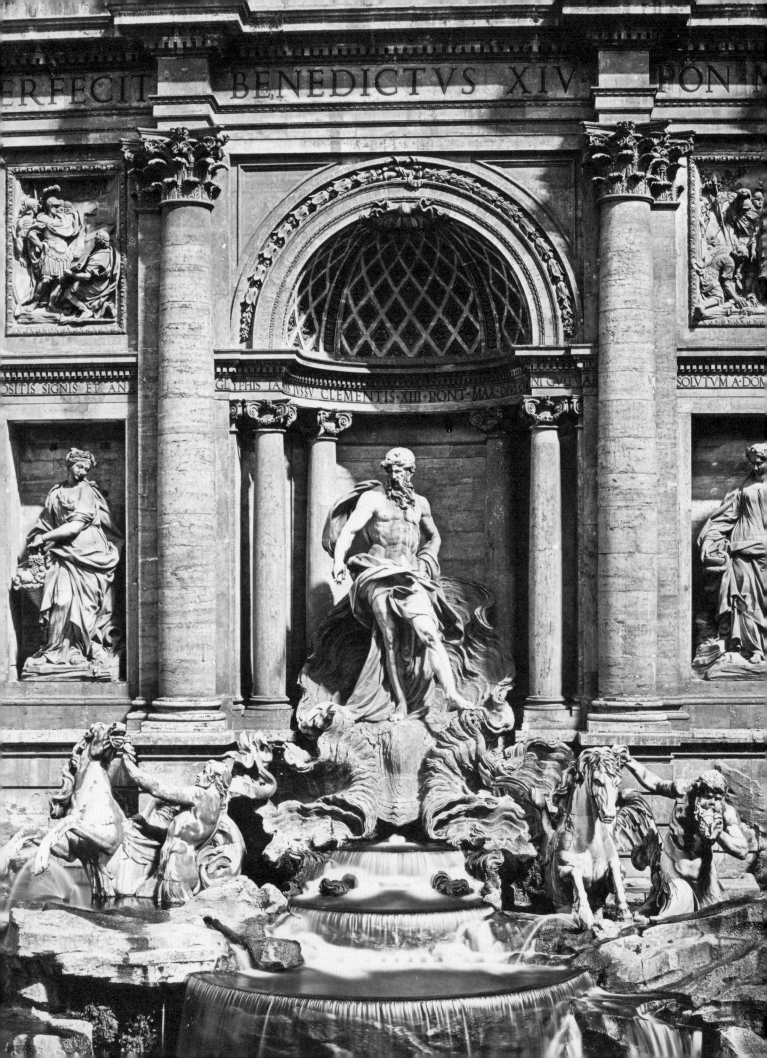

WRITTEN FROM ROME

JEAN-AUGUSTE-DOMINIQUE INGRES
Montauban 1780–1867 Paris

43 *Letter to Marie-Anne-Julie Forestier,* signed and dated

Rome, 19 October 1806

9⅝ x 7¼ inches (244 x 184 mm)

The Morgan Library & Museum, gift of the Fellows, 1968; MA 2553

Best known for his portraits and history paintings, Ingres was also one of the most gifted draftsmen of any age. He studied with David in Paris and won the Prix de Rome in 1801, but his fellowship was postponed until 1806 owing to a lack of government funding. As early as 1804, Ingres had been introduced to the family of Marie-Anne-Julie Forestier and by June 1806 they were engaged to be married. Forestier was a talented painter; she may have studied with David, and she exhibited her work in the Salons from 1804 to 1819. She also played the clavier and shared with Ingres an appreciation of music.

Ingres's engagement preceded by only three months his departure for Rome to fulfill his appointment at the French Academy. Julie Forestier's father, a jurist, was skeptical of Ingres's intentions, and consented to the engagement with the understanding that the artist return from Rome within a year to marry his daughter. M. Forestier's correspondence with Ingres is condescending, which the artist resented. In contrast, Julie's mother appears to have favored the match. Ingres compares the two, remarking, "He is not like our good mother Forestier, who loves us completely, doesn't she, my dear?"

Ingres's letter to Julie, written ten days after his arrival in the Eternal City, expresses the artist's ardent devotion to his fiancée and his distress at their separation. Even her portrait fails to console him:

Six o'clock when I get up, I do not sleep, I roll over in my bed, I cry, I think of you constantly, and I go look at your portrait, which calms me a little, but without making me happy, quite the opposite.

Ingres goes on to say that "I will find it impossible to stay even perhaps a year." In the course of his first weeks in Rome, he made a series of drawings depicting his new surroundings, which he sent to his fiancée.

Soon, however, the artist's feelings—and plans—changed dramatically. As reports of the critical reception accorded his submissions to the Salon of 1806 reached him in Rome, Ingres became disenchanted with Paris. He fell in love with Rome, which became his new inspiration as he explored it through the medium of drawing. By August 1807 he broke off his engagement, declaring that "It is impossible for me to leave such a marvelous country so soon."[1] Indeed, Ingres remained in Rome long after the four-year term of his fellowship, not returning to Paris until 1820.

For her part, Julie Forestier never married. In later years, she wrote a roman à clef entitled *Emma, ou la fiancée,* a story of unrequited love in which the protagonist's mother is aware that letters written by her husband to Emma's absent fiancé will hurt him.[2] When asked why she had never married, Julie is reported to have remarked, "When one has had the honor of being engaged to M. Ingres, one does not marry."[3]

Rome ce 19 octobre. 1806

ma bien aimée, ma bonne julie. vous êtes un ange sur la terre.
combien vous me faites d'entrer mes torts, que j'ai de peine d'avoir
douté un moment de vos tendres sentiments à mon égard.
mais aussi quel bonheur est le mien d'entendre de vous mêmes
ces tendres assurances. non ma belle ne regrettés pas d'avoir —
épanché votre coeur avec celui qui vous adore, et qui n'existe
et ne vit que par vous et pour vous. ma charmante amie
n'ayés donc plus de regrets avec moi, je n'aurai jamais, pour
vous le moindre secret vous verrés toujours mon ame toute entiere,
que de votre coté il en soit de même contes moi le soin de
plaisir, comme le moindre petit chagrin, je vous consolerai du
mieux que je le pourrai, jusqua ce que les noeuds les plus
tendres nous unissent à jamais. c'est moi qui suis malheureux
ma tendre amie de ne vous plus voir, il vous est impossible
de vous l'imaginer, au point que si j'en avois les moyens
je repartirois pour paris, uniquement pour vous mon aimable
amie, j'ai relu cent fois cette charmante écriture au crayon,
je vais continuellement de la lettre au portrait, il me semble
vous voir, je vous parle mais hélas, vous ne me reppondés pas
et ici à chés moi qu'un triste silence interrompu par le bruit
d'une cloche ou d'une pluie qui tombe par torrents, accompagné
d'un tonnerre qui a l'air de partager l'anéantissement du —
monde entier. je suis couché à neuf heures du soir. et jusqua

JEAN-AUGUSTE-DOMINIQUE INGRES

Montauban 1780–1867 Paris

44 *Portrait of Guillaume Guillon-Lethière*, 1815

Graphite on wove paper

11 x 8¾ inches (280 x 221 mm)

Signed and inscribed in graphite at lower right, *M. ^{de} Ingres / a Mad^{lle.} Lescot*; below, traces of a signature, now erased, *Ingres rome 1815*.

The Morgan Library & Museum, bequest of Therese Kuhn Straus in memory of her husband, Herbert N. Straus; 1977.56

When Ingres arrived in Rome in the fall of 1806, the French Academy had only recently moved from the Palazzo Mancini on the via del Corso to the more expansive setting it still occupies on the grounds of the Villa Medici. The academy's director Joseph-Benoît Suvée had supervised the move. In a letter of 7 April 1807 to Pierre Forestier, the father of his fiancée, Ingres describes Suvée's sudden death. Ingres goes on to express his opinion of the two men who would replace Suvée: Pierre-Adrien Pâris, who stepped in as acting director in 1807, and Guillaume Guillon-Lethière: "M. Pâris would be the man we need, but as second best I like M. Lethière very much and hope to get along with him as well as I did with M. Suvée."[1] Lethière took over from Pâris later that year.

Lethière was born on the Caribbean island of Guadeloupe in 1760. As the third child of Guillon, he was called Letiers, which he subsequently changed to Lethière. In 1774 he was sent to France, where he studied history painting with David, eventually winning the Prix de Rome in 1784. During the empire, Lethière assisted Lucien Bonaparte, Napoleon's younger brother, in acquiring paintings and antiquities; Lucien's support weighed heavily in the discussions about the directorship of the academy.

By all accounts, Lethière had a warm and outgoing personality. He and his wife were kind to Ingres, who produced no fewer than ten portrait drawings of Lethière's extended family. One in the series depicts Madame Lethière and her son against the backdrop of the Villa Medici and the Trinità dei Monti. Dated 1808, this is the first of Ingres's portrait drawings to include Roman monuments in the background. The earliest of Ingres's portraits of Lethière as director dates 1811, the year after Ingres's fellowship ended and he moved out of the Villa Medici. This drawing, depicting Lethière in profile, is more intimate, its composition more informal than the present portrait.[2]

In the present drawing, Lethière's face is presented frontally, his penetrating gaze directly engaging the observer. Ingres's composition contributes to the director's formidable presence and air of confident command. A short cape adds to his massive silhouette and he holds a hat. Only Lethière's facial features are fully modeled, with the rest of his body rendered in broad, sweeping outlines, particularly evident in the curving brim of his high-crowned hat.

The drawing is inscribed in the lower right-hand corner with a dedication to *"Mad^{lle.} Lescot."* Antoinette Cécile Hortense Houdebourt-Lescot (1784–1845), a family friend, received instruction in painting from Lethière from the age of seven. In 1808, following Lethière's appointment as director of the French Academy, Mademoiselle Lescot moved to Rome, eliciting rumors about their relationship in the social and artistic circles of the Villa Medici.[3] She remained in Rome through the conclusion of Lethière's term as director in 1816.

GEORGE GORDON BYRON
London 1788–1824 Missolonghi

45 *Childe Harold's Pilgrimage: Canto the Fourth*, London, John Murray, 1818

The Morgan Library & Museum, bequest of Gordon N. Ray, 1987; PML 142284.2

The first two cantos of *Childe Harold's Pilgrimage* were published in 1812, making Byron an instant celebrity. Subtitled *A Romaunt*, or "Romance," the poem is an inspired narrative of adventure based on Byron's travels in the Iberian Peninsula and the Levant. Its protagonist, who has the archaic title *Childe* (denoting a young noble awaiting knighthood), is overtly autobiographical, the quintessential Romantic man of feeling.

When Byron visited Rome, in 1817, the third canto had been published the preceding year, and he was beginning to plot out the fourth, and final, canto, which was to be set in Italy. Byron's stay in Rome lasted only three weeks, much of it, by his own account, spent on horseback, galloping through the campagna to visit classical sites in the neighborhood of Tivoli and the Alban Hills.[1] In letters to his publisher, John Murray, the poet expressed his delight with Rome, comparing it favorably to Athens and Constantinople. Of Rome's celebrated monuments, such as the Colosseum and the Pantheon, he wrote, "They are quite inconceivable and must be *seen*."[2]

Byron was powerfully affected by what he saw, and over half of the 186 stanzas of Canto IV are devoted to Rome. In his letters, Byron was dismissive of straightforward description, associating it with such guidebooks as Forsyth's *Remarks on Antiquities*, the one carried by his companion John Hobhouse. Byron's treatment of Roman monuments concentrated on the powerful effect they have on the observer; he was relatively unconcerned with conveying a clear sense of their structure and appearance. His treatment of the Tomb of Cecilia Metella provides a case in point. His spare description of it, "a stern round tower … with half its battlements alone," sets up a discursive speculation about Metella herself that extends for four stanzas, concluding:

> *This much alone we know—Metella died,*
> *The wealthiest Roman's wife: behold his love or pride.*[3]

Among the most beautiful and haunting evocations of place are those in which nature prevails over artifice, as in the stanzas on the Grotto of the Nymph Egeria (No. 60) and Lake Nemi:

> *Lo, Nemi! navell'd in the woody hills*
> *So far, that the uprooting wind which tears*
> *The oak from his foundation, and which spills*
> *The ocean o'er its boundary, and bears*
> *Its foam against the skies, reluctant spares*
> *The oval mirror of thy glassy lake;*
> *And, calm as cherish'd hate, its surface wears*
> *A deep cold settled aspect nought can shake,*
> *All coil'd into itself and round, as sleeps the snake.*[4]

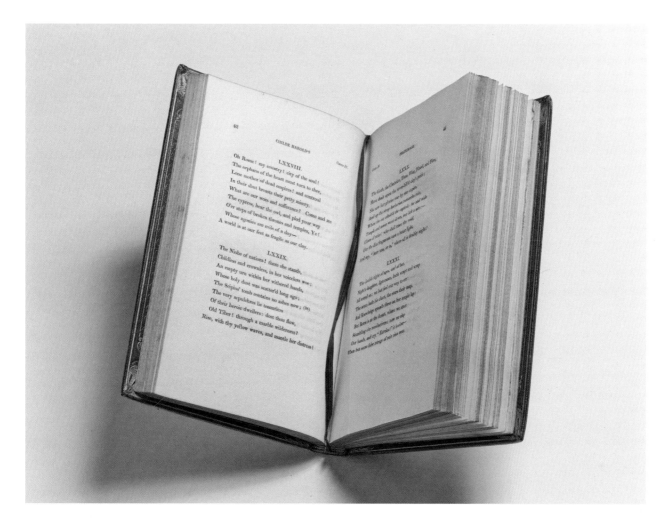

Byron wrote: "my first impressions are always strong and confused, and my memory *selects* and reduces them to order, like distance in the landscape, and blends them better, although they may be less distinct."[5] Perhaps this is why the fourth canto of *Childe Harold* was written in Venice. For Byron, the monuments of Italy, especially Rome, lent themselves to his view that human achievements are ephemeral, that the power of the greatest tyrants, such as Caesar or Napoleon, will pass, and the grandest empires will fall into ruins. Only the sublime creations of the mind and the artist's hand will endure, testifying to man's greatness.

SIR WILLIAM GELL
Hopton 1777–1836 Naples

46 *Letter to Richard Payne Knight*, signed and dated Rome, 25 June 1818

8 x 12½ inches (203 x 318 mm)

The Morgan Library & Museum, purchased 1980; MA 3442

Gell was a classical scholar and topographer active in both the eastern Mediterranean and Italy (see No. 33).[1] Following his first visit to the Levant in 1801, he published a book on the topography of Troy[2] to which Byron alluded in his *English Bards*:

> *Of Dardan tours let dilettanti tell,*
> *I leave topography to classic Gell.*[3]

Byron's opinion of Gell fluctuated: the original manuscript of *English Bards* refers to the antiquarian as "coxcomb Gell," but the poet changed the wording after having met him. In the fifth edition, revised after Byron had actually visited the Troad, he changed *classic* to *rapid*, a sly comment on what he took to be Gell's superficial approach to the site.[4]

Following further travels in Greece, in 1807 Gell was elected to the Society of Dilettanti.[5] His correspondent, the connoisseur, antiquarian, and arbiter of taste Richard Payne Knight, was a fellow member of the Dilettanti and an avid collector of ancient coins and bronze statuettes. In this letter Gell calls his attention to a bronze vase found near Metapontum.[6]

By 1818, Gell was based in Rome and engaged in his topographical study of the walls of Rome. His letter provides Knight with a summary of archaeological news, most of which concerns the shifting identity of monuments in the area of the Forum:

> *There is a great deal of talk & little done in the forum here, but the Temple of Jupiter Stator is now the portico of the Comitia, that of Concord is become fortune, the single column is become that of Phocas, & the real Concord is found under the scala di Marforio near Septimius Severus.... there are some hopes of another arch of Janus in the neighbourhood of the Column of Phocas where the Duchess of Devonshire has excavated. This is all the antiquarian news of Rome, but there are some hopes of seeing a great part of the Forum cleared as they have promised to unite the 3 parts already excavated down to the pavement at the Comitia the arch of Severus & the column of Phocas.*

Elizabeth Cavendish, Duchess of Devonshire (1759–1824), spent her last decade in Rome. Gell illustrated a book on the ancient walls of Rome that is dedicated to her.[7] The excavations undertaken at her expense revealed the stepped platform supporting the Column of Phocas.[8]

In 1830 Gell was appointed representative of the Society of Dilettanti in Naples, which enabled him to keep a close eye on the excavations of Pompeii and Herculaneum, on which he published two books.[9] On separate occasions he showed Sir Walter Scott and Edward Bulwer-Lytton around the excavations; the latter dedicated his novel *The Last Days of Pompeii* to Gell, who died in Naples in 1836.[10]

Rome June 25, 1810

My dear Sir

Thank you for the maps of Troy which I received safely by Dodwell – I think the Critics will fall upon you for your position of the Trojan camp particularly those who recollect that the council of war held by Hector on that night of the encampment must have been at a very great distance from the Rhetean promontory. There need be no question about the Shiman for I have no doubt that might be the Simois of Strabo, & Demetrius, & the very reason they did not find Troy any more than Carlisle & Co ever did or ever will. As to Dr Clarkes Theory of a castle of Banditti above Bonnarbashi that can only be credited by flying travellers, as the walls now generally termed Cyclopean (though they are not so) are found on that hill, if any one will take the pains to look well for them. That is walls of well joined polygonal stones, rather a serious business for Clarkes Pirates. I have sent home by Ld Craven a very curious & perfect Bronze Vase with a sort of Salic priest on one side & portraits on the other & the Lotus ornament at each handle all beat out from within & of very singular workmanship – It was found somewhere near Metapontum in Magna Graecia & belonged to the Ex Queen to some of whose people to whom she owed their wages she gave it or they stole it at the

DOMENICO AMICI
Rome 1808–after 1870

47 *Two Visitors to the Tomb of Bertie Bertie Mathew,* 1846

Pen and brown ink, brown wash, over graphite
14¹³⁄₁₆ x 10⁹⁄₁₆ inches (full sheet; 376 x 268 mm)
Signed and dated in pen and brown ink at lower left, *Domenico Amici fece dal vero Roma 1846*; inscribed on tomb in pen and black ink, *SACRED TO THE MEMORY / OF / BERTIE BERTIE MATHEW / LAST SURVIVING SON / OF / BROWNLOW BERTIE MATHEW ESQ^{RE} / GRANDSON OF GEN^{L.} & LADY. JANE MATHEW / DIED / BY A FALL FROM HIS HORSE WAIIE [sic] HUNIIAIG [sic] / BI THE CAMPAGNA NEAR PORTA SALARA / NOV^{ER.} 19. 1844 / IN THE MIDEST [sic] OF LIFE WF [sic] ARE IN DEATH;* on adjacent side of the monument, *SUB HOC MARMORE / JACET / BERTIE BERTIE MATHEW ARM^{R} / NATI. 15. DEC A.D. 1811 / OB. 19. NOV. A.D. 1844.*

The Morgan Library & Museum, gift of Charles Ryskamp in memory of Mrs. Alan Valentine; 1992.5

Amici followed in the footsteps of Piranesi and Luigi Rossini. Beginning in the early 1830s, he issued engraved views of Roman monuments, including collections published under his own name (see No. 67).[1] A decade after Garibaldi's unsuccessful defense of the Roman Republic, Amici engraved a series after twelve watercolors by Carl Friedrich Heinrich Werner (1808–1894), representing the aftermath of the siege of Rome.[2]

During the first half of the nineteenth century, the Protestant Cemetery expanded westward from the so-called *parte antica,* where the graves of Keats and Severn lie in the shade of the Pyramid of Cestius. The monuments from this later period follow the interior line of the ancient Aurelian Walls, the brick ma-

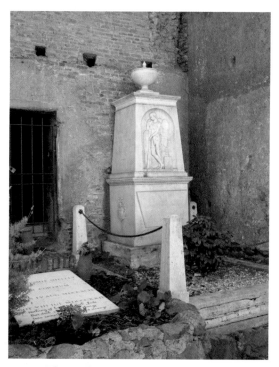

FIG. 1. *The Mathew Monument in the Protestant Cemetery*

sonry of which is visible in the background of Amici's drawing (Fig. 1). Two women, one of whom consults a prayer book or a guidebook, stand before a monument set into a corner formed by one of the towers of the Roman wall. The two visitors are dressed in mourning clothes, including black crepe mantles and veiled bonnets, suggesting that they are relatives of the deceased.

Framed by two cypress trees, recalling those described by Oscar Wilde near the grave of Shelley as being "like burnt-out torches by a sick man's bed," is a monument crowned by an urn.[3] The side facing the visitors bears a coat of arms and an English inscription identifying the departed. The latter records the untimely death in 1832 of Bertie Bertie Mathew, aged thirty-two. In the autumn of that year, Mathew fell from his horse while hunting in the campagna near Porta Salaria. Such misfortunes were not uncommon among foreigners sojourning in Rome. Just a short distance from the Mathew monument is one erected in memory of Rosa Bathurst, who died in 1824 at the tender age of sixteen, thrown from her "spirited horse" into the swollen Tiber.[4]

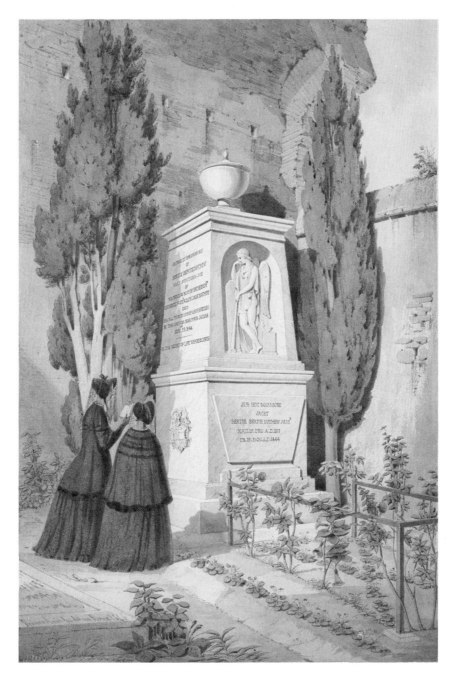

The south-facing side of the Mathew memorial carries a Latin inscription and a bas-relief of a mourning angel. The angel leans on a broken column—a time-honored symbol of a life cut short—and holds a downward-pointing torch. Behind, and to the right, an oil lamp burns on a small pedestal.

Samuel Rogers, writing in 1830, captured the genius of the place:

> It is a quiet and sheltered nook, covered in the winter with violets; and the Pyramid, that overshadows it, gives it a classical and singularly solemn air. You feel an interest there, a sympathy you were not prepared for. You are yourself in a foreign land; and they are for the most part your countrymen. They call upon you in your mother tongue—in English—in words unknown to a native, known only to yourselves.[5]

Over time, the Protestant Cemetery became a Christian Elysium, an evocative intermingling of art, nature, antiquity, and memory.

CHARLES DICKENS
Landport 1812–1870 Higham

48 *Letter to Georgina Hogarth,* signed and dated Rome, 4 February 1845
5½ x 7 inches (140 x 178 mm)

The Morgan Library & Museum, gift of George H. Fitch, 1963; MA 2249.5

Rome. Tuesday Fourth February 1845
My Dearest Georgy.

This is a very short note, but time is still shorter. <u>Come by the first boat, by all means. If there be a good one a day</u>
<u>or two before it, come by that.</u> In case of any missing or unforeseen arrival (which is not likely) we shall be at the
Vittoria Hotel, Naples. Write to us (by De la Rue as usual) and let us know; if there be time; exactly on what day
and by what boat you leave Genoa. Don't delay on any account. I am very sorry you are not here. The Carnival is
a very remarkable, and beautiful sight. I have been regretting the having left you at home, all the way here. Kate
says will you bring her a box of toothpowder. Anne knows where it is. Also will you take counsel with Charlotte
about colour (I put in my word, as usual, for brightness) and have the darlings bonnets made at once, by the same
artist as before. Kate would have written, but is gone, with Black, to a day-Performance at the opera to see Cerito
dance. At two each day, we sally forth in an open Carriage (bearing dear Susan with us)—with a <u>large sack</u> of
sugar plums and at least five hundred little Nosegays, to pelt people with. I should think we threw away yesterday,
a thousand of the latter. We had the Carriage filled with flowers, three or four times. I wish you could have seen
me catch a Swell Brigand (Mr. Wood, exactly) on the nose with a handfull of very large confetti, every time we met
him. It was the best thing I have ever done. The Chimes are nothing to it.

Best loves to Mamey, Katey, Charley, Walley, and Chickenstalker (whose name, I beg to observe, is written all
in one).
Anxiously expecting you, I am ever
Dear Georgy
Yours most Affectionately
CHARLES DICKENS[1]

Dickens and his wife Catherine were in Rome from 30 January through 6 February 1845. This letter
is addressed to Dickens's sister-in-law Georgina (1827–1917), who had moved in with the family three
years previously, at the age of fifteen. Responsibility for Dickens's large and growing family fell to Georgina as housekeeper. The children are all affectionately greeted by their nicknames: Mamey (Mary, born
1838), Charley (Charles, born 1837), Walley (Walter, born 1841) and Chickenstalker (Francis, born 1844),
named after a character in *The Chimes*, which Dickens was writing at the time of Francis's birth. The
performance Catherine Dickens attended was given by Fanny Cerrito (1817–1909), a ballet dancer and
choreographer. In the 1840s, Cerrito danced at Her Majesty's Theatre in the West End.

The Roman carnival, like its Venetian counterpart, figured prominently in nineteenth-century travel
literature and pictorial representations, such as Bartolomeo Pinelli's watercolor (No. 49). Dickens's epistolary description of the event relates closely to the one included in *Pictures from Italy* the following year.
His published account of the carnival naturally provides much more detail than does his letter, including

the precaution he and his company took to wear little wire masks to protect their faces from the flying sugarplums and confetti. Francis Marion Crawford, writing in 1896, elaborated on this festive armor, which included "a shield of thin wire netting to guard the face, and thick gloves to shield the hands; or in older times, a mask, black, white, or red, or modeled and painted in extravagant features, like evil beings in a dream."[2]

Yours received this morning, of course.

Rome. Tuesday the February 1845

My Dearest Georgy.

This is a very short note, but time is still shorter. Come by the first boat, by all means. If there be a good one a day or two before it, come by that. In case of any missing, or unforeseen arrival (which is not likely) we shall be at the Vittoria Hotel, Naples. Write to us (by De La Rue as usual) and let us know; if there be time; exactly on what day and by what boat you leave Genoa. Don't delay on any account. I am very sorry you are not here. The carnival is a very remarkable, and beautiful sight. I have been regretting the having left you at home, all the way here.

Kate says will you bring her a box of tooth powder. Anne knows where it is. Also will you take counsel with Charlotte about colours (I put in my word, as usual, for brightness) and have the darlings' bonnets made at once, by the same artist as before. Kate would have written, but is gone, with Black, to a day-performance at the Opera, to see Cerito dance. At two each day, we sally forth in an open carriage (having dear Susan with us) - with a large sack of sugar plums and at least five hundred little nosegays, to pelt people with. Ishmael thinks we threw away yesterday, a thousand of the latter. We had the carriage filled with flowers, three or four times. I wish you could have seen me catch a Sicle Brigand (Mr Wood, exactly) on the nose with a handful of very large confetti, every time we met him. It was the best thing there was done. The chimes are nothing to it.

Best loves to Mamey, Katey, Charley, Walley, and Chickenstalker (whose name, I beg to observe, is written all in one.)

Anxiously expecting you. I am here,
Dearest Georgy,
Yours most affectionately
Charles Dickens

Mrs Charles Gibbs.

BARTOLOMEO PINELLI
Rome 1781–1835 Rome

49 *Carnival Scene*, 1816

Pen and black ink, watercolor, over graphite
11½ x 16¼ inches (292 x 413 mm)
Signed and dated 1816. Inscribed in black ink at lower right, *Pinelli fece 1816 Roma.*

Roberta J. M. Olson and Alexander B. V. Johnson

Pinelli counts among Rome's most gifted and prolific graphic artists of the first half of the nineteenth century.[1] He issued numerous suites of prints, several of which contribute greatly to our knowledge of Roman costume and customs of the period.[2] In addition he illustrated major works of Italian literature and Roman history.[3] From 1817 onward, Pinelli collaborated with Luigi Rossini, providing the figures that animate many of the latter's printed views of Roman monuments (see No. 37).[4] While best known as a printmaker, Pinelli was an accomplished draftsman as well. This scene of the Roman carnival, in its use of caricature, calls to mind the work of Pinelli's older British contemporary, Thomas Rowlandson.[5]

The festive carnival celebrations took place during the ten days before Ash Wednesday and the austerity associated with Lent. Nineteenth-century accounts often traced the origins of this decidedly secular celebration to ancient festivals, such as the Saturnalia and the Lupercalia. By the middle of the century, the festival had become centered on the north-south axis of the papal capital, the via del Corso. Carriages slowly made their way along the full length of the Corso, extending nearly a mile from the Piazza del Popolo at its north end to the Piazza Venezia at its southern terminus. From the balconies and windows of the princely palaces and other buildings lining the street, onlookers actively engaged the privileged occupants of the carriages by throwing down upon them hardened confetti, sugarplums, and flowers.

The most lethal of these comfits were made by rolling grains of corn in a paste of plaster of Paris, resulting in pea-sized balls. The protagonist of Hans Christian Andersen's *The Improvisatore* makes the mistake of looking into a carriage and has a basketful cast into his face, "so that I, not having any weapons of the same kind, quite powdered over from top to toe, was compelled to make a hasty retreat."[6]

Conventional respect for class and authority was waived in this highly ritualized inversion of roles fostered by the anonymity of the masked revelers. Pinelli recorded the rich variety of costumes, also noted by Dickens in *Pictures from Italy:*

> *Every sort of bewitching madness of dress was there. Little preposterous scarlet jackets; quaint old stomachers, more wicked than the smartest bodices; Polish pelisses, strained as tight as ripe gooseberries; tiny Greek caps, all awry, and clinging to the dark hair, Heaven knows how; every wild, quaint, bold, shy, pettish, madcap fancy had its illustration in a dress; and every fancy was as dead forgotten by its owner, in the tumult of merriment, as if the three old aqueducts that still remain entire had brought Lethe into Rome, upon their sturdy arches, that morning.[7]*

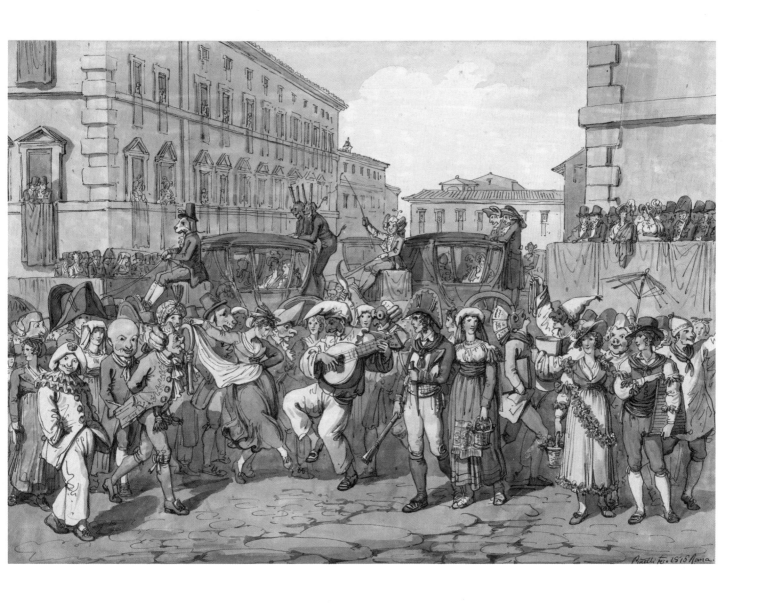

MARGARET FULLER
Cambridge, Massachusetts, 1810–1850 Fire Island, New York

50 *Letter to Elizabeth Hoar,* dated 17 June 1849

8 x 5¼ inches (203 x 133 mm)

The Morgan Library & Museum, purchased as the gift of Mrs. April Axton, 1977; MA 3373

17th June.

I copy this from the Roman Monitor of this week as a natural appendix to my letter.

I feel an inexpressible weariness of spirits today. The state of the siege is very terrible, such continual alarms, then to hear the cannonade day and night and to know with every shot, some fellow man may be bleeding and dying. Sometimes I cannot sleep, sometimes I do again from sheer exhaustion. I did think, since this world was so full of ill, I was willing to see it all. I did not want to be cowardly and shut my eyes. Nor is this perpetual murder of men so bad as to see them indolently lying in the mud. The sad night is cheered by sparklings of pure fire. Yet it is very sad, and oh, Rome, my Rome, every day more and more desecrated! One of the most gentle hallowed haunts, La Maria di Trastevere, is, I hear almost ruined by the bombs of day before yesterday. Almost nightly I see burning some fair cascine. Adieu, dear Lizzie, prize the thoughtful peace of Concord.

"Martyrology of Italian Liberty"

Colomba Antonietti di Fuligno has followed for two years her husband Luigi Porzio, lieutenant in the 2d regiment of the Line, sharing with him fatigues and dangers, the long marches and the fire of the enemy.

She was only 21 years old, of most generous heart, of the highest Italian sentiment. She fought like a man, rather say a hero, in the battle of Volletri, worthy of her husband, worthy of her cousin, the colonel Luigi Masi. Yesterday 13th June, she was near the wall San Pancrazio, threatened by the French fire. There while she passed to her husband what he wanted while working at the breach, a cannon ball struck her in the side. She joined her hands, looked up and died crying Viva l'Italia Frenchmen if Italian men "do not fight" let our women teach you respect for the name and valor of Rome.

Fire barbarians, but incline yourselves![1]

Margaret Fuller is best known for her accomplishments as a writer. She was editor of the Transcendentalist journal *The Dial* (1840–44), author of the influential *Woman in the Nineteenth Century* (1845), and the first female correspondent of Horace Greeley's *New York Tribune* (1844–50).[2] Elizabeth Hoar, to whom this letter is addressed, was a member of Ralph Waldo Emerson's circle.

Fuller sailed to Europe in 1846 and, after spending seven months in England and France, arrived in Rome in late March of the following year. She was quickly engulfed by the dramatic events that swept Europe in 1848, the Year of Revolution. With the proclamation of the Roman Republic on 8 February 1849 and the flight of Pope Pius IX from the Vatican, Rome became the focal point for the efforts to unify Italy. When the French dispatched an expeditionary force to restore the pope, Giuseppe Garibaldi and his followers rallied to the defense of the republic. By the middle of June, the date of Fuller's letter, the French forces had begun to lay siege to Rome, concentrating their efforts on gaining command of the Janiculum Hill.

Since the end of April, Fuller had overseen the care of the wounded in the hospital of the Fatebenefratelli on the Tiber Island as well as on the grounds of Quirinal Palace.[3] In May, commenting on the fell-

ing of ancient trees in the gardens of the Villa Borghese and the Villa Doria Pamphili by the defenders denying the French cover, Fuller observed, "Rome is shorn of the locks which lent grace to her venerable brow."[4] In a letter of 6 June, she described the battle raging within sight of her lodgings:

> On Sunday, from our loggia, I witnessed a terrible, a real battle. It began at four in the morning; it lasted to the last gleam of light. The musket-fire was almost unintermitted; the roll of the cannon, especially from St. Angelo, most majestic. As all passed at Porta San Pancrazio and Villa Pamfili, I saw the smoke of every discharge, the flash of the bayonets; with a glass I could see the men.[5]

The French artillery, while concentrated on the circuit of seventeenth-century walls enclosing the Janiculum, tenaciously defended by Garibaldi's forces, also caused indiscriminate destruction within the city. Her letter mentions damage to the church of S. Maria in Trastevere. In one of her *Dispatches*, Fuller mentioned shells landing all around the via Gregoriana, on the far side of the Tiber.[6] Four days after the date of this letter, the French succeeded in penetrating Garibaldi's defensive lines. On 30 June the Roman Assembly voted to end resistance, and on 2 July, Garibaldi and his remaining troops evacuated the city. The French reclaimed the papal capital the following day.

The appendix to Fuller's letter provides a translation of an account published earlier in the *Monitore Romano* of 14 June 1849.[7] It focuses on the heroic death of Colomba Antonietti, who had cut her hair and wore a man's uniform in order to fight alongside her husband, Luigi Porzi.

GEORGE HOUSMAN THOMAS
London 1824–1868 Boulogne

51 *Panorama of Rome,* 1850
Supplement to *The Illustrated London News*
Etching
17¼ x 40⅝ inches (438 x 1032 mm)

Avery Library of Architecture and Art History, Columbia University

Giuseppe Garibaldi proclaimed the view from the Janiculum Hill "the greatest theatre of the world."[1]
During the spring and early summer of 1849, however, the eyes of the world were fixated not on the view
from the Janiculum but on the hill itself. Garibaldi and a small army of Italian patriots were attempting to
keep at bay the French expeditionary force sent to suppress the Roman Republic proclaimed by Giuseppe
Mazzini. The French intended to restore Pope Pius IX as temporal leader of the Papal States. In the end,
the weight of numbers and artillery prevailed, and Garibaldi, accompanied by what remained of his force,
withdrew from Rome on 2 July.

The fiercely contested battle to command the Janiculum, which constituted the military key to Rome,
left enduring scars on the city. This panoramic view purports to show the immediate aftermath of the

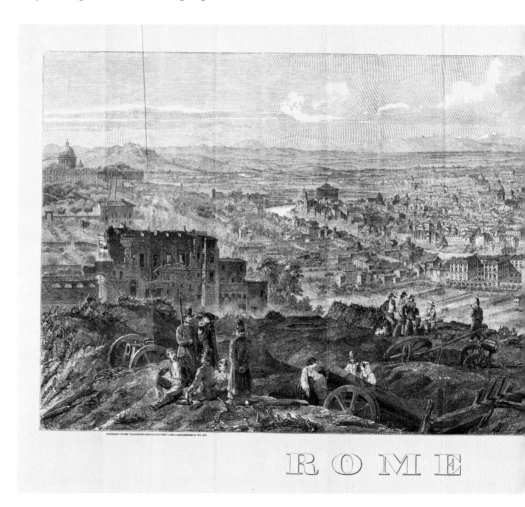

siege, although it was issued almost a year later.[2] It appeared as a supplement to *The Illustrated London News*, which was generally more favorably inclined to Mazzini, Garibaldi, and the forces of unification than was the rest of the British press. George Housman Thomas, a regular contributor who furnished the preparatory drawing for the panorama, was present in Rome during the siege. In the foreground, French officers converse with clerics, representatives of the restored papal rule. Scattered about is the detritus of battle, notably fragmented fascines and cannon carriages. Not evident in the print were the human remains visible to Margaret Fuller as she picked her way over the battlefield: "A pair of skeleton legs protruded from a bank of one barricade; lower, a dog had scratched away its light covering of earth from the body of a man, and discovered it lying face upward all dressed."[3]

The panorama depicts some of the damage inflicted on Rome by the siege. Most evident is the hollow shell of the Villa Savorelli at the far left. Garibaldi had used the villa as his headquarters at the height of the battle, and it suffered many direct hits. Reconstructed following the siege, it changed hands several times and eventually was acquired by the American Academy in Rome as the Villa Aurelia (see No. 8).

The panorama, etched in London by Walter Mason, deserves to be seen in relation to other efforts at documenting Garibaldi's defense of the Roman Republic. Photographers were also quick to document the aftermath of the fighting, notably Stefano Lecci, whose images anticipate in certain respects the better-known work of Roger Fenton in the Crimea.[4]

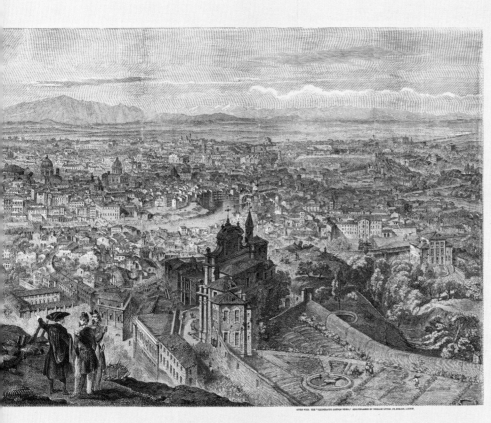

ISSUED WITH THE "ILLUSTRATED LONDON NEWS," AND PUBLISHED BY WILLIAM LITTLE, 96, STRAND, LONDON.

DCCCXLIX

NATHANIEL HAWTHORNE

Salem, Massachusetts, 1804–1864 Plymouth, New Hampshire

52 *Italian Notebooks*, vol. 4, April–May 1858

Autograph manuscript

10 x 7½ inches (254 x 191 mm)

The Morgan Library & Museum, purchased by Pierpont Morgan with the Wakeman Collection, 1909;
MA 589

His literary reputation already established with the publication of *The Scarlet Letter* (1850) and *The House of the Seven Gables* (1851), in 1852 Hawthorne wrote a biography of his friend Franklin Pierce, who was running for president. Upon his election, the grateful Pierce appointed Hawthorne to the position of American consul in Liverpool. Following the completion of his service in 1857, the author and his family traveled on the Continent, staying first in Paris and then in Rome. Throughout this period, he kept a running account of his impressions in small notebooks. This is one of five in the Morgan's collection.

Hawthorne arrived in Rome during a frigid January in 1858, taking up lodgings on the via di Porta Pinciana.[1] He took advantage of the proximity of his residence to the extensive gardens overlooking the Piazza del Popolo: "I generally go to the garden of the Pincian and smoke a cigar at least once a day, sometimes twice."[2] The family spent the spring and summer months in Florence, returning to Rome in mid-October. From then until their departure in May of the following year, they resided in Piazza Poli, next to the Trevi Fountain.[3]

Throughout his stay, Hawthorne energetically applied himself to visiting Rome's ancient and modern monuments. Some of his visits were prompted by the descriptions of other writers, notably Byron and Madame de Staël. For a guidebook, Hawthorne relied on Murray's *Handbook of Rome* (No. 66), on one occasion foregoing a visit to the Grotto of the Nymph Egeria because Murray cast doubt on the identification (Nos. 60 and 61).[4]

In these notebooks, one can see the inspiration for *The Marble Faun* first coming to Hawthorne.[5] An entry records his visit to the sculpture gallery of the Capitoline Museum, where one of the ancient statues, a faun attributed to Praxiteles, deeply impressed him. Many of the Roman sites Hawthorne visited would eventually find their way into the novel, which he began to draft on 25 October 1858 and finished on 30 January of the following year.

Late in April 1858, the author and his wife made a moonlight visit to the Trevi Fountain. The impressions he recorded provide the basis for one of the scenes in Chapter XVI of *The Marble Faun*, "A Moonlight Ramble." As we read the entry, it becomes clear that he was prompted to experience the Trevi at night by his reading of Madame de Staël's *Corinne, or Italy*:[6]

> *We descended to the edge of the basin, and bent over the parapet, in order to ascertain the probability of Lord Nelville's having seen Corinne's image in the water, or if she could have seen his (for I forget which it was) at their moonlight interview. It could not have happened. The transparency of the water, permitting the bottom of the basin to be clearly seen, its agitation, and the angle at which one looks into it, prevent any reflection from being visible. The moon, shining brightly overhead and a little behind us, threw our black shadows on the water; and this is what Lord Nelville or Corinne would have seen, but nothing else.*[7]

1858

Rome, April 25th. Sunday. Night before last, my wife and I took a moonlight ramble through Rome; it being a very beautiful night, warm enough for comfort, and with no perceptible dew or dampness. We set out at about nine o'clock, and our general direction being towards the Coliseum, we soon came to the Fountain of Trevi, full on the front of which the moonlight fell, making Bernini's sculptures look stately and beautiful; though the semi-circular pool and fall of the cascade, and the many jets of the water, pouring and bubbling into the great marble basin, are of far more account than Neptune and his steeds, and the rest of the figures. We descended to the edge of the basin, and bent over the parapet, in order to ascertain the possibility of Lord Melville's having seen Cosmorie incise in the water, or if she could have seen him (for I forget which it was,) at their moonlight interview. It could not have happened. The transparency of the water, permitting the bottom of the basin to be clearly seen, its agitation, and the angle at which one looks into it, prevent any reflection from being visible. The moon, shining brightly overhead and a little behind us, threw our black shadows on the water; and this is what Lord Melville or Cosmorie would have seen, but nothing else.

Thence we went through several streets and through the Piazza of the Holy Apostles, to Trajan's column and forum, skirting along which latter, we tried to imagine its plan and immense extent, only partly indicated by the rows of broken granite columns, that still mark out the direction of the great nave and side aisles of the edifice. The tall shabby structures of modern Rome were ... much of the space over which Trajan's temples and courts extended; and I wish they might be pulled

JAMES ANDERSON
Blencarn 1813-1877 Rome

53 *The Trevi Fountain*, ca. 1862
Albumen print from glass negative
15 x 11 inches (381 x 279 mm)

Collection W. Bruce and Delaney H. Lundberg

James Anderson (born Isaac Atkinson in England) studied art in Paris before moving to Rome in 1837. There he was active both as a painter and a sculptor, producing small bronze reproductions of ancient sculpture.[1] Around 1845 he became interested in photography and was associated with Giacomo Caneva, Frédéric Flachéron, and other members of the Caffè Greco circle. Anderson was friendly with Robert Macpherson, with whom he collaborated in photographing ancient sculpture in the Vatican Museum. In 1859 he issued a list of his photographs of Roman monuments, which could be acquired at the bookseller Joseph Spithöver's shop on Piazza di Spagna.[2] Anderson's work documenting the artistic monuments of Italy was continued by his son, Domenico, and his grandsons until after the middle of the twentieth century.[3]

Constructed between 1732 and 1762, following the designs of Nicola Salvi, the Trevi celebrates the arrival within the city of the waters of the ancient Aqua Virgo.[4] Anderson's photograph, taken around midday, isolates the center of the fountain, where a profusion of sculpture is displayed against an architectural backdrop recalling a triumphal arch. The central figure of Oceanus, lord of water in all of its forms, is shown issuing from his palatial abode in a shell chariot pulled by sea horses accompanied by tritons.[5] The figure of Oceanus is flanked by allegorical figures of Abundance and Health. Above, bas-reliefs illustrate the millennial history of the Aqua Virgo.

By the 1860s, the Trevi Fountain had not yet become a tourist attraction. The practice of tossing coins in the basin to ensure one's return to Rome began only later in the century, encouraged by guidebooks published by Karl Baedeker and others.[6] In *The Marble Faun*, published in 1860, Nathaniel Hawthorne used the Roman setting to contrast the values of the New World with those of the Old, and the Trevi provides the backdrop for a crucial scene set at night. Hawthorne's remarks on the fountain combine two contradictory emotions: his distaste for the perceived excesses of the Baroque style and his apparently reluctant appreciation of its exuberance. His description begins with a reference to "the absurd design of the fountain, where some sculptor of Bernini's school has gone absolutely mad in marble."

In the next paragraph, however, the author's puritanical criticism quickly turns to admiration: he is struck by the Trevi's joyful depiction of nature and the lively civic life the fountain inspires. Hawthorne praises the artificial marine reefs, "strewn with careful art and ordered irregularity." He alludes to the vegetable and fruit dealers, the idlers and tourists, the men with buckets, urchins with cans, and maidens bearing their pitchers on their heads. Ultimately, he cannot resist the ensemble and observes, "And after all, it was as magnificent a piece of work as ever human skill contrived."

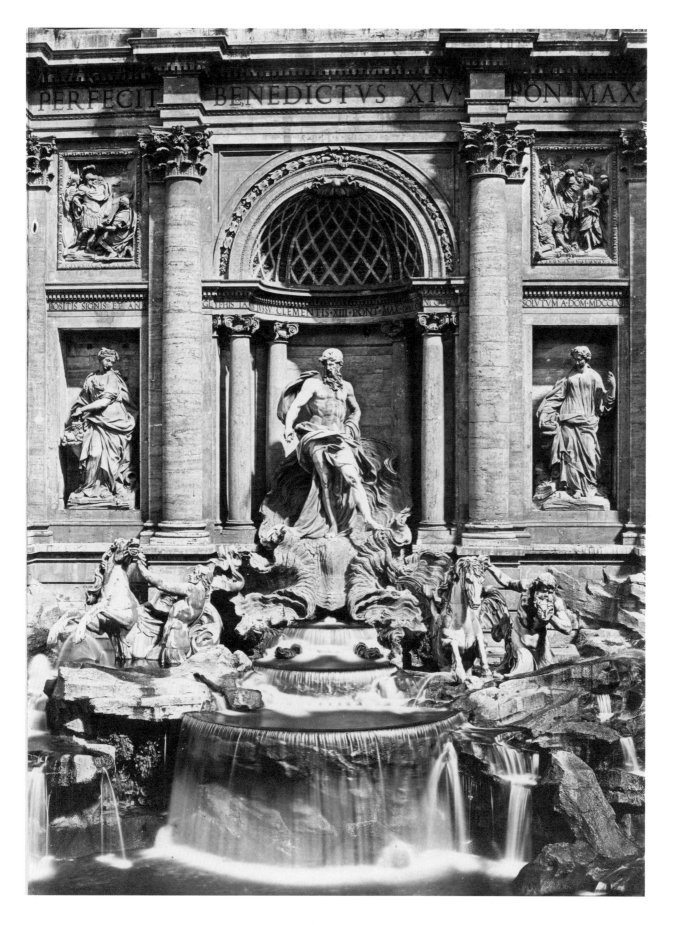

WILLIAM CULLEN BRYANT

Cummington, Massachusetts, 1794–1878 New York

54 *Letters of a Traveller, Second Series,* dated 21 May 1858

Manuscript

8½ x 11 inches (216 x 279 mm)

The Morgan Library & Museum, purchased by Pierpont Morgan, 1909; MA 564.1

Bryant is best known for his poetic evocations of nature, which exerted a powerful influence on the painters of the Hudson River school. Asher Durand's 1849 painting *Kindred Spirits,* in which Bryant is depicted along with Thomas Cole, provides a visual distillation of Bryant's role—to play on a line of Alexander Pope—as the genius of place. Bryant was very much a public figure. As editor of the *New York Evening Post,* he advocated the abolition of slavery and the creation of public parks. He also found time to travel, making no fewer than six extended visits to Europe and the Levant. While abroad, Bryant sent letters back to the *Evening Post* for publication. These were subsequently gathered in two volumes entitled *Letters of a Traveller.*[1]

In spring 1858, he spent thirteen days in Rome, his fourth stay in the papal capital. On previous visits, he had met William Wetmore Story, Margaret Fuller, and other members of the American community.[2] In 1858 Bryant renewed his acquaintance with Story, who introduced him to Nathaniel Hawthorne and Robert Browning, among others.[3] Bryant notes many changes in the city since his first visit in 1835 and comments on the French occupation:

> *The French hold Rome yet—for the Pope. Every morning the streets resound with the tramp of Gallic cavalry. Troops of heavy Norman horses drink from troughs filled by the waters of the Claudian aqueduct, and in the massive Baths of Diocletian are locked up the thunders which at a moment's notice may batter down the city. The stranger who strolls near them with a segar is warned away by the French guards.*

Bryant's letter captures the excitement generated by the discovery of two well-preserved pagan tombs outside of Rome along the via Latina.[4] In locating the tombs, he refers the reader to Sir William Gell's 1834 *Map of Rome and Its Environs* (No. 33). The subterranean chambers had been revealed in 1857 by an amateur archaeologist, Lorenzo Fortunati, who subsequently published an account of his findings.[5] Bryant describes the freshness of the stucco reliefs and paintings adorning the vaults, which include scenes from Homer's *Iliad.*[6] He observes that the discovery attracted a cross section of Roman society and remarks, "There was a great deal of animated and eager discussion under the stucco figures and arabesques, for in Rome art is one of the few subjects on which people are allowed to speak freely."[7]

Among those drawn to the ancient sepulchers, Bryant notes the presence of two cardinals he characterizes as "portly ecclesiastics, whose plump legs were encased in purple stockings." Bryant goes on to comment that cardinals were not permitted to walk within the walls of Rome, the dignity of their office forbidding it. Thus, "whenever they are inclined to fetch a walk, they are obliged to order their carriages and drive out to this solitary Campagna, where they can get out and stretch their legs without reprehension."[8]

with a ladle. At the foot of these five old columns, he would probably find something worth his trouble."

This passion for excavation has been fortunately gratified elsewhere. If you look at ~~Sir William~~ Sir William Gell's Map of the Environs of Rome, you will see traced from near the gate of St. John towards Monte Cavo beyond the Alban lake, an ancient road bearing the name of Via Latina. If you look for it in the Campagna, you will find it covered with grass and cattle grazing over it. On the line of this buried street and not far from the city walls, workmen, employed by the Pope are breaking the green turf and trenching the ground to a considerable depth. They have laid bare several solid masses of Roman masonry, and the foundations of an ancient Christian church, a basilica, over which were scattered in the soil, many marble columns with Corinthian Capitals and bases ~~inscribed~~ on which is carved the figure of the Cross, indicating beyond a question the purpose of the building. But the most remarkable of these discoveries are two places of sepulture, consisting of vaults wrought in the earth, to which you descend by ~~three~~ staircases of stone. The earth had fallen into the entrances and closed them and had nearly filled the space within, so that the stucco medallions and paintings overhead were found in as perfect preservation as when they came from the hands of the artist. In one of these tombs, which consisted of a single vaulted chamber with a pure white surface, I found an artist perched upon a high seat over two huge stone coffins, copying the spirited and fanciful figures of men and animals with which the arched ceiling was studded. The other tomb is larger and deeper in the ground, and consists of two

M.A. 564.

vaulted chambers, communicating with each other against the walls of which stood marble sarcophagi each with figures in high relief. On the ceiling of one of the rooms, among the stucco medallions are arabesques in vivid colors, and landscapes in fresco which show a far more advanced stage of this branch of the art, than any thing which has been found at Pompeii. They are painted in what seems to me a kind of neutral tint. Here are trees with gnarled branches, and foliage drawn with a free and graceful touch, and buildings rising among the trees and figures of people engaged in rural employments, and all is given with a decided and skilful aerial perspective, the objects becoming less distinct as they recede from the eye. ~~the trees~~ "Two years hence," said the artist who accompanied us on that excursion "you may see all these figures engraved and published in a book. Here at Rome we never do any thing in a hurry."

It is not unlikely, that the admission of the external air will cause the stucco to peel from these vaults, or at least will cause the paintings to fade. "I think," said an Italian the artist, "that the landscapes are less distinct now than they were ten days since." In the mean time, all Rome is talking of this discovery; it is the great topic of the time. Numbers of people are constantly flocking out of Rome to visit the excavations on the Via Latina. As we approached the city the other day, by the magnificent paved road called the New Appian Way, we wondered why all Rome should be pushing out to the Campagna; so many people did we meet walking, or so many

WILKIE COLLINS

London 1824–1889 London

55 Letter to Charles Ward, signed and dated Rome, 14 January 1864

8 x 10¾ inches (207 x 274 mm)

The Morgan Library & Museum, purchased 1970; MA 3151.48

Several years after the success of his groundbreaking novel *The Woman in White*, published in 1860, Collins, who suffered from gout, traveled to the Continent for his health. This letter is written from Rome to his family banker, Charles Ward.[1] Collins and Ward were on intimate terms, having traveled together in the 1840s.[2] Collins begins by thanking Ward for having sent him a supply of snuff, remarking that "my bereaved Nose has been in a state of placid cheerfulness ever since." He goes on to describe seeing Pope Pius IX taking snuff as he passed in his carriage:

> I encountered the Pope yesterday, in the Trastevere on the other side of the Tiber, in a street about the width of Cranbourn Alley.[3] An outrider in green came clattering by to drive all vehicles out of the way, or the state coach could not have got by at all. It was followed by a fat member of the Guardia Nobile with his legs almost bursting out of his blue breeches, and his cheeks quivering like jelly as the horse shook him in the saddle. Then two dragoons—then the state coach, an amazing vehicle of the period of two hundred years since—the Pope smiling at the window with the most perfect good humour, and comforting himself with a pinch of snuff. I had just closed my own box—and I felt a sympathy with His Holiness which no words can describe.

The letter continues with an account of Collins's visit to Santa Maria in Trastevere:

> The same day I saw the Pope, I saw a church founded in the <u>year 224</u> (what do you think of that for antiquity?)—with splendidly preserved mosaic pictures six hundred years old—and with the stone exhibited (a spanker, I can tell you!) that was hung round the neck of St. Calixtus before the pagans pitched him head foremost into a well. The columns of the church were of red granite from an old temple, and the ceiling of gold was designed by Domenichino. It was a dim and solitary—a mysterious, awful and ancient place.[4]

Elsewhere in the letter, Collins records that he is "at work again constructing my story. If I know anything about it, I have got a fine subject this time—something entirely new at any rate." The reference is to his novel *Armadale*, published serially in *The Cornhill Magazine* in 1864–66. A description of one of the characters, a young woman called Miss Milroy, reflects the author's dual interest in photography and classical sculpture, likely stimulated by his time in Rome.

> Her nose was too short, her mouth was too large, her face was too round and too rosy. The dreadful justice of photography would have had no mercy on her; and the sculptors of classical Greece would have bowed her regretfully out of their studios.[5]

would drive me distracted. There is one price for the Pope's gold, and another for Victor Emmanuel's, and another for Louis Napoleon's and another for silver — and I have opened an account with Neubom, and have got a primitive Roman cheque-book — and when I don't make mistakes (which I generally do) I get paper-money to pay in, and paper money is at par (and I have I don't know how much, and there is my Financial Statement for the present Session!

My little domestic landscape begins to look brighter at last. Caroline is very much better — able to walk out, and beginning to show some faint signs of colour in her cheeks. She wants to be at home again (how like cats women are!) — and bids me tell you with her kind regard that she wishes she was pouring you out a glass of dry sherry on a nice gloomy English Sunday afternoon. Caroline Junior has had a dirty tongue — but we threw in a little pill and fired off a small explosion of Gregory's Powder — and she is now in higher spirits than ever, and astonishes the Roman public by the essentially British plumpness of her cheeks and calves. As for me, I so am thriving in the cold — and I am at work again constructing my story. If I know anything about it, I have got a fine subject this time — something entirely new at any rate. And so the Times is beginning to put me on

the back — is it? Well, we shall see what they say to my next book if ~~[struck out]~~ I live to write it.

I encountered the Pope yesterday, in the Trastevere on the other side of the Tiber, in a street about the width of Cranbourn alley. An outrider in green came clattering by to drive all vehicles out of the way, or the state coach could not have got by at all. He was followed by a fat member of the Guardia Nobile with his legs almost bursting out of his blue breeches, and his cheeks quivering like jelly as the horse shook him in the saddle. Then two dragoons — then the state Coach, an amazing vehicle of the period of three hundred years since — the Pope smiling at the window with the most perfect goodhumour, and comforting himself with a pinch of snuff. I had just closed my own book — and I felt a sympathy with His Holiness which no words can describe.

How you would enjoy this place! Can't you get sent on some commercial mission while I am here? The same day I saw the Pope, I saw a church founded in the year 224 (what do you think of that for antiquity?) — with splendid preserved Mosaic pictures six hundred years old — and with the stone (a shanker, I can tell you!) that was hung round the neck of St Calixtus before the Pagans pitched him head foremost into a well, sworn

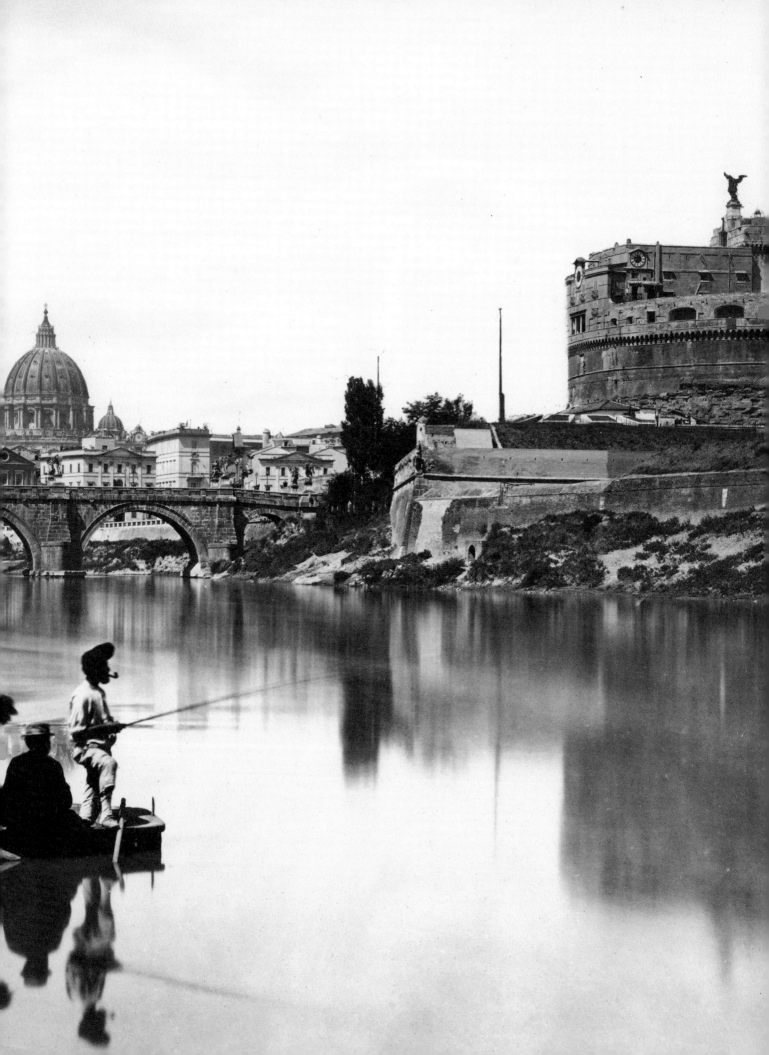

FROM DRAWING AND ETCHING
TO PHOTOGRAPHY

GIOVANNI BATTISTA PIRANESI
Mogliano Veneto 1720–1778 Rome

56 *Catalogue of Published Works*, ca. 1780

Etching

22⅜ x 17 inches (570 x 430 mm)

The Morgan Library & Museum, purchased on the Gordon N. Ray Fund, 2004; PML 129543

Throughout his career, Piranesi was actively engaged in marketing his etchings and publications. The captions on individual prints in his series of Roman Views (*Le vedute di Roma*) often included the price of other prints in the series as well as the address where they could be purchased. As early as 1761, Piranesi issued the first broadsheet catalogue of his works, listing, among other items, the fifty-nine *vedute* that had appeared by that date.[1] Over the course of the remaining seventeen years of his life, Piranesi issued as many as twenty-seven different states of this broadsheet, gradually filling every available surface of the copperplate as his publications and prints proliferated.[2] By the early 1770s, he had run out of space. An additional plate was added at the bottom to accommodate the artist's ever-growing inventory, resulting in a more pronounced vertical format.

The titles of prints that appeared in the intervals between states were often inked in by hand; there are also examples with handwritten dedications. Copies of the catalogue were frequently added to bound volumes sent to subscribers, and it is likely that they were posted in places where tourists congregated, such as the Caffè Inglese near the Spanish Steps.[3] Following Piranesi's death in 1778, his son Francesco assumed control of his printmaking enterprise and continued to issue updated states of the etched catalogue. This is an early posthumous state, which lists one of Francesco's publications that appeared in 1780.[4]

Often referred to as the "etched catalogue" (*catalogo inciso*), the different states of the broadsheet have aided Piranesi scholars in dating the appearance of prints in the Vedute di Roma series.[5] They also provide valuable information about the prices eighteenth-century collectors paid for his work. In 1761, for example, one *veduta* cost 2 *paoli*, a sum that would purchase a three-pound turkey.[6] The complete run of fifty-nine *vedute* could be purchased for 15 *scudi*, one-and-a-half times what it cost to maintain a healthy diet for a family of four.[7]

The broadsheet provides a striking example of Piranesi's imaginative approach to graphic design, in which illusionism, layering, and overlap combine to engage the viewer's interest. Like a computer program's drop-down menu, Piranesi's illusionistic sheets artfully overlap one another.[8] They have curling edges and appear to be held in place by pins that cast shadows. Fictive metal clamps affix the main sheet to an underlying stratum of richly textured Roman masonry. The sheets partially obscure a range of other imagery, including several printed views—one depicting St. Peter's Square. At the upper left, an inscribed marble plaque announces the subject of the broadsheet. A selection of antiquities is arranged on a trompe-l'oeil shelf at the bottom of the upper plate. These are the type of artifacts—often imaginatively restored—that were on sale at Piranesi's house-museum in the Palazzo Tomati, the address of which appears immediately below the shelf.

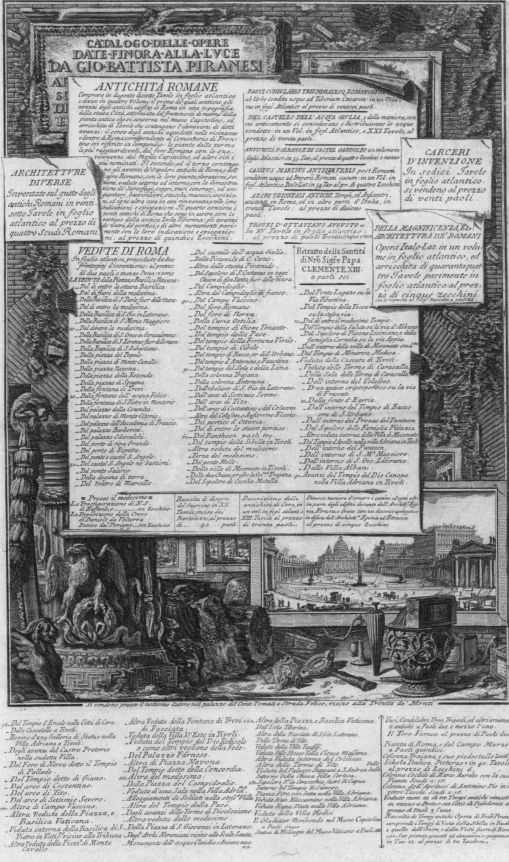

ROBERT TURNBULL MACPHERSON
Dalkeith 1814–1872 Rome

57 *Macpherson's Photographs,* Rome, Robert Turnbull Macpherson, 1862
Printed broadside
20½ x 14 inches (520 x 360 mm)

Collection W. Bruce and Delaney H. Lundberg

In much the same way that Piranesi had published updated lists of the etched views and publications available for purchase in his house-museum (No. 56), Macpherson issued similar lists of the photographic prints that could be acquired from his studio. His lists provide insights not only into his career but also into the relationship between tourism, guidebooks, and the marketing of photographs.[1]

The first of Macpherson's lists, consisting of 143 titles, appeared in 1857.[2] The present broadside, printed in 1862, lists 297 subjects. On it, the address of the photographer's studio is given as Vicolo d'Alibert, near the Spanish Steps. The following year, Macpherson published a collection of photographs of ancient sculpture in the Vatican Museum, accompanied by his own commentary and woodcuts executed by his wife, Geraldine Bate.[3] In the introduction to this work, Macpherson stated, "I remain a photographer to this day, without any feeling that by doing so I have abandoned or have in any way forfeited my claim to the title of artist."[4]

Other specialized lists followed, including one in 1865 dedicated to paintings in the Vatican and another of 1871 devoted to the ancient sculpture in the Capitoline Museum. The last general list, of 1871, totals 420 subjects. The emphasis is on the ancient city, but there are many photographs of later monuments, such as the Spanish Steps (No. 14). Sites in the campagna and environs of Rome are well documented; there are 16 images of Tivoli, for example (No. 36). A few other central Italian cities, such as Orvieto and Perugia, are represented, but Macpherson did not venture north into Tuscany or south to the Bay of Naples.

Macpherson's lists were one important component of his commercial enterprise. For publicity he also relied on recommendations and advertisements, especially those in the popular guidebooks. The 1856 edition of Murray's *Handbook for Travellers in Central Italy,* for example, included the following notice:

Photography has been of late very successfully applied in delineating the monuments of ancient and modern Rome. By far the finest are those made by our countryman Mr. Macpherson.[5]

Macpherson's name does not appear in the 1867 edition of Murray's *Handbook,* however. A public exchange of correspondence between Murray and Macpherson in the pages of the London *Athenaeum* explains why.[6] Macpherson accused Murray of blackmail; Murray countered with a charge of bribery. Macpherson alleged that Murray's agent, a Mr. Pentland, had repeatedly demanded—and received—photographs in exchange for such positive notices. In Macpherson's telling, when he refused to provide Pentland with additional photographs, his identity in the *Handbook* was downgraded from "countryman" to "Canadian," which clearly injured his Scottish pride.

For his part, Murray announced that he was returning Macpherson's photographs, denying that "praise or blame in the *Handbook* can be purchased by gift." In another letter, Murray wondered "whether you might not rather prefer that I should cause your name to be left out altogether in the future, so as to avoid all risque [*sic*] of displeasing you further."

MACPHERSON'S
PHOTOGRAPHS
ROME
1st March 1862.

The photographs named in this list are of one uniform price, namely one scudo each.

GIOVANNI BATTISTA PIRANESI
Mogliano Veneto 1720–1778 Rome

58 *View of the Ponte Sant'Angelo and Castel Sant'Angelo,* 1750–51
Etching
21½ x 33½ inches (546 x 851 mm)

Vincent J. Buonanno Collection

Piranesi's composition is anchored on the right by the cylindrical mass of the Castel Sant'Angelo, the papal fortress that commands the bridge to the Vatican. Its fortified superstructure rises from the remains of Hadrian's Mausoleum, constructed in the second century A.D., together with the bridge, known as the Pons Aelius. The name Castel Sant'Angelo derives from a legend, according to which in the year 590 Pope Gregory the Great, while conducting a procession to pray for an end to the plague in Rome, beheld the Archangel Michael sheathing his sword above the castle as a token that the pestilence would cease.

During the Middle Ages, the bridge, rechristened Ponte Sant'Angelo, became associated with the pilgrims going to and from the Vatican. In 1669–71 Pope Clement IX added the series of ten angels displaying the instruments of the Passion designed by Bernini. With their installation, passage across the bridge constituted the first act of an extended sacred drama extending to Bernini's piazza (a portion of which is visible between the houses of the Borgo) and climaxing inside the basilica, where many of the actual relics were venerated (No. 7).

The soaring profile of Michelangelo's dome of Saint Peter's occupies the center of Piranesi's composition, providing its visual apex. In the space between the cupola and the Castel Sant'Angelo, the Vatican Palace complex is visible, while to the left of the basilica are the hospital of Santo Spirito in Sassia and the Janiculum Hill.

The foreground is devoted to the Tiber and its banks. On the left side, the buildings extend to the river's edge. These include the Teatro Tor di Nona, the most technically advanced theatre of Baroque Rome. The bastions and fortified outworks of the Castel Sant'Angelo dominate the opposite side. Picturesque fishing boats, one dragging its net, ply the river, which reflects the bridge. This is the way the Tiber appeared before the construction of the embankments in 1889–90, which prevented flooding but destroyed the river's intimate relationship with the city.

Partially hidden by shadows cast by the overhanging buildings, the mud flats in the left foreground are teeming with activity that illustrates a different aspect of papal Rome from the celebrated ancient and Christian monuments dear to foreign visitors. Three carts are discharging garbage collected from the city streets, while to the right, other figures scavenge for valuables in a sewer outlet.[1] Montesquieu, writing in 1731, commented on this practice, which continued into the 1880s: "They put it [the city's filth] in a place where the Tiber runs. It leaves things of value which are in the rubbish, like pieces of silver, lost jewels, antique items, and carries away the muck."[2] The accumulated refuse would fester, often for months, until the periodic flooding of the Tiber washed it away.

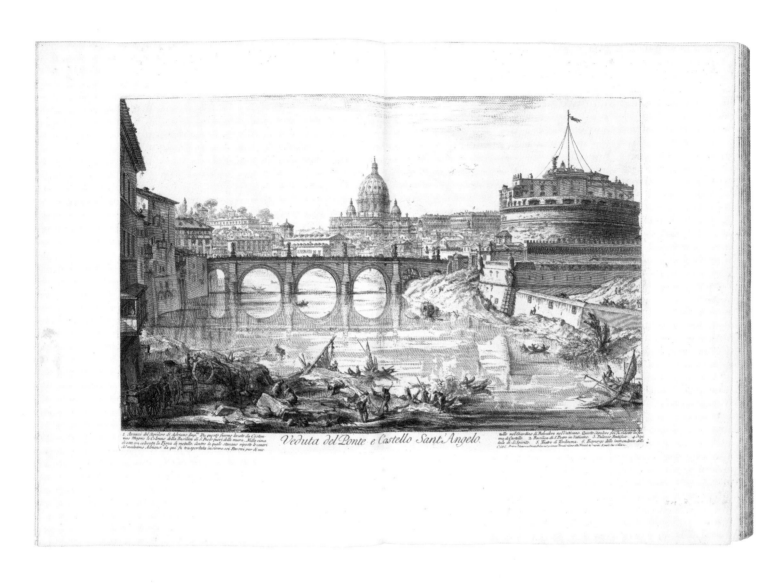

Veduta del Ponte e Castello Sant'Angelo.

GIOACCHINO ALTOBELLI
Terni 1814–after 1878 Rome

59 *The Tiber with Castel Sant'Angelo and St. Peter's,* ca. 1868
Albumen print from glass negative
14⅞ x 10½ inches (166 x 121 mm)

Collection W. Bruce and Delaney H. Lundberg

Before taking up photography, Altobelli was a genre painter and kept a studio on via Margutta. Around 1860 he joined Pompeo Molins in the practice of photography, moving to the via Fontanella Borghese (see No. 65). After separating from Molins in 1865, Altobelli moved to a studio of his own on via della Ripetta. In 1866 he was granted a patent for a composite photographic process involving two negative plates that allowed him to produce images that appeared to be moonlit even though they actually were exposed in daylight.[1] In 1870 he photographed a reenactment of the attack on Porta Pia that ended papal rule in Rome (see No. 17).

Altobelli essentially replicated the composition of Piranesi's etched view but with crucial differences (see No. 58). The long exposure conferred a glassy quality to the water surface, which in turn produced a murkier reflection of the bridge and castle than seen in Piranesi's print. Altobelli brought the viewer closer to the foreground figures, a group of fishermen silhouetted against the water.[2] Piranesi's garbage scavengers have been banished, giving way to a more serene and meditative mood. All the same, the clothes and activity of the fishermen—who were compensated for posing and providing local color—identify them as members of a social class well below that of the increasing number of tourists flocking to Rome with their Baedekers.

Three writers provided widely differing responses to the three main architectural monuments of this composition. Charlotte Eaton, ever critical of the Roman Church and the Baroque style, singled out the angels of the Ponte Sant'Angelo for censure.

> We crossed … through a goodly company of angels, drawn up opposite to each other, exactly as if they were performing a country dance, and standing 'on the light fantastic toe,' in the most distorted and affected attitudes imaginable. These frightful creatures are the production of Bernini and his scholars. Another, larger, and, if possible, still more hideous—a great angel in bronze, crowns the summit of the Castle San Angelo, flapping his wings, and staring you full in the face.[3]

Nathaniel Hawthorne, in *The Marble Faun,* commented on how expectation and the imagination shaped the experience of this iconic view.[4]

> Hilda and her companion … saw … the Castle of St. Angelo; that immense tomb of a pagan emperor, with the archangel at its summit.
> Still farther off appeared a mighty pile of buildings, surmounted by the vast dome, which all of us have shaped and swelled outward, like a huge bubble, to the utmost scope of our imaginations, long before we see it floating over the worship of the city.[5]

Early in 1841 John Ruskin crossed the Ponte Sant'Angelo and was struck by "the Turner clouds above—scarlet" and the papal standard waving "broad in the sun." It was, he noted in his diary, "The best thing I have seen in Rome yet."[6] Much as Ruskin viewed the Roman sunset through the eyes of Turner, Altobelli composed his photograph in the long shadow of Piranesi, who continued to exert a powerful influence on how the city was portrayed well into the nineteenth century.

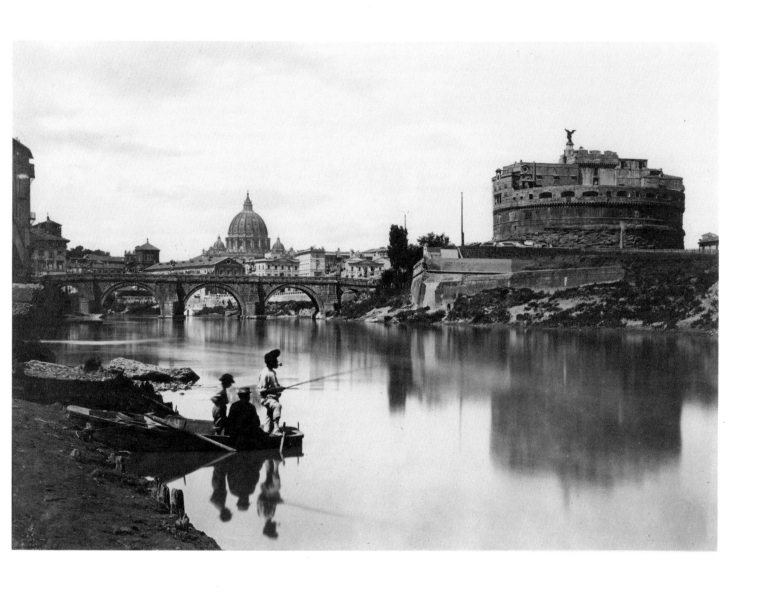

Attributed to PIERRE-HENRI DE VALENCIENNES
Toulouse 1750–1819 Paris

60 *Grotto of the Nymph Egeria*
Oil on paper, mounted to canvas
15 x 21 inches (381 x 533 mm)

The Morgan Library & Museum, Thaw Collection

Valenciennes was a liminal figure in the history of French landscape painting. On the one hand, he should be seen in relation to such eighteenth-century masters as Hubert Robert and Joseph Vernet. On the other, his emphasis on plein-air painting prepared the way for Corot and other nineteenth-century artists. He published an influential treatise on landscape painting in 1800 and played a decisive role in establishing the Prix de Rome in historical landscape, the first winner of which was his pupil Achille-Etna Michallon (see Nos. 28 and 64).[1]

Valenciennes first visited Rome in 1777, when Piranesi was still alive and David was at the French Academy. From 1778 to 1782 he resided on the via del Babuino in the artists' quarter and remained active in Rome until his return to France in 1785.[2] Unlike Piranesi, Valenciennes tended to avoid the monumental set pieces of Rome, preferring subjects off the beaten track. He also emphasized what might be termed simple visual facts over grandiose scale and dramatic contrasts of light and shadow.

The subject of this oil sketch is an ancient Roman nymphaeum, or fountain grotto, traditionally associated with the nymph Egeria.[3] In this composition the brick walls of the grotto reach out to embrace the observer. At the center, in deep shadow, is the terminal concavity from which a natural spring emerges. The ruins seem to revert to a state of nature, with pendant vines suspended from the vault and a leafy crown of verdure silhouetted against the sky. Byron captured this fusion of art and nature perfectly in *Childe Harold*:

> *The mosses of thy fountain still are sprinkled*
> *With thine Elysian water-drops; the face*
> *Of thy cave-guarded spring with years unwrinkled,*
> *Reflects the meek-eyed genius of the place,*
> *Whose green, wild margin now no more erase*
> *Art's works; nor must the delicate waters sleep,*
> *Prisoned in marble, bubbling from the base*
> *Of the cleft statue, with a gentle leap*
> *The rill runs o'er, and round, fern, flowers, and ivy, creep,*
> *Fantastically tangled; . . .*[4]

Byron's lines allude to one of Juvenal's *Satires,* in which the ancient author criticized the way in which a grotto sacred to Egeria had been desecrated by the hand of man:

> *We go down to the Valley of Egeria, and into the caves so unlike to nature: how much more near to us would be the spirit of the fountain if its waters were fringed by a green border of grass, and there were no marble to outrage the native tufa!*[5]

Byron thus added a third—and distinctly Romantic—level of meaning: with the passage of time, shrines originally fashioned from nature but subsequently profaned by the artifice of man eventually become ruins and revert to a state of nature. Valenciennes's oil sketch eloquently captures the picturesque appearance of this artificial grotto reclaimed by nature.

ROBERT TURNBULL MACPHERSON
Dalkeith 1814–1872 Rome

61 *The Grotto of Egeria*, before 1858
Albumen print
12⅛ x 15⅝ inches (308 x 442 mm)

Collection W. Bruce and Delaney H. Lundberg

Situated about a mile and a half outside the Porta San Sebastiano, the Grotto of the Nymph Egeria looks out on the Valle della Caffarella, one of the few portions of Rome's periphery that retains something of its pastoral character. The grotto's rural setting and picturesque appearance have long attracted artists. In the seventeenth century, Claude Lorrain produced a series of plein-air sketches of the grotto and its environs.[1]

The association of this site with the nymph Egeria dates back to the Renaissance, and the identification—though mistaken—has enriched both art and literature for several centuries. (The legendary site where King Numa Pompilius held his secret meetings with the nymph Egeria was situated at the base of the Caelian Hill, well within the Aurelian Walls and nowhere near the Valle della Caffarella.)[2] In antiquity the nymphaeum may have been part of the estate of Herodes Atticus.

Macpherson's composition brings the viewer within the central chamber of the Grotto of Egeria, producing a more direct and intimate sensation of envelopment than Pierre-Henri de Valenciennes's oil sketch, which distances the observer (see No. 60). This shift of viewpoint emphasizes the richly textured walls of the ancient nymphaeum, especially the reticulate masonry visible in the upper portion of the rear wall. Macpherson's lens also captured the marble figure of a reclining river god set immediately above three outlet channels, from two of which water flows into the basin below. The statue was put in place during the sixteenth century and appears in numerous prints and drawings from that point on.[3]

The mythic associations of the Grotto of Egeria, together with its isolated and picturesque setting, appealed to the Romantic sensibility. Charlotte Anne Eaton's 1818 description is typical:

The sides of the grotto are overhung with the beautiful Capillaire plant, that loves to grow on rocks that drink the water drop. This spot, though much more beautiful in painting than in reality, is, however, highly interesting, and it is now abandoned to a solitude as profound as when Numa first sought its enchanted glade.[4]

The abundance of flora that hangs from the damp, moss-covered walls and vault impressed Hans Christian Andersen, who set a scene in his novel *The Improvisatore* in the grotto. Andersen's youthful narrator stops here on his way to visit one of the numerous catacombs that occupy the surrounding subsoil. While enjoying a rustic breakfast, he observes:

The walls and vault of the whole grotto were inside covered over with the finest green, as of tapestry, woven of silks and velvet, and round about the great entrance hung the thickest ivy, fresh and luxuriant as the vine foliage in the valleys of Calabria.[5]

At times, the site was not just overgrown but inaccessible; in 1881, the archaeologist Rodolfo Lanciani was frustrated in his attempt to approach the grotto by a herd of fierce bulls that enjoyed wallowing in its cool aura, menacing all would-be visitors.[6]

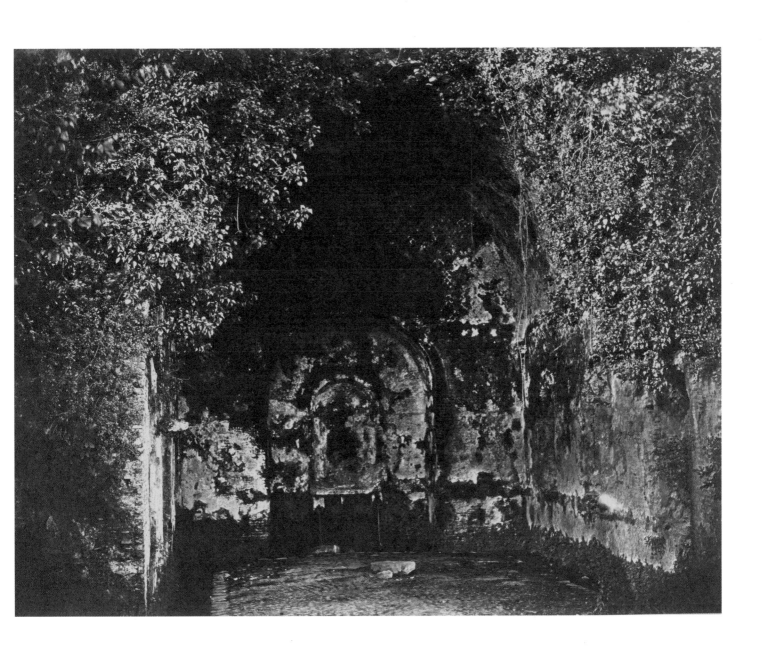

JEAN-AUGUSTE-DOMINIQUE INGRES
Montauban 1780–1867 Paris

62 View of S. Maria Maggiore

Graphite, with pen and brown ink and wash
7⅛ x 9⁹⁄₁₆ inches (182 x 243 mm)
Signed and inscribed in graphite at lower center, *Ingres à Adele.*

The Morgan Library & Museum, Thaw Collection

At the time of Ingres's arrival in Rome in 1806, the French Academy was newly established in the Villa Medici on the Pincian Hill.[1] He soon moved into a studio in the pavilion of San Gaetano, at the northwest corner of the villa's gardens. No doubt encouraged by François-Marius Granet, one of his fellow pensionnaires who had also frequented David's studio, Ingres began to explore Rome through the medium of drawing (see No. 40).

When the term of his fellowship ended in 1810, Ingres stayed on in Rome for another decade, residing near the Villa Medici at via Gregoriana, 40. During this turbulent period, which saw the collapse of Napoleon's rule in Italy, the artist supported himself with a variety of commissions, including portrait drawings of fellow artists and notable visitors to the Eternal City. Many of these portraits include Roman monuments as backdrops. In 1820 Ingres left Rome for Florence and then Paris, but he returned in 1835 as director of the French Academy.

Ingres's highly sophisticated drawing technique, especially his delicate yet firm use of line and mastery of contours, was ideally suited to the representation of cityscapes and views of individual monuments. His preferred materials were sharply pointed graphite pencils on smooth white paper.[2] It is worth noting that in spite of the Continental blockade occasioned by the Napoleonic Wars, Ingres was able to secure high-quality English paper, like this sheet, in Rome.[3] The inscription indicates that Ingres gave the drawing to Adèle Maizony de Lauréal, whose portrait he repeatedly drew in 1813–14.[4]

Among Ingres's numerous drawings of Rome, the area surrounding the Basilica of S. Maria Maggiore is particularly well represented.[5] In several views made between 1813 and 1814, the basilica appears embedded in the city, its lower portions hidden from view by neighboring houses and towers. In this drawing, it is partially obscured by the rise in ground elevation and the row of houses at left. The twin domes of the Sistine and Pauline Chapels, the medieval bell tower, and the sculpture crowning the facade all project into the sky. So, too, does the bronze statue of the Virgin, accented by wash, which stands atop a colossal ancient column erected on axis with the basilica. Below and to the right of the Marian statue, a monument commemorating the absolution of Henry IV is visible (see No. 63). Ingres used the baroque facade as a scenic backdrop for a religious procession that appears to come from the basilica.

Ingres à Abele.

FRANCESCO ADRIANO DE BONIS
Active 1855–1865

63 *S. Maria Maggiore*, 1860–65
Albumen print from glass negative
7¾ x 8½ inches (195 xx 240 mm)

Collection W. Bruce and Delaney H. Lundberg

Among the numerous photographers active in Rome during the second half of the nineteenth century, de Bonis remains a shadowy figure.[1] His name does not appear in the list of photographers in Rome compiled by the papal police in 1867.[2] We do know, however, that he worked on commission with John Henry Parker, along with Baldassare Simelli and other photographers, in the years before 1869.[3] De Bonis used an ink stamp (*AdB*) and a blind stamp (*AB*) to identify his photographs; the corpus of images marked in this way continues to grow.

Many of de Bonis's compositions provide a fresh, and distinctly modern, view of Rome, one that offers new perspectives on familiar monuments and seeks out unusual subjects. These images offer a photographic approach that is less monumental, more personal and nuanced. This photograph is a case in point. The artist eschewed a composition that would reveal the entirety of the basilica's facade, preferring instead a view that partially obscured it. The proximity of his camera to the memorial column in the foreground has the effect of increasing its apparent size and relating it to other more distant vertical elements, the bell tower of the basilica at center and the statue of the Virgin atop an ancient column at the upper left. The figure seated rather uncomfortably on a bollard in the left foreground further complicates the relationships of scale as well as introduces a touch of contemporary humanity into the marmorial stillness of the scene.

This photograph brings us closer to the principal monuments visible in Ingres's drawing of half a century earlier (No. 62). The tall fourteenth-century bell tower of the basilica is precisely center, while the cupola marking the Chapel of Pope Sixtus V appears to the right. Ferdinando Fuga's exuberant Baroque facade, partially hidden from view, appears to the left of center.

On the skyline to the left, a colossal column supporting a larger-than-life-size bronze statue of the Immaculate Virgin is partially blocked from view. In 1614 Pope Paul V Borghese had the column brought to this site from its original location in the Basilica of Maxentius overlooking the Forum. The silhouette of the crescent moon on which the Virgin stands echoes its miniature counterpart on the cruciform finial of the monument in the foreground. It was erected in 1596 by Pope Clement VIII Aldobrandini to celebrate the absolution of Henry IV following the French king's renunciation of Protestantism.[4] The unusual shape of the red granite column shaft, which resembles a long-barreled canon known as a culverin, alludes to the Wars of Religion. Henry's conversion to Catholicism is reputed to have occasioned his remark that "Paris is well worth a Mass."

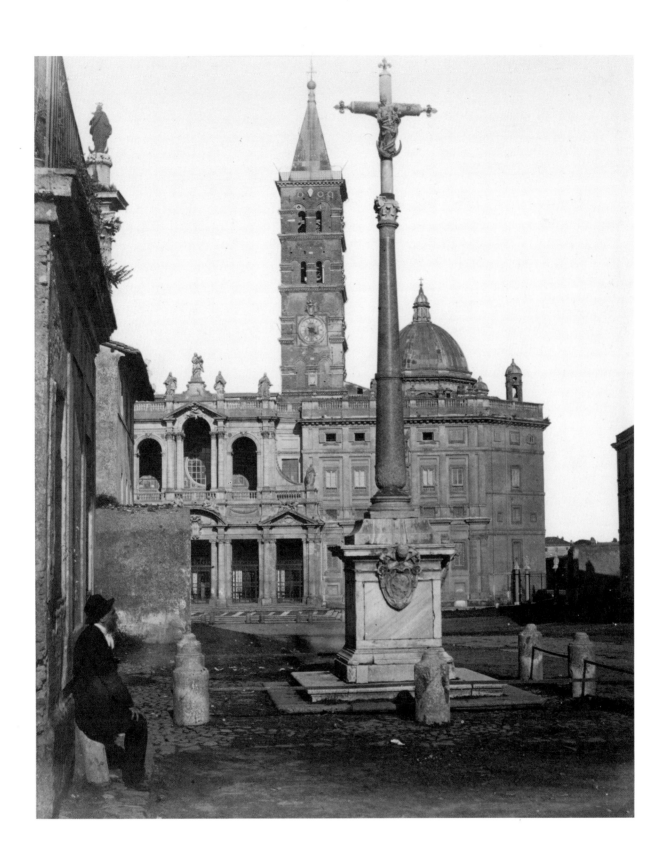

ACHILLE-ETNA MICHALLON
Paris 1796–1822 Paris

64 *View of the Trinità dei Monti*, 1818

Pen and brown ink, brown wash, over graphite
9¹⁵⁄₁₆ x 7³⁄₁₆ inches (253 x 183 mm)
Signed and dated in pen and brown ink at lower left, *Michallon 1818 Rome.*

The Morgan Library & Museum, Thaw Collection

Born into a family of artists, Michallon entered the École des Beaux Arts in 1810, where he studied with the plein-air painter Pierre-Henri de Valenciennes (see No. 60).[1] Michallon specialized in landscape and was the first winner of the Prix de Rome for *paysage historique*.[2] His work in this genre contributed to a revival of landscape painting, which had fallen into decline during the first decade of the nineteenth century.

Following Michallon's arrival in Rome in 1818, he became friends with François-Marius Granet and frequented the community of Nazarene artists. While based at the French Academy, Michallon frequently depicted sites in the Roman campagna, including Tivoli, Subiaco, and Olevano.[3] In 1819 Michallon turned to depictions of the human figure and local costume.[4] In ill health, the artist returned in 1821 to Paris, where he opened an atelier for young artists. During the year preceding his premature death in 1822, Michallon often accompanied his students, among whom was Camille Corot, to paint *en plein air*.[5] One of Michallon's oil sketches executed in the Forest of Fontainebleau depicts a fallen oak tree, the gnarled bark of which recalls the tree trunk in this drawing.[6]

Framed by the overarching boughs of an ilex, Michallon's composition extends from the fountain in the shaded foreground to a cascade of more distant monuments bathed in light and silhouetted against the sky. Closest and most prominent are the convent and twin-towered facade of Trinità dei Monti. Directly in front of the church is the obelisk that once stood in the Gardens of Sallust and was erected on this site by Pius VI in 1789. The obelisk partially obscures the more distant tower of the Papal Palace on the Quirinal. Below and to the right of the obelisk base, a flight of steps descends to the lower portions of the city, connecting to the Salita di S. Sebastianello. A picturesque figure leans on the parapet; directly above him Francesco Borromini's bell tower and encased dome of S. Andrea delle Fratte project into the skyline. Just to the right of S. Andrea appears the profile of the medieval Torre delle Milizie.

The proximity of the fountain to the Villa Medici ensured that it was often depicted by the French artists residing there. The pensionnaires also took advantage of a more elevated position within the Villa Medici to represent much the same view looking south, anchored by the convent and church of Trinità dei Monti.[7] Comparison with Pompeo Molins's photograph of the Villa Medici fountain (No. 65) is instructive. Employing different media, both artists play upon the reflective qualities of water, the silhouetted figures, and the contrast between natural forms and the built environment. In addition, both make use of contrasts between a dark foreground and a bright skyline to establish spatial continuity extending from the foreground to the distant horizon.

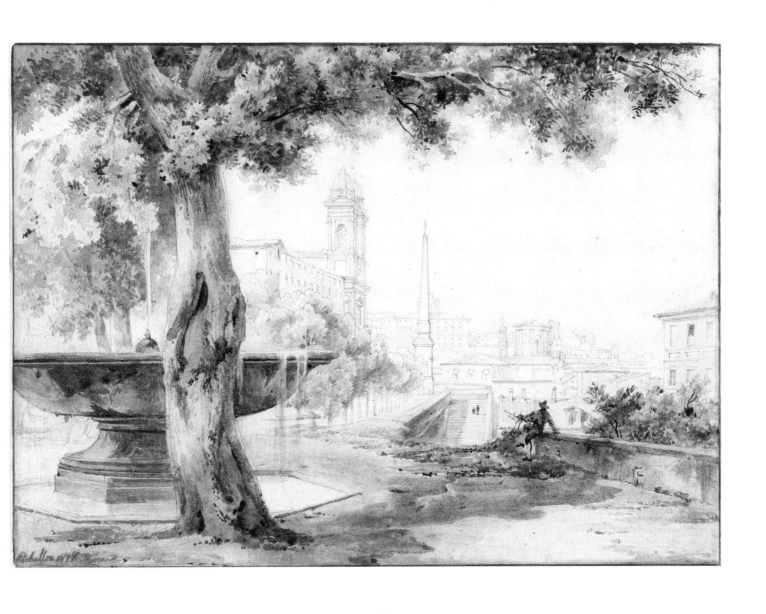

POMPEO MOLINS
Rome 1827–ca. 1900 Rome

65 *The Fountain of the Villa Medici,* 1862
Albumen print from glass negative
10 x 14½ inches (254 x 368 mm)

Collection W. Bruce and Delaney H. Lundberg

Before dedicating himself to photography, Molins studied with the painter Tommaso Minardi (1787–1871), whose style was much influenced by the "purism" of Ingres and the Nazarenes. After turning to photography, Molins joined forces for five years (1860–65) with another of Minardi's students, Giaocchino Altobelli.[1] Their photographic studio was located in the heart of the artists' quarter, on via Fontanella Borghese, 46. During this period, Molins and Altobelli enjoyed exclusive rights as the official photographers of the French Academy and the recently created papal railway. After separating from Altobelli, Molins continued to practice, moving in 1880 to a shop on the via dei Condotti, even closer to the Spanish Steps. Over the course of his professional career, Molins appears to have acquired the negatives of other photographers, many of which were lost in a fire in 1893.

The fountain is closely associated with the history of the Villa Medici. The basin of Egyptian red granite was acquired by Cardinal Ferdinando de' Medici in 1587 from the monks of S. Salvatore in Lauro.[2] This was one of many antiquities acquired by Cardinal de' Medici to adorn his villa and gardens, which were nearing completion at this time. The cardinal was an influential member of the commission charged by Pope Sixtus V (Felice Peretti) with conveying the water of the Acqua Felice to Rome.[3] The Acqua Felice was capable of supplying the more elevated portions of the city, such as the Pincio, from which the cardinal directly benefited.

The picturesque setting of the fountain on the edge of a shady parapet overlooking Rome, with a view of Saint Peter's in the distance, ensured that it was a popular subject for artists (see Nos. 64 and 67). Goethe sketched it in 1787. After 1803, when the Villa Medici became the site of the French Academy, it was repeatedly depicted by French artists, notably Ingres and Corot.[4] In the early twentieth century, Ottorino Respighi took the Pincian fountain at sunset as the subject of one of the tone poems comprised by his *Fountains of Rome.*

Molins's composition brilliantly plays on contrasts of light and shade, near and far. The dark central orb emerges from the brilliant reflective surface of the water in the basin, its silhouette mimicking that of St. Peter's dome in the distance. Other features of the city project above the parapet, notably the twin towers of S. Atanasio dei Greci, visible to the right of St. Peter's. In the foreground, ilex trees cast deep shadows that envelop the fountain, while in the middle ground, fully sunlit figures pose by the parapet. Molins and Altobelli characteristically choreographed such figure groups in their carefully composed views of Rome.

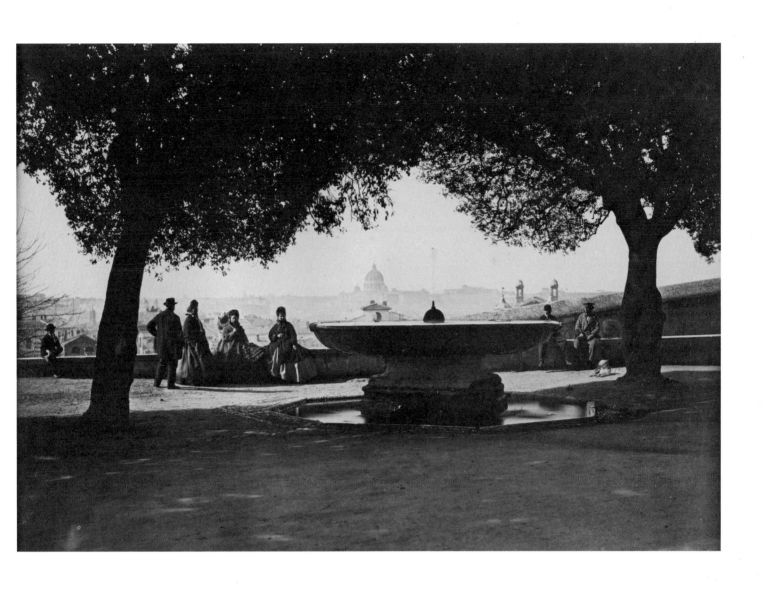

66 Three Roman Guidebooks

Itinerario di Roma e delle sue vicinanze compilato secondo il metodo di M. Vasi da A. Nibby, Rome, Pietro Aurelj, 1858

Private collection

John Murray, *A Handbook of Rome and Its Environs,* London, John Murray, 1867

The Morgan Library & Museum, purchased on the Gordon N. Ray Fund, 2015; PML 196129

Karl Baedeker, *L'Italie: Manuel du Voyageur, 2. L'Italie Centrale et Rome,* Coblenz, Karl Baedeker, 1869

The Morgan Library & Museum, purchased on the Gordon N. Ray Fund, 2015; PML 196120

Rome surpasses all other cities in the extent and variety of its guidebook literature, extending back to itineraries written for medieval pilgrims. The most popular guide of the later eighteenth century was Giuseppe Vasi's *Itinerario istruttivo,* first published in 1763.[1] Vasi's son Mariano brought out revised editions through the first two decades of the nineteenth century. From 1818 on, collaboration with Antonio Nibby ensured that successive editions reflected the latest archaeological discoveries. As its title indicates, Vasi's guide was structured around itineraries, which grounded its structure in topography. The eight itineraries could theoretically be completed in as many days, but only with iron discipline and a rapid pace; in reality, Vasi's guide presumed copious amounts of leisure.

Following the conclusion of the Napoleonic Wars, increasing numbers of travelers made their way to Rome. Approximately 2,000 English visitors passed through the city in 1818, the year the fourth canto of Byron's *Childe Harold* was published by John Murray.[2] With the passage of time and the emergence of modern transportation, notably the railroad, the numbers of visitors swelled. Many of these visitors had less time to devote to Rome than did their privileged ancestors who had come on the Grand Tour. Mass tourism proliferated after 1864 with the first tours to Italy organized by Thomas Cook.

To serve the needs of this growing public, John Murray III began issuing a series of guidebooks that were concise, rather than discursive, and were oriented toward practical concerns, such as food and lodging.[3] Murray's recommendations even extended to the purchase of photographs (see No. 57).

Murray's first *Handbook for Travellers in Central Italy,* which covered Rome, appeared in 1843. The early editions of Murray's guides were compact and instantly recognized by their red covers. They were tightly organized, not around itineraries but in the manner of a dictionary or gazetteer, with classical and Christian sites grouped separately and churches listed alphabetically.

Murray's friend and rival Karl Baedeker also aimed to satisfy the needs of the short-term traveler. He openly imitated many of the features of Murray's guides, including the system of stars to indicate the relative importance of sites. Baedeker famously traveled incognito, the better to evaluate the hotels recommended in his guidebooks. Over time both Murray and Baedeker enriched their travel guides with site plans and folded maps.

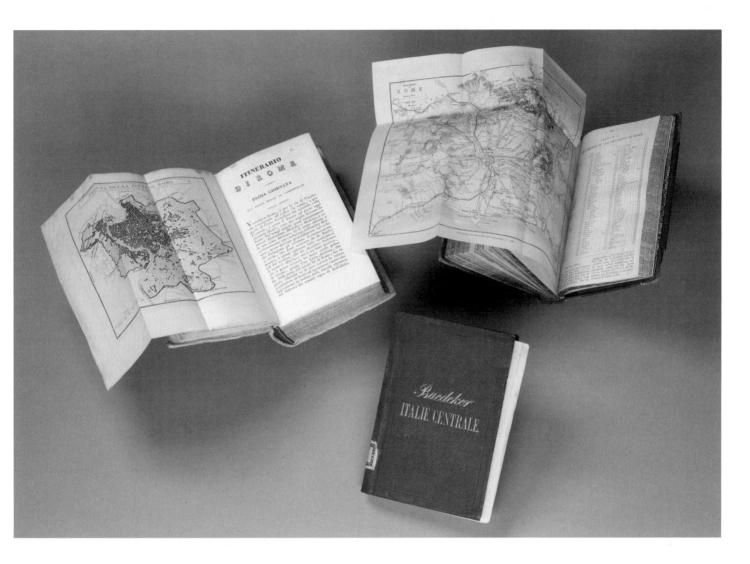

Not surprisingly, many first–time visitors to Rome found themselves bewildered by the lists of Murray and Baedeker. Their requirements were addressed by Augustus Hare's *Walks in Rome*, first published in 1870.[4] Hare returned to the structure of the itinerary and was enriched with a wealth of quotations, producing what a contemporary reviewer described as a "refined and gentlemanly Murray—a guide-book of a higher class, full of other people's opinions, from Ampère to Lady Eastlake—from the dreamy sketches of Hawthorne to the impertinences of Dickens."[5]

DOMENICO AMICI

Rome 1808–after 1870 Rome

67 *Album of Roman Views*, ca. 1828

Etchings, with additions in pen and brown ink and wash
7½ x 9⅞ inches (190 x 250 mm)

The Avery Library of Architecture and Fine Arts, Columbia University

In the era before photography, local artists often prepared albums of Roman views composed of prints or drawings selected as souvenirs by wealthy foreign tourists. Such travel albums were often attractively bound and personalized, as is the case with this example, which for many years was in the library of the Tegernsee Abbey in Bavaria before entering the collection of the Avery Library. The provenance, together with other internal evidence, suggests that the album may have originally belonged to Prince Friedrich Wilhelm, the future king of Prussia (1795–1861; r. 1840–61).[1] As a child, Friedrich Wilhelm took drawing lessons and developed an abiding interest in the arts. As a young man, he served in the Prussian army during the Napoleonic Wars. In 1828 the prince visited Italy. It is possible that he acquired the album at that time.

The rich leather binding is enriched by a watercolor depicting flowers on the front cover, set off by a guilloche pattern in brass (Fig. 1). The contents of the album consist of twenty-two views of Rome mounted on forty-one colored leaves, watermarked "J. Whatman Turkey Mill." There is also one miniature portrait of a woman whose face is partially obscured by mist. The identity of this figure may provide a clue as to the owner of the album.[2]

The views of Rome are interesting in that they display the use of mixed media. At first glance, they appear to be drawings produced by a fine steel-nibbed pen and sepia washes. On closer inspection, however, the outlines are clearly etched and not drawn. While many of the views have been cropped, several sheets retain evidence of plate marks. The artist responsible for the etchings is the Italian printmaker Domenico Amici, whose signature appears on three of the sheets (see No. 47).[3] Comparisons with other prints by Amici reveal affinities to his personal style, particularly in the representation of figures.[4] All of the prints in the album have been worked up by hand, some quite skillfully, with additions in pen, ink, and colored washes. The varying quality of these interventions suggests the hand of an amateur, perhaps the owner of the album.

Among the views are two depictions of Amici at work. One shows him in front of the Colosseum with his back turned to the

FIG. 1. *Album of Roman Views* (cover), Avery Library of Architecture and Art History, Columbia University, New York

FIG. 2. *Album of Roman Views* (detail, showing artist and signature), Avery Library of Architecture and Art History, Columbia University, New York

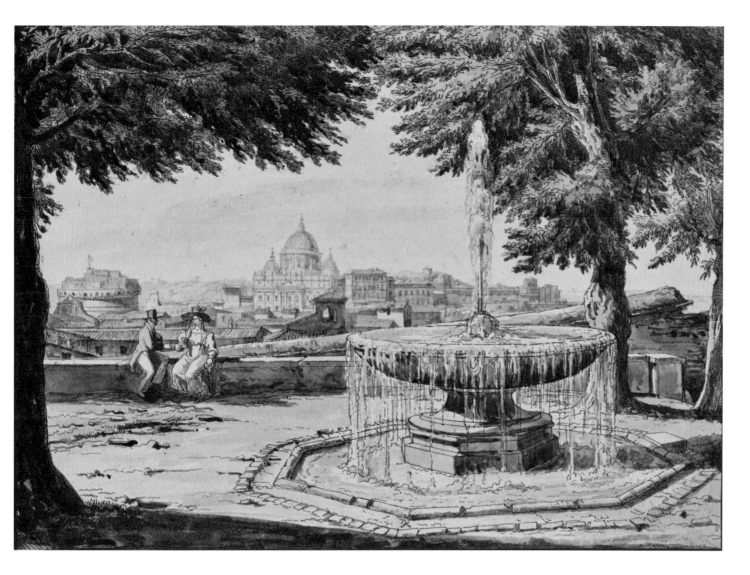

viewer (Fig. 2).[5] He sits on a low campstool in front of his portable easel with his maulstick extended. Amici's signature appears on the column to his left. One of the most charming views in the album depicts the Pincian fountain, a popular subject for artists and—later—photographers (Nos. 64 and 65). In the foreground, the fountain jets from the central orb and then falls back to overflow from the basin, forming a translucent veil. To the left, a couple seated informally on the parapet engage in conversation, while behind them extends a magnificent panorama over the city, which includes the Castel Sant'Angelo, St. Peter's and the Vatican palace complex.

NOTES

1. LETAROUILLY, *PLAN OF ROME*

1. Bayley 1984, pp. xi–xiii; Adams 2014, pp. 71–72; and Aversa 1999, pp. 10–11.

2. Letarouilly 1870. The fourth, quarto, volume provided commentary on the plates.

3. Letarouilly 1882.

4. Broderick 2010, p. 174. Lawrence Grant White, the son of Stanford White, was given a copy of the *Édifices* by Charles Follen McKim (Columbia University, Avery Library, AA 523 L56 FF).

5. Ceen 1984 and Bevilacqua 1998.

6. The following notice appears at the lower left of the 1838 plan: *"On trouve le même Plan complété par la Topgraphie et orné de groupes de monumens et de figures allégoriques. Cette gravure, terminée au burin, se vend séparément."*

7. For a detailed analysis of this shift, see Rome 2003, p. 47.

8. Trevelyan 1908, p. 128. The Porta Pertusa is shown as open on the Nolli plan.

2. COZENS, *ROME FROM THE VILLA MELLINI*

1. Martin Hardie, quoting and commenting on John Constable's remarks on Cozens, in Hardie 1968, p. 132.

2. Oppé 1954.

3. Paris and Mantua 2001, p. 36.

4. Hornsby 2002, nos. 11–18.

5. Sickler 1817. See Rome 2007, p. 308, no. 234; a facsimile of Sickler's panorama is also reproduced in Hornsby 2002.

3. ANDERSON, *PANORAMA OF ROME*

1. For Spithöver, see Munich 2005, p. 21.

2. For a reproduction and short entry on this panorama, see Munich 2005, pp. 48–49 and 183.

3. For the Casale Strozzi, see Barsali 1983, p. 383.

4. Henry James, "Roman Rides," in James 1979, p. 156.

4. DAVID, *THE CAMPIDOGLIO*

1. Rome 1981–82.

2. New York and Montreal 1993, p. 222.

3. A memorial to Pope Innocent XII Pignatelli, who improved this street in 1692, includes his coat of arms composed of three jugs, which give the street its name.

4. Marquis de Sade 1995, p. 90.

5. Goethe 1970, p. 497.

5. DESPREZ, *THE GIRANDOLA AT CASTEL SANT'ANGELO*

1. Stockholm 1992.

2. Pinto 2012, pp. 175–98.

3. Olausson in Paris 1994a, p. 50.

4. Dickens 1957, p. 407.

6. QUARENGHI, *COLONNADE OF ST. PETER'S*

1. Piljavskij 1984, pp. 12–36.

2. Angelini 1967, Album I-13.

3. Ibid., I-16 and I-29.

4. For the Milanese drawings, see Bergamo 1994, pp. 174–75; for the Vatican sheet, see Cleveland, New York, and elsewhere 1988–90, no. 21.

5. Williamson 1918, p. 70.

7. TURNER, *INTERIOR OF ST. PETER'S*

1. Powell 1987.

2. Powell 1982, pp. 408–25.

3. It is worth noting that Hakewill's publisher, John Murray, was also Byron's. In 1832 Turner exhibited a painting entitled *Childe Harold's Pilgrimage*, now in the Tate Gallery.

4. The Tate Gallery, Turner Bequest, CLXXXVIII.

5. Wilton-Ely 1994, 1, no. 137.

6. Arisi 1986, no. 217. The painting was commissioned in 1734 by Henry Gray, Duke of Kent. In Turner's day it hung in the family house at 4 St. James Square.

7. Byron 1818, p. 158.

8. ECKERSBERG, *PIAZZA DEL FONTANONE*

1. Due to its enormous size, the Fontana dell'Acqua Paola is commonly referred to as the *Fontanone*, or "big fountain," which gives the name to the piazza in front of it. Following the heroic events of 1849, the final stretch of the via Aurelia was renamed via Garibaldi.

2. The casino of the Orto dei Semplici was probably designed by Giovanni Battista Contini.

3. Washington 2003–4, p. 6.

4. Eckersberg 1841.

5. Washington 2003–4, p. 92.

6. Kunstmuseet Brundlund Slot-Museum, Sønderjylland; Olsen 1985, pp. 28–29.

7. Additional staffage figures have been added to the painting: two men in the center foreground and a young woman looking down from one of the balconies at the left. A coat of arms on the east front of the Villa Aurelia appears in the drawing but is not included in the painting.

9. ROSSINI, *PANORAMA OF ROME*

1. Rossini 1823.

2. For a reproduction of the print, dated 1822, see Chiasso and Rome 2014, p. 113.

3. *Veduta della Piazza di Monte Cavallo*, ca. 1746–48; an early print from the *Vedute di Roma* series. Focillon 1918, no. 732; Hind 1922, no. 15; Wilton-Ely 1994, no. 142; Ficacci 2011, no. 880.

4. For an analysis of the distortions introduced by Piranesi, see Philadelphia, New York, and Rome 1989–90, pp. 48–49.

5. Since the Renaissance these statues had been incorrectly attributed to the Greek sculptors Phideas and Praxiteles, hence the inscriptions on the pedestals.

6. The obelisk had been found in fragments near the Mausoleum of Augustus in 1781. Collins 2004, pp. 195–203.

7. Jones 1964, p. 88.

10. CROMEK, *THE VIA SISTINA AND THE PALAZZO ZUCCARO*

1. Numerous albums belonging to Cheney were sold in 1885. The Morgan album has a seventeenth-century gilt leather binding that may once have belonged to the Rospigliosi family.

2. J. Fowler, "A biographical notice of Thomas Hartley Cromek, esq.," *Wakefield Express*, 19 April 1873, cited by Warrington 2004.

3. Harewood and Bath 1999–2000.

4. The capital had been donated to the monastery of the Trinità dei Monti by Francesco Gualdi in 1652. See Franzoni and Tempesta 1992, pp. 1–42.

5. Pinto 2012, pp. 66–69.

6. For the history of the Palazzo Zuccaro, see Kieven 2013.

11. GUESDON, *BIRD'S-EYE VIEW OF ROME*

1. Besse 2013, p. 69.

2. The first documented instance of a photograph taken from a hot-air balloon is a view of Paris taken by Nadar in 1858.

3. Stroffolino 2004, p. 68.

4. Steamboats plying the Tiber north of Rome docked at the Porto di Ripetta. For a photograph of 1865 showing a side-wheeler, the *Tevere*, tied up there, see Rome and Copenhagen 1977, no. 142.

12. BENOIST, *THE VATICAN PALACE AND GARDENS*

1. It is worth noting that Philippe Benoist studied with Daguerre, the inventor of photography.

2. Trastulli 1987, p. 246. The only lithograph in the collection that emphasizes figures, rather than monuments, depicts Pius IX in his *Sedia Gestatoria* processing through Saint Peter's.

3. For a vivid description of the ascent to the dome see Eaton 1820, 2, pp. 259–65.

13. JONES, *THE EQUESTRIAN MONUMENT OF MARCUS AURELIUS*

1. Buckman 1990, p. 9.

2. Known as "joiners." Buckman 1990, AR 1 72 and AR 1 73.

3. For Jones's Italian photographs, also see Florence 1988.

4. Buckman 1990, p. 8.

5. Buckman 1990, p. 12.

6. Accession no. 1992.5167.

7. Hawthorne 1899, 1, p. 184.

8. James 1974, p. 176.

14. MACPHERSON, *THE SPANISH STEPS*

1. The print carries the number *51*, which corresponds to the entry "Church of the Trinità de' Monti" on the 1858 list of Macpherson's photographs.

2. Story 1887, 2, p. 40.

15. CUCCIONI, *THE THEATRE OF MARCELLUS*

1. Miraglia 1895, 31, pp. 303–6.

2. Cuccioni's shop was located on via della Croce, 88. He subsequently moved to via dei Condotti, 18, where his photographs were for sale.

3. For two early photographs illustrating the urban context of the theatre, see Brizzi 1975, p. 148; and New York and Rome 2006–8, p. 50.

4. For a reproduction of the painting by the Danish artist Ernst Meyer, see Olsen 1985, p. 86, no. 32.

5. Hawthorne 1980, p. 106.

16. ANDERSON, *THE PIAZZA NAVONA FLOODED*

1. Story 1887, 2, pp. 495–96.

17. ALTOBELLI, *THE ATTACK ON PORTA PIA*

1. Rome and Copenhagen 1977, p. 173.

2. De Amicis 1870, pp. 43–44. John Pinto translation.

3. Barucci 2006, pp. 89–98. The inner face of the Porta Pia was designed by Michelangelo.

18. KNIP, *TEMPLE OF MINERVA MEDICA*

1. 's Hertogenbosch 1977.

2. In fact, the Giustiniani *Minerva* (now in the Vatican Museum) was found near the church of S. Maria sopra Minerva. See Rome 2001–2, pp. 181–86.

3. Nibby 1838, p. 235.

4. Two small trees appear in the central arched opening.

5. *Pistacia lentiscus*. See Rome 2000–1, p. 90.

6. Eaton 1820, p. 245.

7. Munich, Graphische Sammlung. See Garms 1995, D64.

8. Wilson's 1754 drawing is in the Yale Center for British Art, B 1977.14.4654; Turner's 1819 watercolor is in the Tate Museum, Turner Bequest CLXXXIX.

19. KLEIN, *THE BASILICA OF CONSTANTINE*

1. Rome and Paris 1985–86, p. 212.

2. Zola 1913, 1, p. 229.

3. Hoenigswald in Tonkovich 2011, p. 21.

20. TURPIN DE CRISSÉ, *THE ARCH OF CONSTANTINE FROM THE COLOSSEUM*

1. Angers and Boulogne-Billancourt 2006–7.

2. Choiseul-Gouffier 1782–1824.

3. Cambridge 1967, no. 45.

4. Reproduced in Rome 2009–10, p. 22, and Tonkovich 2011, p. 144, no. 128.

5. De Staël 2008, p. 168.

21. COROT, *THE ARCH OF CONSTANTINE*

1. Galassi 1991 and Washington, Brooklyn, and St. Louis 1996–97.

2. Washington and Houston 2008.

3. Robaut 1905, 2, p. 160, no. 445.

4. Focarino 2003, pp. 404–7.

5. Le Corbusier 1972, p. 31.

22. DE PRANGEY, *ROUND TEMPLE BY THE TIBER*

1. Baalbek, in modern Lebanon, is one such site. De Prangey documented it in one hundred daguerreotypes.

2. See Barger and White 1991.

3. It is worth noting that a nearly identical daguerreotype by de Prangey is in the collection of the J. Paul Getty Museum. See Stewart in Los Angeles 2005, p. 73, fig. 3.

4. Modern archaeologists favor a dedication to Hercules.

5. Hare 1909, pp. 178–79.

6. They originally supported a marble entablature, which no longer survives.

7. See Jacobson 2015, especially pp. 251 (cat. 13) and 273 (cat. 108).

23. FLACHÉRON, *THE TEMPLE OF CASTOR*

1. Milan and Paris 2003–4.

2. Also known as the wet paper process. See Daffner 2003, no. 3, pp. 425–39.

3. A watermark at top could well be WHATMAN.

4. The sky is painted out with a dense opaque flat silvered wash.

5. The negative is far more vibrant and striking than the corresponding positive image.

6. Fifty Roman feet equal 48.55 modern feet, or 14.8 meters.

24. JONES, *INTERIOR OF THE COLOSSEUM*

1. For a reproduction of the exterior view, see Rome and Copenhagen 1977, no. 47.

2. The open arch just to the right of the standing figure marks the major axis of the oval arena.

3. Ridley 1992, pp. 39–40.

4. Rome 1991–92, p. 423.

5. Olsen 1985, nos. 15 and 17.

6. It was common for early calotype photographers to apply ink to the sky on their paper negatives in order to produce a uniformly bright, clear sky.

7. Noble 1853, pp. 159–60. For a reproduction of Cole's painting of the interior of the Colosseum, see Vance 1989, pp. 1, 46, fig. 9.

8. Dickens 1957, p. 366.

25. CAFFI, *THE COLOSSEUM ILLUMINATED*

1. Caffi produced forty-two variations on this composition.

2. Pirani in Belluno and Rome 2005–6, pp. 73–85.

3. Bengal lights were called so because the chief source of saltpeter, one of the key ingredients, was in the Indian subcontinent. They typically produced a steady, vivid, blue light and were also called Blue Lights, widely used for signaling at sea.

4. Belluno and Rome 2005–6, no. 77. Other versions range in date from 1856 to 1864: Venice 1979, nos. 28, 34, and 35.

5. Trollope 1889, 3, p. 340.

6. Sir Walter Scott, *The Lay of the Last Minstrel* (1805), canto 2, p. 1.

26. PERCIER AND FONTAINE, *COURTYARD OF THE VILLA GIULIA*

1. Percier and Fontaine 1798.

2. Percier and Fontaine 1809.

3. According to Vasari, Michelangelo also consulted on the design.

4. The plate is entitled *Vue de l'interieur de la grande cour, près le vestibule d'entrée.*

5. See G. P. Consoli, *"Un architetto quasi romano': Percier e i suoi rapporti con l'architettura e gli artisti italiani,"* in Frommel et al. 2014, pp. 55–63; and Garric 2004, pp. 125–64. My thanks to Professor Basile Baudez for calling my attention to two drawings by Percier in the Metropolitan Museum of Art (acc. nos. 56.559.2 and 65.717.2) that provide instructive comparisons.

6. Garric 2004.

27. ECKERSBERG, *THE CHURCH OF SS. GIOVANNI E PAOLO*

1. The Casa Buti, via Sistina, 48; part of the Palazzo Tomati, formerly the residence of Giovanni Battista Piranesi.

2. Munk in Rome 2006, pp. 26–40.

3. Fischer 1993, p. 7.

28. MICHALLON, *THE RUIN FOLLY OF THE VILLA BORGHESE*

1. See, for example, John Izard Middleton's nearly contemporary drawing. Mack and Robertson 1997, p. 62, pl. 7.

2. Dwight 1824, pp. 250–51.

29. PALM, *ENTRANCE TO THE GIARDINO DEL LAGO*

1. Paris and Mantua 2001, p. 346, no. 214.

2. Paris and Mantua 2001, p. 348, no. 215.

3. Di Gaddo 1985, p. 182.

4. Forsyth 1835, pp. 230–31.

5. Hawthorne 1899, 1, p. 83.

30. NORMAND, *STATUE OF THE GODDESS ROMA*

1. Bouqueret and Livi 1989, p. 277, and Rennes 1981.

2. Rome and Paris 1985–86, pp. 15–39. Normand's *envois* of 1849 restored the House of the Faun in Pompeii; see Paris and Naples 1981, pp. 240–45.

3. Le Gall in Rome and Paris 2003-4, p. 62.

4. de Azevedo 1951, pp. 89–90.

5. In 1822 the statue was moved to this position from its location at the northern end of the main cross axis of the Villa Medici gardens, with its back to the public gardens on the Pincio. It was returned to its original location.

6. A variant of this print, with a semicircular top, is reproduced in Rome and Paris 2003-4, p. 140. A frontal view is reproduced in Rennes 1981, p. 13, no. 27.

31. DEGAS, *VIEW OF THE VILLA BORGHESE*

1. Reff 1985.

2. An 1851 photograph by Alfred-Nicolas Normand offers an instructive comparison to Degas's sketch. See Rome and Paris 2003-4, p. 127.

3. Dumas in Rome 2004, p. 50.

4. James 1979, pp. 205–6.

32. LE GRAY AND LE DIEN, *BERNINI'S TRITON FOUNTAIN*

1. Chicago 1987.

2. Kennel in Washington and Houston 2008, pp. 152–67.

3. Aubenas 2002, pp. 297–313.

4. Calotypes are salt or albumen prints from paper negatives. Prints of some of Le Dien's images have a blindstamp: *Le Dien et Gustave Le Gray.*

5. Andersen 1869.

6. For a reproduction of a photograph by Gioacchino Altobelli and Pompeo Molins of the Triton Fountain covered in ice, see South Hadley 1980, p. 9, no. 13.

7. Browning 1949, 1, pp. 28–29.

8. For other early photographic views of the Piazza Barberini, see New York and Rome 2006-8, pp. 90–93.

9. Now much reduced, the Triton's jet originally shot over fifteen feet into the air. See Rinne 2010, p. 222. For the Colonnette di Barberini, see Rufini 1847, p. 61.

33. GELL, *MAP OF ROME AND ITS ENVIRONS*

1. For Nibby's account of his expeditions with Gell, see Frutaz 1972, 1, p. 120, and Catasta in Riccio 2013, pp. 30–31.

2. Clay 1976.

3. Gell 1834, 1, p. iv.

4. Wallace-Hadrill 2006, p. 285.

5. It probably was consulted by Lear and Corot and was cited as a reference by William Cullen Bryant; The Morgan Library & Museum, MA564.1, 1v.

34. CASSAS, *LANDSCAPE WITH ARCH OF DRUSUS*

1. Tours and Cologne 1994–95, pp. 10–26.

2. New York and Montreal 1993, p. 197.

3. Pinto 2012, pp. 217–73.

4. Cassas and Lavallée 1802.

5. Cassas 1798.

6. Goethe 1970, p. 390.

35. JONES, *VIEW OF THE VILLA MAECENAS AT TIVOLI*

1. Cardiff, Manchester, and London 2003-4.

2. For a discussion of Jones's technique, see New York and Montreal 1993, pp. 132–33.

3. Oppé 1951, pp. 1–162.

4. Oppé 1951, p. 65.

5. MacDonald and Pinto 1995, p. 241.

6. Oppé 1951, p. 55.

7. See Cardiff, Manchester, and London 2003-4, nos. 84–88. Number 88 is very close to the Morgan sheet in composition and point of view.

8. Eaton 1820, 3, p. 347.

36. MACPHERSON, *PANORAMA OF TIVOLI*

1. No. 118: "*Large Waterfall.*" See Becchetti in Rome and Copenhagen 1977, p. 43.

2. Hare 1875, 1, pp. 198–99.

37. ROSSINI, *THE SERAPEUM AT HADRIAN'S VILLA*

1. See Rome 1982, Pirazzoli 1990, and Chiasso and Rome 2014.

2. Rossini 1823.

3. Rossini 1826, tav. 34 (dated 1824).

4. Wilton-Ely 1994, no. 264.

5. MacDonald and Pinto 1995, pp. 112–16.

6. MacDonald and Pinto 1995, pp. 6–7.

7. For Rossini's drawings and their relation to his published plates, see Scaloni in Chiasso and Rome 2014, pp. 63–75.

8. Fusco in Chiasso and Rome 2014, pp. 50–61.

9. Pinelli 1815, tav. 13: "*Il giuoco della morra in Roma.*"

10. Chateaubriand 1969, p. 135.

38. LEAR, *PANORAMIC VIEW OF TIVOLI*

1. Hofer 1967, plate 11.

2. Lear 1841, no. 23.

3. Hare 1875, 1, pp. 199–200.

39. LEAR, *RUINS OF THE VILLA SETTE BASSI*

1. Harvard University, Houghton Library, MS Typ 55.26 NI.L3, item 41 (the Temple of Venus and Rome) and MS Typ 55.26, Oversize Box 10, item 231 (the Ponte Nomentano).

2. Harvard University, Houghton Library, MS Typ 55.26 NI.L9, items 363–370.

3. Ashby 1927, pp. 156–59, Lupu 1937, pp. 117–88.

40. GRANET, *DUSK, MONTE MARIO*

1. Washington, Brooklyn, and St. Louis 1996–97, p. 154.

2. Granet collaborated with Boguet on the decoration of a suite of rooms for Napoleon's family in the Quirinal Palace. See Hornsby 2002, p. 16.

3. Rome 1996–97, no. 64.

4. New York, Cleveland, and San Francisco 1988–89, p. 50.

5. Goethe 1970, p. 157.

41. ANDERSON, *THE ARCH OF NERO*

1. Ashby 1935, p. 273, and Aicher 1995, pp. 139–41.

2. Eaton 1820, 3, p. 353.

3. Letter dated 13 July 1832 in McNulty 1983, pp. 56–57.

4. Entry dated 24 August 1831; quoted in Baigell 1981, p. 46.

42. PRELLER, *THE PONTE NOMENTANO*

1. Weinrautner 1997.

2. Piranesi included the bridge among the prints comprising his *Vedute di Roma*.

3. Mendelssohn 1863, pp. 101–2.

43. INGRES, *LETTER TO JULIE FORESTIER*

1. Lapauze 1910, p. 187.

2. Published by Henry Lapauze, *Le roman d'amour de M. Ingres*, Paris, 1910, pp. 199–242.

3. Conisbee in London, Washington, and New York 1999–2000, p. 75.

44. INGRES, *PORTRAIT OF GUILLON-LETHIÈRE*

1. The Morgan Library & Museum, MA 2701, p. 3.

2. Cambridge 1967, no. 19; Naef 1977–80, 4, p. 130.

3. Conisbee in London, Washington, and New York 1999–2000, p. 182.

45. BYRON, *CHILDE HAROLD'S PILGRIMAGE*

1. Cochran 2001, pp. 49–63.

2. Moore 1854, 4, p. 28.

3. Byron 1818, stanza 103, lines 926–27.

4. Byron 1818, stanza 173, lines 1549–57.

5. Moore 1854, 4, p. 26.

46. GELL, *LETTER TO RICHARD PAYNE KNIGHT*

1. See Riccio 2013.

2. Gell 1804.

3. Byron 1837, p. 153.

4. Byron went on to note: "'Rapid' indeed! He topographised and typographised king Priam's dominions in three days."

5. For the Society of Dilettanti, see Los Angeles 2008.

6. Knight was a trustee of the British Museum, to which he bequeathed his collection.

7. Nibby 1820.

8. Ridley 1992, p. 298.

9. Gell and Gandy 1817–19 and Gell 1832.

10. Gell had long suffered from gout. The letter to Knight concludes with a pessimistic assessment of his health—"I have scarcely been able to walk alone since my last trip to England"—and the treatment recommended by his doctors: "magnesia & Rheubarb."

47. AMICI, *TWO VISITORS TO THE TOMB*

1. See, for example, Amici 1835, 1839, and 1847.

2. Werner 1858. Amici's copperplates survive in the collection of the Calcografia nazionale.

3. Wilde's 1877 poem "The Grave of Shelley." Beckson and Fung 2000, p. 43.

4. The circumstances of Bathurst's death prompted responses from Giuseppe Gioacchino Belli, Chateaubriand, and Stendhal.

5. Rogers 1842, pp. 167–68.

48. DICKENS, *LETTER TO GEORGINA HOGARTH*

1. See Dickens 2001, 4, pp. 260–61.

2. Crawford 1900, 1, p. 196. Noted by Varriano 1991, p. 127.

49. PINELLI, *CARNIVAL SCENE*

1. Rome 1956; Fagiolo and Marini 1983.

2. Pinelli 1809.

3. Among the Italian writers, Pinelli illustrated the work of Dante, Ariosto, Tasso, and Manzoni.

4. Fusco in Chiasso and Rome 2014, p. 52.

5. Olson 2001, p. 17.

6. Andersen 1869, p. 113.

7. Dickens 1957, pp. 372–73.

50. FULLER, *LETTER TO ELIZABETH HOAR*

1. Hudspeth 1988, p. 241, no. 831.

2. Marshall 2013.

3. Deiss 1969, p. 233.

4. Fuller 1991, p. 280.

5. Hudspeth 1988, p. 238.

6. Fuller 1991, p. 303.

7. Hudspeth 1988, p. 241.

51. THOMAS, *PANORAMA OF ROME*

1. *"Sul teatro delle maggiori grandezze del mondo."* Quoted by Trevelyan 1908, p. 2.

2. Vol. 16, no. 424, 4 May 1850.

3. Fuller 1991, p. 310.

3. Vol. 16, no. 424, 4 May 1850.

4. Rome 2011–12.

52. HAWTHORNE, *ITALIAN NOTEBOOKS*

1. Via di Porta Pinciana, no. 37: MA 588, p. 1.

2. MA 589, p. 15.

3. Piazza Poli, no. 68: MA 590, p. 239.

4. MA 588, p. 90.

5. *The Marble Faun* was published in 1860.

6. De Staël 1807.

7. MA 589, p. 1.

53. ANDERSON, *THE TREVI FOUNTAIN*

1. Munich 2005.

2. Margiotta in Rome and Paris 2003–4, p. 32. Anderson's photographs often have several numbers and are difficult to sequence.

3. Becchetti 1986, 2, no. 4, pp. 56–67.

4. Pinto 1986.

5. On the Oceanus and the iconography of the Trevi, see Pinto 1986, pp. 220–35.

6. Morton 1966, p. 85.

54. BRYANT, *LETTERS OF A TRAVELLER*

1. Bryant 1850; Bryant 1859.

2. Godwin 1967, 2, p. 73.

3. Godwin 1967, 2, pp. 111–14.

4. The so-called Tombe Latine, identified with the Valeri and Pancrati families.

5. Fortunati 1859.

6. Bryant would later translate *The Iliad*, but his account of the Tomb of the Pancrati overlooks illustrations of key events, such as the judgment of Paris and Priam's visit to the tent of Achilles to claim Hector's body.

7. Hawthorne, who visited the site two weeks earlier with W. W. Story, also comments on the crowds. Hawthorne 1980, pp. 200–203.

8. Émile Zola made a similar observation: see Zola 1913, 1, pp. 246–47.

55. COLLINS, *LETTER TO CHARLES WARD*

1. Collins wrote on hotel stationery; the Hotel des Iles Britanniques was situated on the Piazza del Popolo.

2. Ward was married to Collins's favorite cousin, Jane Carpenter.

3. In London, near Leicester Square.

4. St. Calixtus, an early pope and martyr, is venerated in S. Maria in Trastevere. His remains were brought there from the catacombs in the eighth century, and a marble sphere associated with his martyrdom is displayed inside the church.

5. Collins 1866, 1, p. 257. Photographs illustrating *The Woman in White* taken by Cundall, Downes & Co. of New Bond Street had proven immensely successful. Collins wrote from Rome to his mother one week before this letter of his intention to sit for his portrait by Cundall and Downes. Baker and Clarke 1999, 1, pp. 241–43.

56. PIRANESI, *CATALOGUE OF PUBLISHED WORKS*

1. Tulsa and elsewhere 1975–78, p. 297.

2. Mayer-Haunton in Venice 1978, pp. 9–10.

3. The broadsheet was often added at the end of bound copies of Piranesi's *Della Magnificenza ed Architettura de'Romani* (1761). See Robison 1970, pp. 192–93.

4. Piranesi 1780.

5. Focillon 1918, pp. 9–10; Hind 1922, pp. 4–7; and Focillon 1967, pp. 275–77.

6. Andrieux 1968, p. 72.

7. Gross 1990, p. 114.

8. For a more extended discussion of Piranesi's layered compositions, see Pinto 2012, pp. 159–75.

57. MACPHERSON, *MACPHERSON'S PHOTOGRAPHS*

1. Becchetti and Pietrangeli 1987, pp. 42–52, reproduces a selection of Macpherson's lists.

2. Crawford 1999, p. 303.

3. Geraldine Bate was the niece of Anna Brownell Jameson, the author of *Diary of an Ennuyée*.

4. Macpherson 1863, introduction.

5. Murray 1856, p. xv, cited by Szegedy-Maszak 1999, p. 93.

6. *The Athenaeum* 1867, pp. 589 and 728–29.

58. PIRANESI, *VIEW OF THE PONTE SANT'ANGELO*

1. It is worth noting that Piranesi's caption specifically identifies the site as dedicated to garbage disposal: *6. Espurgo delle immondezze della Città*. See Rinne 2010, p. 24.

2. Quoted by Wrigley 2013, p. 177.

59. ALTOBELLI, *THE TIBER*

1. For a reproduction of one of Altobelli's "moonlight" views of the Forum, see Munich 2005, p. 103.

2. A variant of this view by Altobelli shows the same pipe-smoking fisherman using a net rather than a rod. See Siegert 1985, no. 32.

3. Eaton 1820, 2, pp. 227–28.

4. Hawthorne was describing the panorama from the Pincio, but his words apply equally well to this view from the banks of the Tiber.

5. Hawthorne 1899, 1, p. 121.

6. Evans and Whitehouse 1956, 1, pp. 132–33.

60. ATTRIBUTED TO VALENCIENNES, *GROTTO OF THE NYMPH EGERIA*

1. Valenciennes 1820.

2. He lived in the Casa Giannotti, at no. 179. Toulouse 2003, p. 46.

3. Neuerburg 1965, pp. 161–62.

4. Byron 1818, stanzas 116–17.

5. Juvenal 1992, 3.15–20.

61. MACPHERSON, *THE GROTTO OF EGERIA*

1. Roethlisberger 1968, 1, nos. 389, 480, and 1039.

2. Lanciani 1893, p. 293.

3. Di Giovine 2012, p. 75. Piranesi's print in the series of *Vedute di Roma* is particularly noteworthy for its detail and its reference to the passage from Juvenal's *Satires* referring to the shrine of Egeria; see Focillon 1918, no. 782; Hind 1922, no. 80; Wilton-Ely 1994, no. 213; and Ficacci 2011, no. 951.

4. Eaton 1820, 2, pp. 201–2.

5. Andersen 1869, p. 9.

6. Rome 1981, p. 129.

62. INGRES, *VIEW OF S. MARIA MAGGIORE*

1. In 1803 the academy moved from the Palazzo Mancini on the via del Corso. Conisbee in London, Washington, and New York 1999–2000, pp. 97–115.

2. Cambridge 1967, p. xiii.

3. New York 1994, no. 65.

4. Naef 1977–80, 1, pp. 353–56; 4, pp. 182–200.

5. Naef 1962, nos. 50–54.

63. DE BONIS, *S. MARIA MAGGIORE*

1. For de Bonis, see the entries and essays in New York and Rome 2006–8, especially Maria Francesca Bonetti, "A. De Bonis, an 'Outsider' Photographer," pp. 25–28.

2. *Nota dei fotografi e stabilimenti fotografici esistenti nei vari rioni di Roma*, Rome, Archivio di Stato, Congregazione del Buon Governo [1592–1870], busta 44 [Carte di Polizia, serie I, 1816–1870].

3. For Parker, see Brizzi 1975 and Pietrangeli 1989.

4. Clement's coat of arms is visible on the pedestal. In 1881 the monument was moved to the courtyard adjacent to the sacristy of the basilica. See Tomassetti 1882, pp. 73–93.

64. MICHALLON, *VIEW OF THE TRINITÀ DEI MONTI*

1. Paris 1994, pp. 26–48.

2. Galassi 1991, p. 58.

3. Paris 1994, p. 34. In 1819 Michallon spent six months painting in the Bay of Naples and visited Sicily the following year.

4. Paris 1994, nos. 38–48.

5. Paris 1994, pp. 156–60.

6. Washington and Houston 2008, p. 66, fig. 34.

7. See, for example, oil sketches by Louis Dupré and Charles-Auguste van den Berghe from the 1820s; Paris and Mantua 2001, pp. 182–85.

65. MOLINS, *THE FOUNTAIN OF THE VILLA MEDICI*

1. For Molins, see Rome and Mantua 2008, p. 200.

2. D'Onofrio 1957, pp. 96–99.

3. Rinne 2010, p. 121.

4. Galassi 1991, p. 160, fig. 169.

66. THREE ROMAN GUIDEBOOKS

1. Vasi 1763. See also Hamilton 2010, pp. 77–79.

2. Withey 1997, p. 59; Buzard 1993, pp. 64–67.

3. Bush 2007, pp. 181–204.

4. Hare 1870. Within a decade, Hare's guide had gone through twelve editions on both sides of the Atlantic. In 1875 Hare brought out a similar guide to the environs of Rome illustrated by his own sketches: *Days Near Rome*, London, Daldy, Isbister & Co., 1875, 2 vols.

5. *Blackwood's Magazine*, 109, 1871, pp. 457–58.

67. AMICI, *ALBUM OF ROMAN VIEWS*

1. Johannsen 2007.

2. The entry in the sales catalogue notes that the portrait resembles Princess Elisabeth Ludovika of Bavaria, who married Friedrich Wilhelm in 1823. Michael Kühn Bookseller, New York Antiquarian Book Fair, 2011, p. 22, no. 24.

3. Amici's last name appears on three sheets in the album: no. 20 (the Arch of Constantine), no. 21 (the Colosseum), and no. 23 (the Tomb of Cecilia Metella).

4. Amici 1835. The frontispiece carries the date of 1835, but the dates of the individual prints range from 1832 to 1841.

5. The other depiction of an artist at work within one of the views appears in no. 20 (the Arch of Constantine), where he is shown seated in the shade of an umbrella.

WORKS CITED IN ABBREVIATED FORM

Aicher 1995

Peter J. Aicher, *Guide to the Aqueducts of Ancient Rome*, Wauconda, 1995.

Amici 1835

Domenico Amici, *Raccolta delle principali vedute di Roma disegnate dal vero ed incise da Domenico Amici*, Rome, 1835.

Amici 1839

Domenico Amici, *Raccolta di trenta vedute degli obelischi, scelte fontane, e chiostri di Roma. Disegnato dal vero ed incise in rame da Domenico Amici Romano*, Rome, 1839.

Amici 1847

Domenico Amici, *Raccolta delle vedute dei contorni di Roma disegnate dal vero ed incise in rame da Domenico Amici Romano*, Rome, 1847.

Andersen 1869

Hans Christian Andersen, *The Improvisatore*, translated by Mary Howitt, New York, 1869.

Andrieux 1968

Maurice Andrieux, *Daily Life in Papal Rome in the Eighteenth Century*, London, 1968.

Angelini 1967

Sandro Angelini, ed., *I cinque album di Giacomo Quarenghi nella civica Biblioteca di Bergamo*, Bergamo, 1967.

Arisi 1986

Ferdinando Arisi, *Gian Paolo Panini e i fasti della Roma del '700*, second edition, Rome, 1986.

The Art Journal 1839–1912

The Art Journal, 7 vols., London, 1839–1912.

Ashby 1927

Thomas Ashby, *The Roman Campagna in Classical Times*, London, 1927.

Ashby 1935

Thomas Ashby, *The Aqueducts of Ancient Rome*, Oxford, 1935.

The Athenaeum 1867

The Athenaeum, "Handbook for Italy," no. 2062, 1 May 1867, p. 589; and no. 2066, 1 June 1867, pp. 728–29.

Aubenas 2002

Sylvie Aubenas, "On Photographic Collaboration: Firmin Eugène Le Dien and Gustave Le Gray," in *Gustave Le Gray, 1820–1884*, Los Angeles, 2002.

Aversa 1999

A. di Luggo Aversa, "Nota biografica," in *Paul Letarouilly: Il Vaticano e la Basilica di San Pietro*, Novara, 1999.

de Azevedo 1951

Michelangelo Cagiano de Azevedo, *Le antichità di Villa Medici*, Rome, 1951.

Baigell 1981

Matthew Baigell, *Thomas Cole*, New York, 1981.

Baker and Clarke 1999

William Baker and William M. Clarke, eds., *The Letters of Wilkie Collins*, 2 vols., London, 1999.

Barger and White 1991

M. Susan Barger and William B. White, *The Daguerreotype: Nineteenth-Century Technology and Modern Science*, Washington, D.C., 1991.

Barkan 1999

Leonard Barkan, *Unearthing the Past: Archaeology and Aesthetics in the Making of Renaissance Culture*, New Haven, 1999.

Barsali 1983

Isa Belli Barsali, *Ville di Roma*, Milan, 1983.

Barucci 2006

Clementina Barucci, *Virginio Vespignani: Architetto tra stato pontificio e regno d'Italia*, Rome, 2006.

Bayley 1984

J. B. Bayley, *Letarouilly on Renaissance Rome*, New York, 1984.

Becchetti 1986

Piero Becchetti, "Una dinastia di fotografi romani: Gli Anderson," in *Archivio fotografico toscano* 2, no. 4, 1986.

Becchetti and Pietrangeli 1987

Piero Becchetti and Carlo Pietrangeli, *Robert Macpherson: Un inglese fotografo a Roma*, Rome, 1987.

Beckson and Fung 2000

K. Beckson and Bobby Fung, eds., *The Complete Works of*

Oscar Wilde: Poems and Poems in Prose, Oxford, 2000.

Besse 2013

Jean-Marc Besse, "European Cities from a Bird's-Eye View: The Case of Alfred Guesdon," in *Seeing from Above: The Aerial View in Visual Culture,* edited by Mark Dorrian and Frédéric Pousin, London and New York, 2013, pp. 66–82.

Bevilacqua 1998

Mario Bevilacqua, *Roma nel secolo dei lumi: Architettura, erudizione, scienza nella pianta di G. B. Nolli "célèbre geometra,"* Naples, 1998.

Bouqueret and Livi 1989

Christian Bouqueret and François Livi, eds., *Le voyage en Italie: Les photographes français en Italie, 1840–1920,* Lyon, 1989.

Brizzi 1975

Bruno Brizzi, *Roma cento anni fa nelle fotografie della raccolta Parker,* Rome, 1975.

Broderick 2010

Mosette Broderick, *Triumvirate: McKim, Mead & White: Art, Architecture, Scandal, and Class in America's Gilded Age,* New York, 2010.

Browning 1949

Robert Browning, *The Ring and the Book,* 2 vols., New York, 1949.

Bryant 1850

William Cullen Bryant, *Letters of a Traveller, or, Notes of Things Seen in Europe and America,* New York, 1850.

Bryant 1859

William Cullen Bryant, *Letters of a Traveller, Second Series,* New York, 1859.

Buckman 1990

Rollin Buckman, *The Photographic Work of Calvert Richard Jones,* London, 1990.

Bush 2007

Anne Bush, "The Roman Guidebook as a Cartographic Space," in *Regarding Romantic Rome,* edited by Richard Wrigley, Bern and New York, 2007.

Buzard 1993

James Buzard, *The Beaten Track: European Tourism, Literature, and the Ways to Culture, 1800–1918,* Oxford, 1993.

Byron 1818

George Gordon Byron, *Childe Harold's Pilgrimage, Canto the Fourth,* London, John Murray, 1818.

Byron 1837

George Gordon Byron, *English Bards and Scotch Reviewers* in *Miscellanies by Lord Byron,* London, 1837.

Caneva 2004

Giulia Caneva, ed., *Amphitheatrum Naturae. Il Colosseo: Storia e ambiente letti attraverso la sua flora,* Milan, 2004.

Cassas 1798

Louis-François Cassas, *Voyage pittoresque de la Syrie, de la Phénicie, de la Palestine et de la Basse-Égypte,* Paris, 1798.

Cassas and Lavallée 1802

Louis François Cassas and Joseph Lavallée, *Voyage pittoresque et historique de l'Istrie et de Dalmatie,* 2 vols., Paris, 1802.

Ceen 1984

Allan Ceen, *Rome 1748: The Pianta Grande di Roma of Giambattista Nolli,* Highmount, 1984.

Chateaubriand 1969

François-René Chateaubriand, *Voyage en Italie,* Geneva, 1969.

Choiseul-Gouffier 1782

Marie-Gabriel-Auguste-Florent, comte de Choiseul-Gouffier, *Voyage pittoresque de la Grèce,* Paris, 1782–[1824].

Clay 1976

Edith Clay, ed., *Sir William Gell in Italy: Letters to the Society of Dilettanti, 1831–1835,* London, 1976.

Cochran 2001

Peter Cochran, "'A Higher and More Extended Comprehension:' Byron's Three Weeks in Rome," *Keats-Shelley Review* 15, no. 1, 2001.

Collins 1866

Wilkie Collins, *Armadale,* 3 vols., Leipzig, 1866.

Collins 2004

Jeffrey Collins, *Papacy and Politics in Eighteenth-Century Rome: Pius VI and the Arts,* Cambridge, 2004.

Crawford 1898

Francis Marion Crawford, *Ave Roma Immortalis, Studies from the Chronicles of Rome,* 2 vols., London, 1898.

Crawford 1999

Alistair Crawford, "Robert Macpherson 1814–72, the Foremost Photographer of Rome," *Papers of the British*

School at Rome 67, 1999, pp. 353–403.

Daffner 2003

Lee Ann Daffner, "'A Transparent Atmosphere:' The Paper Negatives of Frédéric Flachéron in the Harrison D. Horblit Collection," in *Journal of the American Institute for Conservation* 42, no. 3, 2003.

Deakin 1855

Richard Deakin, *Flora of the Colosseum of Rome*, London, 1855.

De Amicis 1870

Edmondo De Amicis, *Impressioni di Roma*, Florence, 1870.

De Brosses 1931

Charles de Brosses, *Lettres familières sur l'Italie*, 2 vols., Paris, 1931.

Deiss 1969

Joseph Jay Deiss, *The Roman Years of Margaret Fuller: A Biography*, New York, 1969.

Dickens 1957

Charles Dickens, *American Notes and Pictures from Italy*, London and New York, 1957 [1846].

Dickens 2001

Charles Dickens, *The Letters of Charles Dickens, 1820–1870*, electronic edition (2nd release), based on the Pilgrim Edition edited by Madeline House, Graham Storey, and Kathleen Tillotson, Charlottesville, Virginia, 2001.

Di Gaddo 1985

Beata Di Gaddo, *Villa Borghese: Il giardino e le architetture*, Rome, 1985.

Di Giovine 2012

Mirella Di Giovine, ed., *La Valle della Caffarella*, Milan, 2012.

D'Onofrio 1957

Cesare D'Onofrio, *Le Fontane di Roma*, Rome, 1957.

Dwight 1824

Theodore Dwight, *A Journal of a Tour in Italy in the Year 1821, with a Description of Gibraltar by an American*, New York, 1824.

Eaton 1820

Charlotte Anne Eaton, *Rome in the Nineteenth Century: Containing a Complete Account of the Ruins of the Ancient City, the Remains of the Middle Ages, and the Monuments of Modern Times. With Remarks on the Fine Arts, on the State of Society, and on the Religious Ceremonies, Manners, and Customs, of the Modern Romans. In a Series of Letters Written During a Residence at Rome, in the Years 1817 and 1818*, 3 vols., Edinburgh, 1820.

Eckersberg 1841

C. W. Eckersberg, *Linearperspectiven, anvendt paa Malerkunsten: En Række af perspectiviske Studier*, Copenhagen, 1841.

Edel 1978

Leon Edel, *Henry James: The Untried Years: 1843–1870*, New York, 1978.

Eliot 1885

George Eliot, *George Eliot's Life as Related in Her Letters and Journals*, 3 vols., London, 1885.

Evans and Whitehouse 1956

Joan Evans and John Howard Whitehouse, eds., *The Diaries of John Ruskin, Vol. 1: 1853–1857*, Oxford, 1956.

Ficacci 2011

Luigi Ficacci, *Giovanni Battista Piranesi: The Complete Etchings*, 2 vols., Cologne, 2011.

Fischer 1993

Erik Fischer, *C. W. Eckersberg: His Mind and Times*, Hellerup, 1993.

Fleming 1962

John Fleming, *Robert Adam and His Circle in Edinburgh and Rome*, London, 1962.

Focarino 2003

Joseph Focarino, ed., *The Frick Collection: An Illustrated Catalogue, Vol. 9: Drawings, Prints & Later Acquisitions*, Princeton, 2003.

Focillon 1918

Henri Focillon, *Giovanni Battista Piranesi: Essai de catalogue raisonné de son oeuvre*, Paris, 1918.

Focillon 1967

Henri Focillon, *Giovanni Battista Piranesi*, Bologna, 1967.

Forsyth 1835

Joseph Forsyth, *Remarks on Antiquities, Arts and Letters During an Excursion in Italy in the Years 1802 and 1803*, fourth edition, London, 1835.

Fortunati 1859

Lorenzo Fortunati, *Relazione generale degli scavi e scoperte fatte lungo la via Latina*, Rome, 1859.

Franzoni and Tempesta 1992

Claudio Franzoni and Alessandra Tempesta, "Il museo di Francesco Gualdi nella Roma del Seicento tra raccolta privata ed esibizione pubblica," *Bollettino d'Arte* 73, 1992.

Freud 1989

Sigmund Freud, *Civilization and Its Discontents*, translated by James Strachey, New York and London, 1989.

Frommel et al. 2014

Charles Percier e Pierre Fontaine: Dal soggiorno romano alla trasformazione di Parigi. Atti della giornata internazionale di studi, 9–10 dicembre 2008, edited by Sabine Frommel, Jean-Philippe Garric, and Elisabeth Kieven, Milan, 2014.

Frutaz 1972

Amato Pietro Frutaz, ed., *Le carte del Lazio*, 3 vols., Rome, 1972.

Fuller 1991

Margaret Fuller, *"These Sad but Glorious Days:" Dispatches from Europe, 1846–1850*, edited by Larry J. Reynolds and Susan Belasco Smith, New Haven, 1991.

Galassi 1991

Peter Galassi, *Corot in Italy: Open-Air Painting and the Classical-Landscape Tradition*, New Haven and London, 1991.

Garms 1995

Jörg Garms, *Vedute di Roma dal Medioevo all'Ottocento: Atlante iconografico, topografico, architettonico*, 2 vols., Naples, 1995.

Garric 2004

Jean-Philippe Garric, *Recueils d'Italie: Les modèles italiens dans les livres d'architecture français*, Sprimont, 2004.

Gell 1804

Sir William Gell, *The Topography of Troy and Its Vicinity*, London, 1804.

Gell 1832

Sir William Gell, *Pompeiana: The Topography, Edifices and Ornaments of Pompeii, the Result of Excavations Since 1819*, London, 1832.

Gell 1834

Sir William Gell, *The Topography of Rome and Its Vicinity*, 2 vols., London, 1834.

Gell and Gandy 1817–19

Sir William Gell and John P. Gandy, *Pompeiana: The Topography, Edifices and Ornaments in Pompeii*, London, 1817–19.

Gernsheim 1965

Helmut Gernsheim, *A Concise History of Photography*, London, 1965.

Godwin 1967

Parke Godwin, *A Biography of William Cullen Bryant*, 2 vols., New York, 1967.

Goethe 1970

Johann Wolfgang von Goethe, *Italian Journey, 1786–1788*, translated and edited by W. H. Auden and Elizabeth Mayer, Harmondsworth, 1970.

Gorra 2012

Michael Gorra, *Portrait of a Novel: Henry James and the Making of an American Masterpiece*, New York, 2012.

Gross 1990

Hanns Gross, *Rome in the Age of Enlightenment: The Post-Tridentine Syndrome and the Ancien Regime*, Cambridge, 1990.

Hardie 1968

Water-Colour Painting in Britain, edited by Dudley Snelgrove with Jonathan Mayne and Basil Taylor, 3 vols., London, 1966–68.

Hare 1870

Augustus J. C. Hare, *Walks in Rome*, London, 1870.

Hare 1875

Augustus J. C. Hare, *Days Near Rome*, 2 vols., London, 1875.

Hare 1909

Augustus J. C. Hare. *Walks in Rome*, 18th ed., London, 1909.

Hawthorne 1860

Nathaniel Hawthorne, *Transformation: or, the Romance of Monte Beni*, 2 vols., Leipzig, 1860.

Hawthorne 1899

Nathaniel Hawthorne, *The Marble Faun*, 2 vols., Boston and New York, 1899.

Hawthorne 1980

Nathaniel Hawthorne, *The French and Italian Notebooks*, edited by Thomas Woodson, Columbus, 1980.

Headley 1845

Joel Tyler Headley, *Letters from Italy*, London, 1845.

Helsted 1978

Dyveke Helsted, "Rome in Early Photographs," *The History of Photography* 2, no. 4, 1978, pp. 335–46.

Hind 1922

Arthur M. Hind, *Giovanni Battista Piranesi: A Critical Study, With a List of His Published Works and Detailed Catalogues of the Prisons and the Views of Rome*, London, 1922.

Hofer 1967

Philip Hofer, *Edward Lear as a Landscape Draughtsman*, Cambridge, Massachusetts, 1967.

Hornsby 2002

Clare Hornsby, *Nicolas-Didier Boguet (1755–1839): Landscapes of Suburban Rome*, Rome, 2002.

Hudspeth 1988

Robert N. Hudspeth, ed., *The Letters of Margaret Fuller, Vol. 5: 1848–49*, Ithaca, 1988.

Jacobson and Jacobson 2015

Ken Jacobson and Jenny Jacobson, *Carrying Off the Palaces: John Ruskin's Lost Daguerreotypes*, London, 2015.

James 1920

Henry James, *The Letters of Henry James*, edited by Percy Lubbock, New York, 1920.

James 1974

Henry James, *Letters, Vol. 1*, edited by Leon Edel, Cambridge, Massachusetts, 1974.

James 1979

Henry James, *Italian Hours*, New York, 1979.

Jameson 1836

Anna Brownell Jameson, *Diary of an Ennuyée*, Paris, 1836.

Johannsen 2007

Rolf Hermann Johannsen, *Friedrich Wilhelm IV von Preussen: Von Borneo nach Rom, Sanssouci und die Residenzprojekte 1814 bis 1848*, Kiel, 2007.

Jones 1964

Frederick L. Jones, ed., *The Letters of Percy Bysshe Shelley, Vol. 2: Shelley in Italy*, Oxford, 1964.

Juvenal 1992

Juvenal, *The Satires*, translated by Niall Rudd, Oxford, 1992.

Keats 1817

John Keats, *Poems by John Keats*, London, 1817.

Kieven 2013

Elisabeth Kieven, ed., *100 Jahre Bibliotheca Hertziana: Max-Planck-Institut für Kunstgeschichte, Vol. 2: Der Palazzo Zuccari und die Institutsgebäude*, Munich, 2013.

Lanciani 1893

Rodolfo Lanciani, *Pagan and Christian Rome*, Boston and New York, 1893.

Lapauze 1910

Henry Lapauze, *Le roman d'amour de M. Ingres*, Paris, 1910.

Lear 1841

Edward Lear, *Views in Rome and Its Environs*, London, 1841.

Le Corbusier 1972

Le Corbusier, *Towards a New Architecture*, translated by Frederick Etchells, New York, 1972.

Lee 1906

Vernon Lee [pseud.], *The Spirit of Rome: Leaves from a Diary*, London and New York, 1906.

Letarouilly 1870

Paul Marie Letarouilly, *Édifices de Rome moderne; ou, Recueil des palais, maisons, églises, couvents et autres monuments publics et particuliers les plus remarquables de la ville de Rome*, 3 vols. and 3 atlases, Paris, 1870[?]–ca. 1874.

Letarouilly 1882

P. M. Letarouilly, *Le Vatican et la Basilique de Saint-Pierre de Rome*, 4 vols., Paris, 1882.

Lupu 1937

N. Lupu, "La Villa di Sette Bassi sulla via Latina," *Ephemeris Dacoromana* 7, 1937.

MacDonald and Pinto 1995

William L. MacDonald and John Pinto, *Hadrian's Villa and Its Legacy*, New Haven, 1995.

Mack and Robertson 1997

Charles R. Mack and Lynn Robertson, *The Roman Remains: John Izard Middleton's Visual Souvenirs of 1820–1823, with Additional Views in Italy, France, and Switzerland*, Columbia, South Carolina, 1997.

Macpherson 1863

Robert Macpherson, *Vatican Sculptures, Selected and Arranged in the Order in Which They Are Found in the Galleries*, London, 1863.

Marquis de Sade 1995

Marquis de Sade, *Voyage d'Italie, ou, Dissertations critiques, historiques et philosophiques sur les villes de Florence, Rome, Naples, Lorette et les routes adjacentes à ces quatre villes*, Paris, 1995.

Marshall 2013

Megan Marshall, *Margaret Fuller: A New American Life*, Boston and New York, 2013.

Martial 1919

Martial, *Epigrams*, Loeb Classical Library, translated by Walter C. A. Ker, vol. 1, London and New York, 1919.

McNulty 1983

J. Bard McNulty, ed., *The Correspondence of Thomas Cole and Daniel Wadsworth*, Hartford, 1983.

Mendelssohn 1863

Felix Mendelssohn, *Letters from Italy and Switzerland*, Philadelphia and New York, 1863.

Miraglia 1985

Marina Miraglia, "*sub voce* Cuccioni, Tommaso," in *Dizionario Biografico degli Italiani* 31, 1985.

Moore 1854

Thomas Moore, *Life of Lord Byron, with His Letters and Journals*, 6 vols., London, 1854.

Morton 1966

H. V. Morton, *The Waters of Rome*, London, 1966.

Murray 1856

John Murray, *A Handbook for Travellers in Central Italy, Part 2: Rome and Its Environs*, fourth edition, London, 1856.

Naef 1962

Hans Naef, *Ingres Rom*, Zurich, 1962.

Naef 1977–80

Hans Naef, *Die Bildniszeichnungen von J.-A.-D. Ingres*, 5 vols., Bern, 1977–80.

Neuerburg 1965

Norman Neuerburg, *L'architettura delle fontane e dei ninfei nell'Italia antica*, Naples, 1965.

Nibby 1820

Antonio Nibby, *Le mura di Roma disegnate da Sir William Gell, illustrate con testo e note de A. Nibby*, Rome, 1820.

Nibby 1838

Antonio Nibby, *Itinerario di Roma e delle sue vicinanze*, Rome, 1838.

Nicassio 2009

Susan Vandiver Nicassio, *Imperial City: Rome Under Napoleon*, Chicago, 2009.

Noble 1853

Louis Legrand Noble, *The Course of Empire, Voyage of Life, and Other Pictures of Thomas Cole, N.A., with Selections from His Letters and Miscellaneous Writings, Illustrative of His Life, Character, and Genius*, New York, 1853.

Olsen 1985

Harald Peter Olsen, *Roma com'era nei dipinti degli artisti danesi dell'Ottocento*, Rome, 1985.

Olson 2001

Roberta J. M. Olson, "An Album of Drawings by Bartolomeo Pinelli," *Master Drawings* 39, no. 1, 2001, pp. 12–44.

Oppé 1951

Adolf Paul Oppé, "The Memoirs of Thomas Jones," *London Walpole Society Annual* 32, 1951.

Oppé 1954

Adolf Paul Oppé, *Alexander & John Robert Cozens, with a Reprint of Alexander Cozens' A New Method of Assisting the Invention in Drawing Original Compositions of Landscape*, Cambridge, Massachusetts, 1954.

Percier and Fontaine 1798

Charles Percier and Pierre-François-Léonard Fontaine, *Palais, maisons, et autres édifices modernes, dessinés à Rome*, Paris, 1798.

Percier and Fontaine 1809

Charles Percier and Pierre-François-Léonard Fontaine, *Choix des plus célèbres maisons de plaisance de Rome et de ses environs*, Paris, 1809.

Pietrangeli 1989

Carlo Pietrangeli et al. *Un Inglese a Roma, 1864–1877: La Raccolta Parker nell'Archivio fotografico comunale*, Rome, 1989.

Piljavskij 1984

Vladimir Ivanovich Piljavskij, *Giacomo Quarenghi*, edited by Sandro Angelini, catalogue by Vanni Zanella, Milan, 1984.

Pinelli 1809

Bartolomeo Pinelli, *Raccolta di cinquanta costumi pittoreschi, incisi all'acqua forte*, Rome, 1809.

Pinelli 1815

Bartolomeo Pinelli, *Nuova raccolta di cinquanta costumi pittoreschi*, Rome, 1815.

Pinto 1986

John Pinto, *The Trevi Fountain*, New Haven, 1986.

Pinto 2012

John Pinto, *Speaking Ruins: Piranesi, Architects, and Antiquity in Eighteenth-Century Rome*, Ann Arbor, 2012.

Piranesi 1743

Giovanni Battista Piranesi, *Prima parte di architetture e prospettive inventate ed incise da Giambatista Piranesi*, Rome, 1743.

Piranesi 1780

Francesco Piranesi, *Raccolta de'Tempj Antichi: Prima parte*, Rome, 1780.

Pirazzoli 1990

Nullo Pirazzoli, *Luigi Rossini, 1790–1857: Roma antica restaurata*, Ravenna, 1990.

Powell 1982

Cecilia Powell, "Topography, Imagination and Travel: Turner's Relationship with James Hakewill," *Art History* 5, no. 4, 1982.

Powell 1987

Cecilia Powell, *Turner in the South: Rome, Naples, Florence*, New Haven, 1987.

Reff 1985

Theodore Reff, *The Notebooks of Edgar Degas*, 2 vols., 2nd rev. ed., New York, 1985.

Riccio 2013

Bianca Riccio, ed., *William Gell, archeologo, viaggiatore e cortigiano: Un inglese nella Roma della Restaurazione*, Rome, 2013.

Ridley 1992

Ronald T. Ridley, *The Eagle and the Spade: Archaeology in Rome During the Napoleonic Era 1809–1814*, Cambridge and New York, 1992.

Rinne 2010

Katherine Rinne, *The Waters of Rome: Aqueducts, Fountains, and the Birth of the Baroque City*, New Haven, 2010.

Robaut 1905

Alfred Robaut, *L'oeuvre de Corot: Catalogue raisonné et illustré*, 4 vols., Paris, 1905.

Robison 1970

Andrew Robison, "Giovanni Battista Piranesi: Prolegomena to the Princeton Collections," *The Princeton University Library Chronicle* 31, no. 5, 1970, pp. 165–206.

Roethlisberger 1968

Marcel Roethlisberger, *Claude Lorrain: The Drawings*, 2 vols., Berkeley and Los Angeles, 1968.

Rogers 1842

Samuel Rogers, *Italy, a Poem*, London, 1842.

Rossini 1823

Luigi Rossini, *Le antichità romane, divise in cento tavole*, Rome, 1819–23.

Rossini 1826

Luigi Rossini, *Le antichità dei contorni di Roma, ossia le più famose città del Lazio: Tivoli, Albano, Castel Gandolfo, Palestrina, Tuscolo, Cora, e Ferentino*, Rome, 1826.

Rufini 1847

Alessandro Rufini, *Dizionario etimologico-storico delle strade, piazze, borghi e vicoli della città di Roma*, Rome, 1847.

Scott 1975

Jonathan Scott, *Piranesi*, London and New York, 1975.

Shelley 1821

Percy Bysshe Shelley, *Adonais: An Elegy on the Death of John Keats*, Pisa, 1821.

Sickler 1817

Friedrich Karl Ludwig Sickler, *Pantogramma des environs de Rome*, London, 1817.

Siegert 1985

Dietmar Siegert, *Rom vor hundert Jahren: Photographien 1846–1890*, Ebersberg, 1985.

De Staël 1807

Madame de Staël, *Corinne, ou l'Italie*, Paris, 1807.

De Staël 2008

Madame de Staël, *Corinne, or Italy*, translated by Sylvia Raphael, Oxford, 2008.

Stendhal 1959

Stendhal, *A Roman Journal*, translated by Haakon Chevalier, London, 1959.

Stiligoe 1995

John Stiligoe, "Introduction," in John Wood, *The Scenic Daguerreotype: Romanticism and Early Photography*, Iowa City, 1995, pp. i–xiv.

Story 1887

William Wetmore Story, *Roba di Roma*, Vol. 2, Boston and New York, 1887.

Stroffolino 2004

Daniela Stroffolino, "Alfred Guesdon, 'L'Italie à vol d'oiseau' (1849): La veduta a volo d'uccello dalle ali d'Icaro alla mongolfiera," in *Tra oriente e occidente: Città e iconografia dal XV al XIX secolo*, edited by Cesare de Seta, Naples, 2004, pp. 67–76.

Szegedy-Maszak 1999

Andrew Szegedy-Maszak, "Roman Views," in *Six Exposures: Essays in Celebration of the Opening of the Harrison D. Horblit Collection of Early Photography*, Cambridge, Massachusetts, 1999, pp. 89–106.

Tomasseti 1882

Giuseppe Tomasseti, "Della colonna detta di Enrico IV sull'Esquilino," in *Bullettino della commissione archeologica comunale di Roma* 10, 1882.

Tonkovich 2011

Jennifer Tonkovich, ed., *Studying Nature: Oil Sketches from the Thaw Collection*, New York, 2011.

Trastulli 1987

Paolo Emilio Trastulli, *Roma: Grandezza e splendore*, Rome, 1987.

Trevelyan 1908

George Macaulay Trevelyan, *Garibaldi's Defence of the Roman Republic*, London and New York, 1908.

Trevelyan 1911

George Macaulay Trevelyan, *Garibaldi and the Making of Italy, June–November 1860*, London and New York, 1911.

Trollope 1889

Thomas Adolphus Trollope, *What I Remember*, 3 vols., London, 1889.

Valenciennes 1820

Pierre-Henri de Valenciennes, *Éléments de perspective pratique à l'usage des artistes . . . suivis de réflexions et conseils à un élève sur la peinture et particulièrement sur le genre du paysage*, Paris, 1820.

Vance 1989

William L. Vance, *America's Rome*, 2 vols., New Haven, 1989.

Varriano 1991

John L. Varriano, *A Literary Companion to Rome*, London, 1991.

Vasi 1763

Giuseppe Vasi, *Itinerario istruttivo diviso in otto stazioni o giornate per ritrovare con facilità tutte le antiche e moderne magnificenze di Roma*, Rome, 1763.

Wallace-Hadrill 2006

Andrew Wallace-Hadrill, "Roman Topography and the Prism of Sir William Gell," in *Imaging Ancient Rome: Documentation, Visualization, Imagination*, edited by L. Haselberger and J. Humphrey, Portsmouth, Rhode Island, 2006, pp. 285–96.

Warrington 2004

Michael Warrington, "Cromek, Thomas Hartley (1809–1873)," in the *Oxford Dictionary of National Biography*, Oxford, 2004; online ed., May 2005.

Weinrautner 1997

Ina Weinrautner, *Friedrich Preller d. Ä (1804–1878): Leben und Werk*, Münster, 1997.

Werner 1858

Karl Friedrich Heinrich Werner, *Vedute dell'assedio di Roma del 1849, divise in dodici tavole dipinte dal prof. Carlo Werner ed incise all'acqua forte e bulino da Domenico Amici*, Rome, 1858.

Williamson 1918

George Charles Williamson, *Life and Works of Ozias Humphry, R.A.*, London, 1918.

Wilton-Ely 1994

John Wilton-Ely, *Giovanni Battista Piranesi: The Complete Etchings*, 2 vols., San Francisco, 1994.

Withey 1997

Lynne Withey, *Grand Tours and Cooks' Tours: A History of Leisure Travel, 1750–1915*, New York, 1997.

Wrigley 2013

Richard Wrigley, *Roman Fever: Influence, Infection and the Image of Rome, 1700–1870*, New Haven, 2013.

Zola 1913

Émile Zola, *Rome*, translated by Ernest Alfred Vizetelly, New York, 1913.

EXHIBITIONS

Angers and Boulogne-Billancourt 2006–7

Musée des Beaux-Arts, Angers, Bibliothèque Marmottan, Boulogne-Billancourt, *Lancelot-Théodore Turpin de Crissé: Peintre et collectionneur, Paris, 1782–1859*, organized by Caroline Chaine and Patrick Le Nouëne, 2006–7.

Belluno and Rome 2005–6

Palazzo Crepadona, Belluno, Palazzo Braschi, Museo di Roma, Rome, *Caffi: Luci del Mediterraneo*, catalogue by Annalisa Scarpa, 2005–6.

Bergamo 1994

Palazzo della ragione, Bergamo, *Giacomo Quarenghi: Architetture e vedute*, catalogue by Gianni Mezzanotte et al., introduction by Alessandro Bettagno, 1994.

Cambridge 1967

Fogg Art Museum, Harvard University, Cambridge, Massachusetts, *Ingres Centennial Exhibition, 1867–1967*, catalogue by Agnes Mongan and Hans Naef, 1967.

Cardiff, Manchester, and London 2003–4

National Museum & Gallery, Cardiff, Whitworth Art Gallery, Manchester, National Gallery, London, *Thomas Jones (1742–1803): An Artist Rediscovered*, catalogue edited by Ann Sumner and Greg Smith, 2003–4.

Chiasso and Rome 2014

m.a.x. museo, Chiasso, Istituto nazionale per la grafica, Rome, *Luigi Rossini, 1790–1857, Engraver: The Secret Journey*, catalogue by Maria Antonella Fusco and Nicoletta Ossanna Cavadini, 2014.

Chicago 1987

Art Institute of Chicago, *The Photography of Gustave Le Gray*, catalogue by Eugenia Parry Janis, 1987.

Cleveland, New York, and elsewhere 1988–90

Cleveland Museum of Art, Cooper-Hewitt Museum, New York, *Views of Rome*, catalogue by Raymond Keaveney, 1988–90.

Eugene and Princeton 2010

Jordan Schnitzer Museum of Art, Eugene, Oregon, and the Princeton University Art Museum, *Giuseppe Vasi's Rome: Lasting Impressions from the Age of the Grand Tour*, edited by James T. Tice and James G. Harper, 2010.

Florence 1988

Museo di storia della fotografia, Florence, *The Romantic Era: Reverendo Calvert Richard Jones, 1804–1877; Reverendo George Wilson Bridges, 1788–1863; William Robert Baker di Bayfordbury, 1810–1896. Il lavoro di tre fotografi inglesi svolto in Italia nel 1846–1860, usando il procedimento per Calotipia (Talbotipia)*, catalogue by Robert E. Lassam and Michael Gray, 1988.

Harewood and Bath 1999–2000

Harewood House, Harewood, Holburne Museum, Bath, *Thomas Hartley Cromek: A Classical Vision*, introduction by Ann Sumner; biographical sketch by Suzanne Zack, 1999–2000.

London, Washington, and New York 1999–2000

The National Gallery, London, the National Gallery of Art, Washington, D.C., and The Metropolitan Museum of Art, New York, *Portraits by Ingres: Image of an Epoch*, edited by Gary Tinterow and Philip Conisbee, 1999–2000.

Los Angeles 2005

The J. Paul Getty Museum, Los Angeles, *Antiquity & Photography: Early Views of Ancient Mediterranean Sites*, catalogue by Claire Lyons et al., 2005.

Los Angeles 2008

The J. Paul Getty Museum, Los Angeles, *Dilettanti: The Antic and the Antique in Eighteenth-Century England*, catalogue by Bruce Redford, 2008.

Munich 2005

Neue Pinakothek, Munich, *Rom 1846–1870: James Anderson und die Maler-Fotografen, Sammlung Siegert*, catalogue by Dorothea Ritter, 2005.

New York 1994

The Pierpont Morgan Library, New York, *The Thaw Collection: Master Drawings and New Acquisitions*, catalogue by Cara D. Denison et al., 1994.

New York and Montreal 1993

The Pierpont Morgan Library, New York, Centre Canadien d'Architecture, Montreal, *Exploring Rome: Piranesi and His Contemporaries*, catalogue by Cara D. Denison, Myra Nan Rosenfeld, and Stephanie Wiles, 1993.

New York and Rome 2006–8

American Academy in Rome, New York City, American Academy in Rome, *Steps Off the Beaten Path: Nineteenth-Century Photographs of Rome and Its Environs*, edited by W. Bruce Lundberg and John A. Pinto, 2006–8.

New York, Cleveland, and San Francisco 1988–89

The Frick Collection, New York, Cleveland Museum of Art, California Palace of the Legion of Honor, Fine Arts Museums of San Francisco, *François-Marius Granet:*

Watercolors from the Musée Granet at Aix-en-Provence, catalogue by Edgar Munhall, 1988–89.

Paris 1994

Musée du Louvre, Paris, *Achille-Etna Michallon*, catalogue by Vincent Pomarède, Blandine Lesage, and Chiara Stefani, 1994.

Paris 1994a

Musée du Louvre, Paris, *La chimère de monsieur Desprez*, organized by Régis Michel, 1994.

Paris and Mantua 2001

Galeries nationales du Grand Palais, Paris, Palazzo Te, Mantua, *Un paese incantato: Italia dipinta da Thomas Jones a Corot*, catalogue by Anna Ottani Cavina, 2001.

Paris and Naples 1981

École nationale supérieure des beaux-arts, Paris, Institut français, Naples, *Pompei e gli architetti francesi dell'Ottocento*, catalogue by Stefano De Caro et al., 1981.

Philadelphia, New York, and Rome 1989–90

Arthur Ross Gallery, University of Pennsylvania, Philadelphia, Italian Consulate for the American Academy in Rome, New York, American Academy in Rome, *Piranesi: Rome Recorded*, catalogue edited by Malcolm Campbell, 1989–90.

Poughkeepsie 2014

Vassar College, Poughkeepsie, *The Architect's Library: A Collection of Notable Books on Architecture at Vassar College*, edited by Nicholas Adams, 2014.

Rennes 1981

Musée de Rennes, Rennes, *Alfred-Nicolas Normand, architecte: Photographies de 1851–1852*, 1981.

Rome 1956

Palazzo Braschi, Museo di Roma, Rome, *Bartolomeo Pinelli*, catalogue by Giovanni Incisa della Rocchetta, 1956.

Rome 1981

Palazzo Braschi, Museo di Roma, Rome, *La Valle della Caffarella*, catalogue by Sandro Ranellucci, 1981.

Rome 1981–82

Accademia di Francia, Rome, *David e Roma*, catalogue by Arlette Sérullaz, Udolpho van de Sandt, and Régis Michel, 1981–82.

Rome 1982

Palazzo Braschi, Museo di Roma, Rome, *Luigi Rossini, incisore: Vedute di Roma, 1817–1850*, catalogue edited by Lucia Cavazzi, 1982.

Rome 1983

Rondanini galleria d'arte contemporanea, Rome, *Bartolomeo Pinelli, 1781–1835, e il suo tempo*, catalogue edited by Maurizio Fagiolo and Maurizio Marini, 1983.

Rome 1991–92

Museo nazionale di Castel Sant'Angelo, Rome, *In urbe architectus, modelli, disegni, misure: La professione dell'architetto, Roma, 1680–1750*, catalogue by Bruno Contardi and Giovanna Curcio, 1991–92.

Rome 1996–97

American Academy in Rome, *Paesaggi perduti: Granet a Roma, 1802–1824*, organized by Caroline Astrid Bruzelius, catalogue by Maureen B. Fant and Sarah Hartman, 1996.

Rome 2000–1

Palazzo Altemps, Museo nazionale romano, Rome, *Frondose arcate: Il Colosseo prima dell'archeologia*, organized by F. Scoppola, 2000–1.

Rome 2001–2

Palazzo Fontana di Trevi, Rome, *I Giustiniani e l'antico*, catalogue by Giulia Fusconi, 2001–2.

Rome 2003

Studium Urbis, Rome, *Roma Nolliana*, catalogue by Allan Ceen, 2003.

Rome 2004–5

Complesso del Vittoriano, Rome, *Degas: Classico e moderno*, edited by Maria Teresa Benedetti, 2004–5.

Rome 2006

Complesso del Vittoriano, Rome, *'800 Danese: Architettura di Roma e paesaggi di Olevano Romano*, edited by Jens Peter Munk and Sandro Barbaglio, 2006.

Rome 2007

Palazzo Incontro, Rome, *Le piante di Roma delle collezioni private*, catalogue by Clemente Marigliani, 2007.

Rome 2009–10

Museo Mario Praz, Rome, *Disegni romani di Lancelot-Théodore Turpin de Crissé (1782–1859) dalle collezioni del Louvre*, catalogue by Patrizia Rosazza-Ferraris, 2009–10.

Rome 2011–12

Palazzo Braschi, Museo di Roma, Rome, *Fotografare la storia: Stefano Lecchi e la Repubblica romana del 1849*, catalogue by Maria Pia Critelli, 2011–12.

Rome 2014

American Academy in Rome, *Building an Idea: Mc-Kim, Mead & White and the American Academy in Rome, 1914–2014*, catalogue edited by Marida Talamona and Peter Benson Miller, 2014.

Rome and Copenhagen 1977

Palazzo Braschi, Museo di Roma, Rome, Thorvaldsen Museum, Copenhagen, *Roma dei fotografi al tempo di Pio IX, 1846–1878: Fotografie da collezioni danesi e romane*, 1977.

Rome and Modena 2008

Calcografia, Rome, Fotomuseo Giuseppe Panini, Modena, *Roma, 1840–1870: La fotografia, il collezionista, e lo storico*, catalogue by Maria Francesca Bonetti, Chiara Dall'Olio, and Alberto Prandi, 2008.

Rome and Paris 1985–86

Villa Medici, Rome, École nationale supérieure des beaux-arts, Paris, *Roma antiqua, envois des architectes français, 1788–1924: Forum, colisée, palatin*, catalogue edited by François-Charles Uginet, 1985.

Rome and Paris 2003–4

Palazzo Caffarelli, Musei Capitolini, Rome, Maison européenne de la photographie, Paris, *Roma 1850: Il circolo dei pittori fotografi del Caffè Greco*, catalogue by Anne Cartier-Bresson et al., 2003–4.

's Hertogenbosch 1977

Noordbrabants Museum, 's Hertogenbosch, *J. A. Knip, 1777–1847*, catalogue by Elinoor Bergvelt and Margriet van Boven, 1977.

South Hadley 1980

Mount Holyoke College Art Museum, South Hadley, Massachusetts, *Images of Italy: Photography in the Nineteenth Century*, catalogue by Wendy M. Watson, 1980.

Stockholm 1992

Nationalmuseum, Stockholm, *Louis-Jean Desprez: Tecknare, teaterkonstnär, arkitekt*, catalogue by Ulf Cederlöf et al., 1992.

Toulouse 2003

Musée Paul-Dupuy, Toulouse, *"La nature l'avait créé peintre:" Pierre-Henri de Valenciennes, 1750–1819*, catalogue edited by Valérie Viscardi, 2003.

Tours and Cologne 1994–95

Musée des Beaux-Arts de Tours, Wallraf-Richartz Museum, Cologne, *Louis-François Cassas, 1756–1827, dessinateur, voyageur im Banne der Sphinx: ein französischer Zeichner reist nach Italien und in den Orient*, organized by Annie Gilet and Uwe Westfehling, catalogue by Maria Bohusz et al., 1994.

Tulsa and elsewhere 1975–78

Philbrook Art Center, Tulsa, *The Arthur M. Sackler Collection: Piranesi at the Avery Architectural Library*, catalogue by Dorothea Nyberg, 1975–78.

Venice 1978

Fondazione Giorgio Cini, Istituto di storia dell'arte, Venice, *Piranesi: Incisioni, rami, legature, architetture*, organized by Alessandro Bettagno, 1978.

Venice 1979

Museo d'arte moderna Ca' Pesaro, Venice, *Ippolito Caffi, 1809–1866*, catalogue by Guido Perocco, 1979.

Washington 2003–4

National Gallery of Art, Washington, *Christoffer Wilhelm Eckersberg, 1783–1853*, catalogue by Philip Conisbee, Kasper Monrad, and Lene Bøgh Rønberg, 2003–4.

Washington, Brooklyn, and St. Louis 1996–97

National Gallery of Art, Washington, Brooklyn Museum, Saint Louis Art Museum, *In the Light of Italy: Corot and Early Open-Air Painting*, catalogue by Philip Conisbee et al., 1996–97.

Washington and Houston 2008

National Gallery of Art, Washington, Museum of Fine Arts, Houston, *In the Forest of Fontainebleau: Painters and Photographers from Corot to Monet*, catalogue by Kimberly Jones et al., 2008.

ACKNOWLEDGMENTS

The author is grateful to the following colleagues for their assistance with this publication:

Nicholas Adams, John Alexander, Colin Bailey, Karen Banks, Basile Baudez, John Bidwell, Bruce Boucher, Sandra Brooke, Vincent Buonanno, Allan Ceen, Adele Chatfield-Taylor, Giada Damen, Patricia Emerson, Carole Ann Fabian, Peggy Fogelman, Leslie Geddes, Laura M. Giles, Alden Gordon, William M. Griswold, Eliza Heitzman, Alexander B. V. Johnson, Jerry Kelly, Declan Kiely, Michael Koortbojian, Susan Lehre, W. Bruce Lundberg, Delaney H. Lundberg, John Marciari, Anita Masi, Julie Melby, Vernon Minor, Maria Molestina-Kurlat, Christine Nelson, Lena Newman, Roberta J. M. Olson, Marilyn Palmeri, Arnold Paradise, Paula Pineda, Meg Pinto, Marion Riggs, Elizabeth Barlow Rogers, Stephen Saitas, Nicola Shilliam, Christopher Scholz, Joel Smith, Eva Soos, Karin Trainer, Jennifer Tonkovich, Madeleine Viljoen, and Carolyn Yerkes.

INDEX

CREDITS

Every effort has been made to trace copyright owners and photographers. The Morgan apologizes for any unintentional omissions and would be pleased in such cases to add an acknowledgment in future editions.

PHOTOGRAPHIC COPYRIGHT:

Avery Architectural & Fine Arts Library, Columbia University, Nos. 1, 51, 67, No. 26, Fig. 1, No. 67, Figs. 1–2; Collection of Vincent Buonanno, Fig. 3 (p. 17), No. 9, Fig. 1, No. 58; Biblioteca Civica Angelo Mai e Archivi storici comunali, Bergamo, No. 6, Fig. 1; The David Collection, Copenhagen, inv. no. 18/1969, No. 27, Fig. 2; Copyright The Frick Collection, No. 21, p. 66; Keats-Shelley Memorial Association, Fig. 4 (p. 18); © 2015 Kunsthaus Zürich, Fig. 2 (p. 14); Collection W. Bruce and Delaney H. Lundberg, back cover, Nos. 3, 13–17, 22–24, 30, 32, 36, 53, 57, 59, 61, 63, 65, 41, pp. 122, 126, 154; Marquand Library of Art and Archeology, Princeton University, Fig. 6 (pp. 20–21); image copyright © The Metropolitan Museum of Art, image source: Art Resource, NY, Nos. 5, 20, No. 41, Fig. 1; The Morgan Library & Museum, Fig. 7 (p. 24), front cover, frontispiece, Nos. 2, 4, 6–7, 9–10, 18–19, 27, 29, 31, 34–35, 37–38, 40, 42–48, 50, 52, 54–56, 60, 62, 64, 66, No. 27, Fig. 1, No. 38, Fig. 1, pp. 8, 34, 88, 104; Roberta J. M. Olson and Alexander B. V. Johnson, Nos. 8, 25–26, 28, 49; Princeton University Art Museum, Princeton, NJ, Fig. 1 (p. 13); Kunstmuseet Brundlund Slot-Museum Sønderjylland, No. 8, Fig. 1; private collection, Nos. 33, 39, 66, No. 37, Fig. 1; © RMN–Grand Palais / Art Resource, NY, No. 7, Fig. 1; Staatliche Graphische Sammlung München, inv. 445Z, No. 18, Fig. 1; © Städel Museum–U. Edelmann-ARTOTHEK, Fig. 5 (p. 18); Studium Urbis, Rome, Nos. 11–12.

PHOTOGRAPHY:

Janny Chiu, Nos. 8, 25–26, 28, 43, 49; Steven H. Crossot, front cover, Nos. 4, 6–7, 18, 34–35, 38, 44, 47, 62, pp. 34, 104; Graham S. Haber, back cover, Fig. 7 (p. 24), frontispiece, Nos. 2–3, 9–17, 22–24, 27, 30–33, 36–37, 39, 41–42, 45–46, 48, 50, 52–61, 63–66, No. 9, Fig. 1, No. 27, Fig. 1, No. 37, Fig. 1, No. 38, Fig. 1, pp. 8, 126, 154; © Pernille Kempe, No. 8, Fig. 1; Schecter Lee, Nos. 19, 29, p. 88; John Pinto, No. 28, Fig. 1, No. 29, Fig. 1, No. 39, Fig. 1; Marion Riggs, No. 47, Fig. 1; Bruce M. White, Fig. 1 (p. 13).

Published by the Morgan Library & Museum,
the University Press of New England, and
the Foundation for Landscape Studies

THE MORGAN LIBRARY & MUSEUM

Karen Banks, *Publications Manager*
Patricia Emerson, *Senior Editor*
Eliza Heitzman, *Editorial Assistant*

PROJECT STAFF

Marilyn Palmeri, *Manager, Imaging and Rights*
Eva Soos, *Assistant Manager, Imaging and Rights*
Kaitlyn Krieg, *Administrative Assistant,
 Imaging and Rights*
Graham S. Haber, *Photographer*

Designed by Jerry Kelly

Typeset in Nonpareil Quarto and Adobe Trajan

Printed on 130gsm Yulong Pure 1.3 Creamy
Woodfree and bound by Oceanic Graphic
International, Inc.

The publishers wish to thank Min Tian.